HOW TO Photograph Dogs

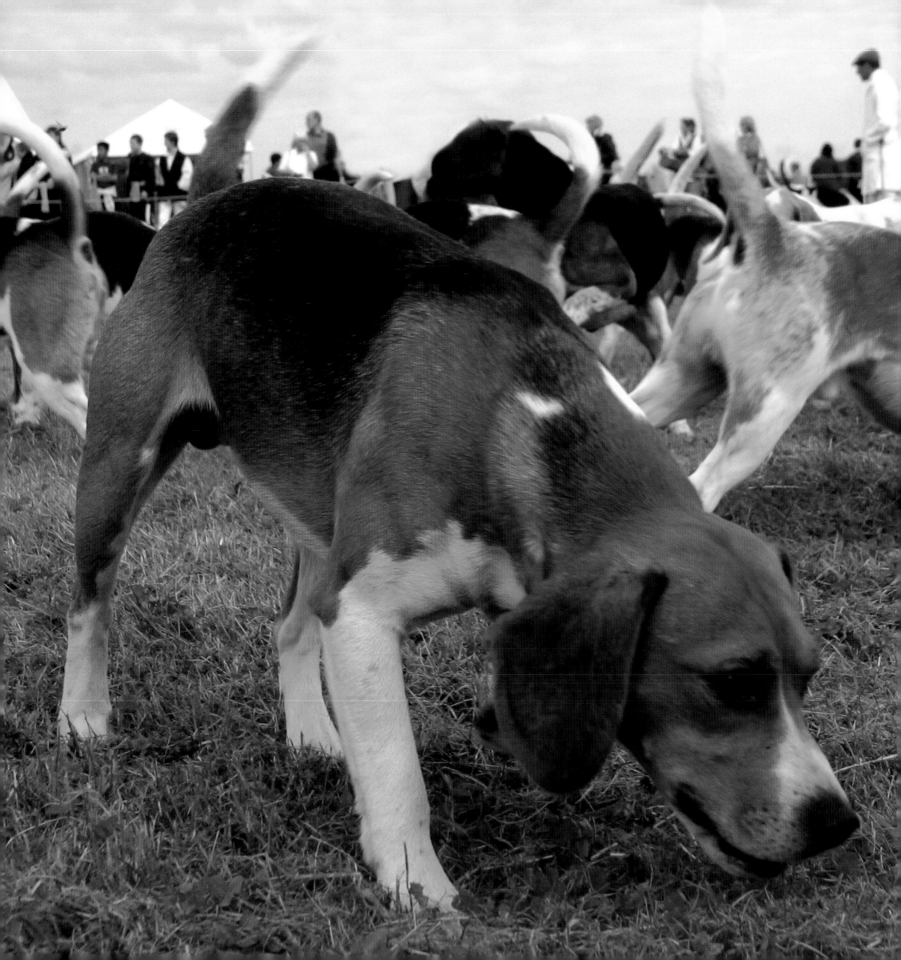

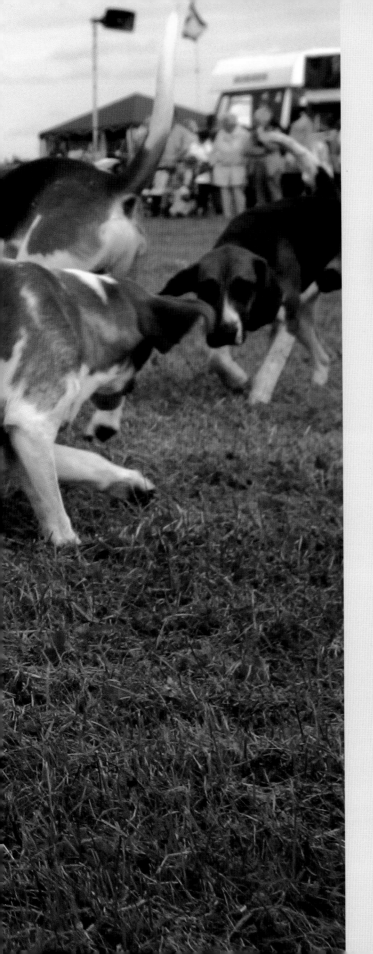

HOW TO Photograph Dogs

Nick Ridley

photographers'
pip
institute press

First published 2004 by
Photographers' Institute Press/PIP
166 High Street, Lewes
East Sussex, BN7 1XU

Text © Nick Ridley 2004

© in the work Photographers' Institute Press/PIP

Photographs: Nick Ridley
Illustrations: John Yates

ISBN 1 86108 332 7

British Cataloguing in Publication Data

A catalogue record of this book is available from the British Library.

Publisher: Paul Richardson
Art Director: Ian Smith
Managing Editor: Gerrie Purcell
Commissioning Editor: April McCroskie
Production Manager: Stuart Poole
Editors: Gill Parris and James Beattie
Cover design: Rob Wheele at Wheelhouse Design
Book Design: GMC Publications

Typeface: Avenir, Berkeley
Colour reproduction by MRM Graphics, Winslow, Bucks
Printed and bound by Kyodo Printing Co. Ltd, Singapore

DEDICATION

In 2003 my life entered a new chapter as I embarked on yet another of
my many 'dreams and schemes', leaving a secure job and embarking on
a full-time career as a professional photographer and freelance writer. I
could not have contemplated this change without the constant support
of my wife Debbie and my two daughters Gemma and Holly: I am
eternally grateful for the way you all keep my feet firmly on the ground.

And to Greg Knight, a very special friend: may this book inspire
and encourage you.

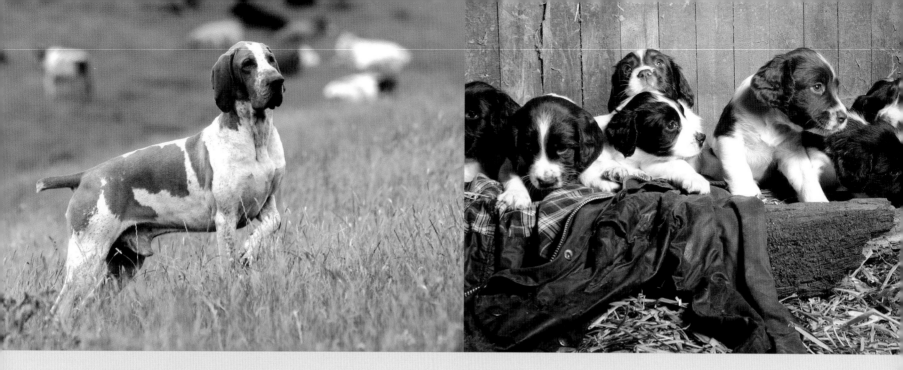

Contents

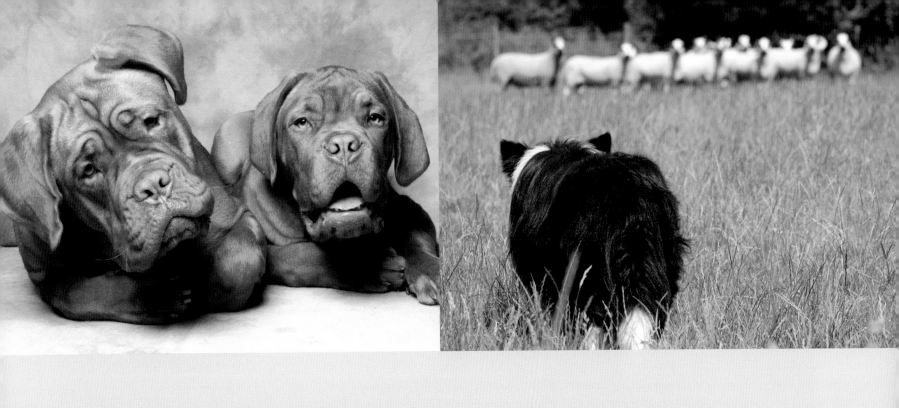

Introduction

It is no coincidence that the domestic dog is also known as Man's best friend; even its scientific classification *Canis familiaris* means 'friendly dog'. Recent fossil discoveries suggest that the first domestication of the dog took place in the Middle East at least 20,000 years ago; some believe it could be even longer. Although we will never really know how the first affiliation between humans and dogs came about, in today's world that relationship is very special indeed.

Our Best Friend

The latest figures suggest that there are in excess of 100 million dogs sharing our homes in Europe and the USA. Although dogs are not the most numerous of our pets they are arguably the most important: they live as family members; their loyalty is unquestionable and, when required, they can work in more traditional roles such as guarding, hunting or herding. When highly trained they can be used as our eyes or ears, they can be taught to locate explosives, drugs, or even human remains. They are truly remarkable creatures.

One for the Album

It should come as no surprise that most dog owners' homes are adorned with photographs of their 'best friend' but, all too often, these treasured images do not do justice to the relationship between them. The good news is that, to take professional-looking pictures of your dog, you will not need to break the bank buying top-of-the-range equipment. What you do need is an affinity with your subject, a basic technical understanding of photography, a few trade secrets and, most important of all, loads and loads of patience.

Improving Your Technique

Good photographers have the ability to 'see' a picture long before the shutter button is fired; they then have the skill to put the elements in place to achieve the desired effect. This skill can be learnt through experience and practice, 'trial and error' is a phrase that the budding

Canis familiaris, the domestic dog, arguably the most important animal to share our lives.

GOLDEN LABRADOR
Canon EOS D60; focal length 200mm; 1/500sec at f/4.5; ISO 800

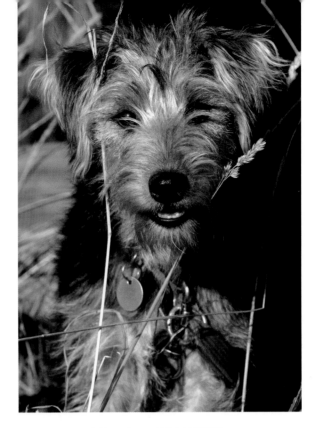

LAKELAND-CROSS-JACK RUSSELL TERRIER
Canon EOS D60; focal length 175mm; 1/1000sec at f/8; ISO 400

BORDER COLLIE
Canon EOS D60; focal length 135mm; 1/1500sec at f/6.7; ISO 400

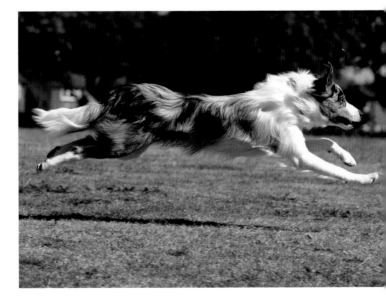

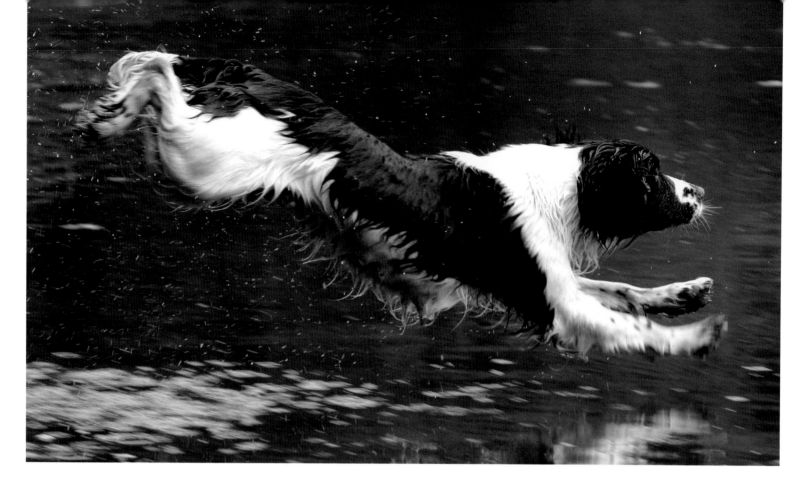

My favourite kind of action shot. You will need to perfect a number of photographic techniques to be able to regularly capture a dog in mid-flight into a lake or over a jump.

ENGLISH SPRINGER SPANIEL
Canon EOS D60; focal length 105mm; 1/750sec at f/9.5; ISO 800

dog photographer will come to know well. I would suggest that dogs can make the perfect photographic subject. A well-trained dog is capable of a variety of poses, ranging from the classic 'sit up and beg', to explosive bursts of action

Dogs can test a photographer's reflexes to the limit, especially if you are trying to capture them in mid-air as they leap over jumps or into a lake while, in quieter moments, close-ups of loyal eyes can make very intimate and personal images.

Working with Dogs

No matter what you want to achieve with your photography, no picture is worth causing stress or harm to the animal. Camera lenses and flashguns can turn a normally bold dog into a quivering wreck, remember there are humans that do not like their photographs being taken and dogs are no different. Learn to read your dog's body language and adjust your techniques accordingly. Be flexible, make the sessions short, and always carry a biscuit in your pocket – bribery can work wonders!

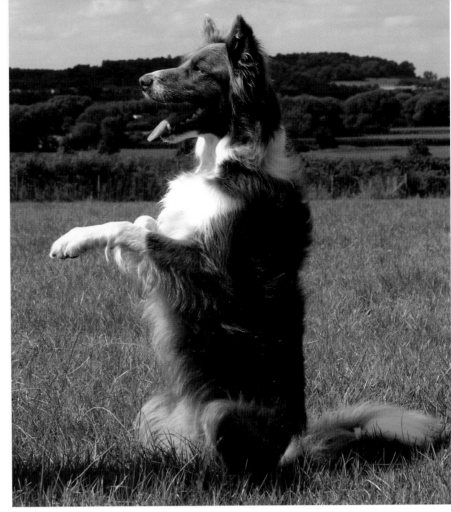

The Digital Age

The huge increase in the sale of digital cameras has made learning and perfecting photographic techniques far quicker and easier. You shoot, you view, you try again, many cameras can even record the camera settings, so you can instantly make adjustments to shutter and aperture values if the result is not what you expected.

Most households now own computers, and digital image manipulation is no longer solely the realm of the professional. It is not a difficult job to paste a tennis ball in front of a running dog, although I have never done this and none of the images in this book has been manipulated in this way. I prefer to practise my methods and techniques until I start to get consistent results.

Most of the action images have been taken during working tests, be they agility, obedience or gun dog tests and so I only have one opportunity to get it right. Occasionally I will spend time with an individual dog to get the 'perfect' shot but whatever the situation, the owner or handler will always be given a genuine image. Set out your standards and stick to them.

ABOVE RIGHT The classic 'sit up and beg' pose.

BORDER COLLIE
Canon EOS D60; focal length 135mm; 1/500sec at f/6.7; ISO 100

ABOVE LEFT Lighting, composition, and a bit of luck can turn an ordinary snap into something very special.

BORDER COLLIE
Canon EOS D60; focal length 300mm; 1/350sec at f/6.7; ISO 400

NOTE

All of the of the images in this book have been taken using digital cameras: the Canon EOS D30, D60 and the 10D and a variety of Sigma and Canon lenses.

In the captions you will see that I have recorded the exposure and focal length details, as well as which camera I used. Where I have used a zoom lens I have recorded the specific focal length that the lens was set at. While exposure details are important, and I hope you will be able to draw on them to improve your own techniques, you shouldn't get too hung up on the technical side of things. Often taking a great photo is simply a case of recognizing an opportunity and firing the shutter button.

Equipment

Take a look in any high street photography shop and you will see a vast array of cameras and equipment on sale. In this chapter we look at the advantages and disadvantages of each camera format, as well as comparing digital and film. We'll also see what else you need to get you started, from basic camera accessories, to a few little tricks of the trade that I like to keep to hand to entertain my canine models.

EQUIPMENT: **WHAT TYPE OF CAMERA IS BEST?**

35mm Compact Zoom Cameras

There is a huge range of compact zoom cameras available, and you can pay almost any price that you want. Although these cameras do have limitations, they are capable of producing excellent results when photographing dogs, especially when used outside.

Advantages

Like the SLR below, some models offer a high degree of automation along with standard pre-set modes. The higher-specified cameras allow photographers to choose their own settings, permitting greater creativity, and the zoom lens normally covers a focal length of between 28 and 70mm, which is perfect for most situations. Nearly all compact zooms have motorized film advance and built-in flash units.

Disadvantages

Compact cameras do not normally allow for the more powerful and useful accessory flashguns to be fitted. They can inhibit your creativity if they do not allow you to change exposure or focus settings. Also, because of the way a compact camera is designed, the photograph you take will not be exactly the same as the scene you see through the viewfinder.

35mm Single Lens Reflex Cameras (SLRs)

RECOMMENDED

The 35mm SLR camera is a very popular format with amateur and professional photographers alike. There is an extensive range of cameras as well as lenses and accessories that are available to accompany them. It is one of the most practical types of camera for taking pictures of dogs, especially as most modern models offer fast and reliable autofocus, which enables you to take both static and action shots. This is normally combined with autoexposure, so you can concentrate on taking the picture and let the camera work out the exposure settings.

Advantages

Modern SLRs offer a higher degree of automation than most other types of camera. Often the functions on the SLR can be manually overridden, if you wish to be more creative. Some SLRs include built-in flash (useful for adding a highlight in the animal's eye) and a motorized film advance that is perfect for taking a series of action shots. They also allow the photographer to attach accessories such as flashguns and filters to the lens to create special effects. The SLR camera is a great place to start and, by shopping around, you can pick up some real bargains that will be easy to use without limiting your creativity.

Disadvantages

An SLR camera is heavier and bulkier than a compact or APS camera. As 35mm SLRs use film they can be expensive to run, if this is an issue you should think about buying a digital camera.

14

Advance Photo System (APS) Cameras

APS technology is based on a smaller format of film than 35mm cameras. They are widely available and rival 35mm compact zooms for popularity.

Advantages

The APS system gives the user the advantage of three different formats from the same film: Classic, HDTV (High-Definition Tele-Vision) and Panoramic. The main benefits of this system over traditional film are that you get a printed index sheet back with your photographs and that film loading system is very easy.

Disadvantages

APS cameras normally have a limited range of camera functions. The APS format currently offers no great advantage over traditional 35mm equipment. APS film is also often more expensive to process than 35mm film.

Digital Cameras

Digital technology is advancing at a tremendous rate and nowhere more so than in the manufacture of cameras. Digital cameras use photo-sensors and storage cards instead of film. Both compact and SLR versions are available to buy.

Advantages

The biggest advantage of using digital is that it is immediate: you can take the picture, view it on the LCD (liquid crystal display), download it to the computer, print it, or even e-mail it. It is also the perfect tool to practise your techniques as, once you have made the initial outlay for the equipment (see page 123–7), there are no ongoing film or processing costs.

Disadvantages

Battery consumption is a major headache with digital cameras and this can catch you out if you are not prepared. Many cameras use rechargeable cells, so double check that these are fully charged before setting out. Because of the electronic components digital cameras can also be very expensive.

AUTHOR'S CHOICE

Medium Format Cameras

Medium format cameras use a larger film (called 120 or 220 roll film) than 35mm cameras, and these cameras are often favoured by professional photographers.

Advantages

Because of the larger film size a better quality print or transparency, with finer grain is produced, meaning that the photo can be blown up to a much higher size than a 35mm camera.

Disadvantages

Medium format cameras are heavier and generally slower to use than 35mm cameras. They tend to be more expensive than 35mm, and are definitely not recommended for the beginner.

15

Lenses

A camera is of no use without a lens and the choice for 35mm and digital SLRs is truly vast. One of the biggest advantages of the SLR camera is that the lenses can be interchanged. The two basic choices are prime lenses, which are a fixed focal length, and zoom lenses, which have a variable focal length. Because of the way they are manufactured, prime lenses are generally better quality, but zoom lenses are more convenient.

Zoom Lenses

Zoom lenses enable the photographer to change the way they frame a scene without actually having to change their position or lens. A zoom lens with a focal length of around 24–80mm will cover most eventualities, but in some cases the extra working distance of a telephoto zoom – with a focal length of between 75–300mm – can be useful. In fact many budget-priced SLRs will be sold as part of a kit: including the camera body, a standard zoom lens and a telephoto zoom.

Wide-angle lenses (35mm and shorter) are great for close-up abstract images of dogs.

GOLDEN LABRADOR
Canon EOS D60; focal length 15mm; 1/180sec at f/5.6; ISO 100

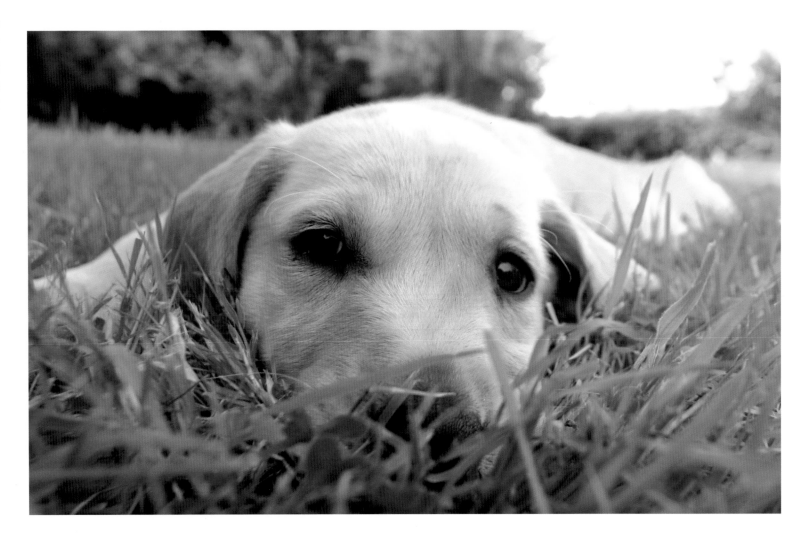

The standard 50mm lens gives the same field of view as our own eyes and is the perfect lens for straightforward portraits.

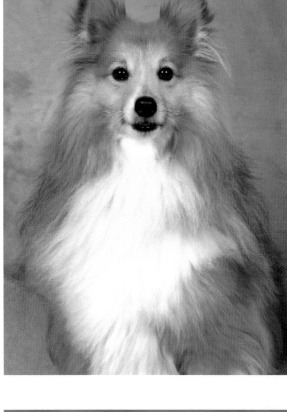

SHELTIE
Canon EOS D60; focal length 50mm; 1/60sec at f/22; two studio flash units; ISO 100

Telephoto zoom lenses are not only good for making a distant subject appear larger in the frame, but also they create a compressed perspective which can have the effect of isolating the dog from the fore- and background.

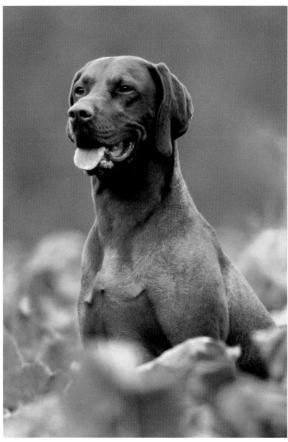

HUNGARIAN VIZSLA
Canon EOS D60; focal length 200mm; 1/350sec at f/5.6; ISO 400

Wideangle lenses

Focal lengths: 17–35mm
- Wideangle lenses provide an interesting perspective and can be used for abstract close-ups of dogs lying down.
- They also help include a large area and are useful for portraits showing the dog and its environment, or for photographing groups of dogs.

Standard prime lenses

Focal length: 50mm
- This focal length covers the same field of view as our own eyes so is a good all round lens for general portraits.
- Standard prime lenses are quite often overlooked in favour of zoom lenses, however they can be cheap to buy and are well worth having.

Telephoto lenses

Focal lengths: 75–600mm
- The lower end focal lengths, e.g. 75–135mm, are ideal for portraits where the photographer needs to increase the distance between him- or herself and the dog.
- The mid-range focal lengths, e.g. 135–300mm are good for taking action shots of dogs hunting, running or jumping.
- The extreme telephoto lenses (400–600mm) are not widely used for photographing dogs, but could be useful for zooming in on a dog across a field.

Image Storage

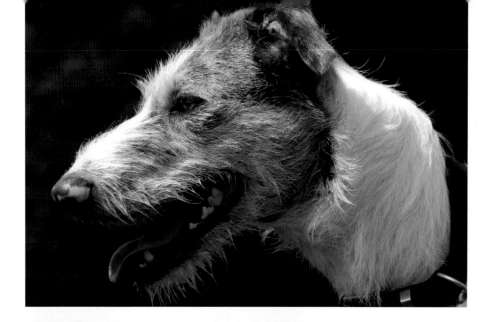

Regardless of whether you use digital or film technology, image capture and storage is an integral part of the photographic process.

Film

The quality of the film used has a direct effect on the final image. Use inferior film and you will get inferior results – it's that simple. Another factor to be taken into account is the importance of using the right type of film for the job. Film can be divided into two types: negative and transparency, also known as slide film.

Negative Film
It is estimated that over 20 million photographs are taken each year in the UK alone and it is a fair bet that the majority of them are taken using negative film. Negative film is easy to find on the high street and can be bought very cheaply, although the quality of cheap negative films can be dubious.

Once the film has been processed, the prints are produced. You can take negative film to any high street lab and expect to get reasonable results.

A major advantage of negative film is that it is very forgiving during exposure; it has a wide latitude and can therefore deal with reasonable degrees of under- or overexposure (see page 26).

Prints are also easier to view than slides, as to view slides you will have to project them or look at them on a light-box.

Slide Film
This type of film is also known as transparency film. It is generally felt that slide film gives better-quality pictures, as there is only one stage in the developing process, which means less degradation of the image. Prints can be made from transparencies but they do tend to be rather expensive. This type of film does not have very wide exposure latitude and therefore pictures will appear more 'contrasty'.

A relatively slow rating (ISO 100) was used here. The enlargement (left) shows that even at high magnification there are no signs of any grain / noise in the image.

COLLIE-CROSS-LURCHER Canon EOS D60; focal length 50mm; 1/500sec at f/6.7; ISO 100

EQUIPMENT: **NEGATIVE OR SLIDE FILM?**

Negative Film
- A wider exposure latitude and more 'forgiving' than slide film.
- Easily available and cheap to process.
- Easier and cheaper to view than transparencies.

Slide Film
- Better quality as there is only one processing stage.
- Richer colours and more contrast than negative film.
- If you want to sell your photos only slides or digital will do.

Digital Imaging

Obviously digital cameras don't use film. The digital process is a two-stage operation; the first stage is digital capture: capturing the image on the photo-sensor; this information is then passed on to the second stage: storing the digital images.

Digital Capture The heart of any digital camera is the photo-sensor, this is the digital equivalent of traditional film. The photo-sensor is basically a grid of extremely small light-sensitive cells. When light reaches these sensors (also known as pixels), an electrical signal is produced and it is from the resulting pattern that the digital image is built up. The more pixels that can be built onto the photo-sensor, the finer the detail in the image will be, and this is the challenge faced by manufacturers of digital cameras.

Digital Storage The information captured by the photo-sensor is then passed on to a storage device. Digital files take up a huge amount of storage space, although most digital cameras will give you a choice of taking pictures at different resolutions (high, medium and low quality). The higher the quality, the larger the

file. Digital cameras used to have built-in storage disks and this limited the number of pictures that could be taken before they were downloaded to a computer.

The answer to this problem was to use removable storage disks (more commonly called 'cards'), that could be replaced when full, just like film. There are four main types of card on the market: CompactFlash, SmartMedia, Microdrive and the recently introduced xD cards. CompactFlash, SmartMedia and xD are solid-state cards (have no moving parts). They vary in capacity, and the larger cards can store hundreds of high-quality images. The Microdrive is simply a very small hard drive, similar to those used in PCs, which can hold a huge amount of data. Microdrives tend to be slightly less robust than solid-state cards and they do not stand up to very rough handling.

Digital cameras tend to use one type of storage card so, once you have chosen your camera, you are tied to the storage system; however, some cameras can use a combination of cards, giving the photographer a choice of using one or indeed both systems in tandem. The price of storage cards has plummeted in recent years, but it is well worth shopping around, especially as some very good deals can be found on the Internet.

ABOVE, FROM TOP: a SmartMedia, a Microdrive, and a CompactFlash card. New formats are being introduced constantly.

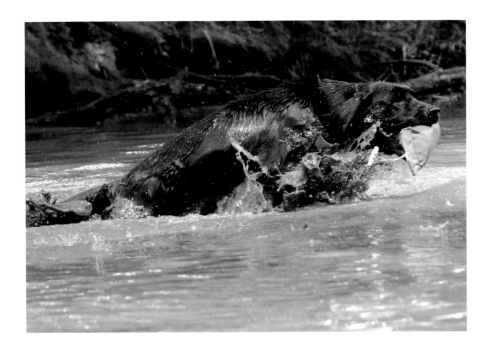

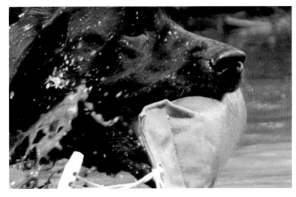

A high ISO rating was used (ISO 800) in this digital photo. This has resulted in an action-stopping image but with significant noise in the dark areas of the enlarged version.

BLACK LABRADOR
Canon EOS D60; focal length 235mm; 1/750sec at f/6.7; ISO 800

Accessory Flash

Accessory flashguns will enable you to expand your photographic horizons. Apart from being used in low-light conditions they can be used to good effect during bright sunshine to soften the shadow areas (fill-in flash). They come in all shapes and sizes and can be surprisingly inexpensive, considering the improvement they can make to your photography.

Flashguns normally attach to the top of the camera via a hotshoe fitment. This will still locate the flash above the axis of the lens, which is not ideal but, because it is higher, than the built-in unit, there is less chance of green eye. A good rule of thumb is to purchase a flash that has a good 'guide number' (see box below).

Sync Cable A very useful accessory that can be purchased for most flashguns is a sync cable; this will allow the flash to be used off-camera and will permit greater creativity when taking photographs. You will also have to buy a socket that fits into the hotshoe of the camera and then attach the flash to the camera via the cable. Make sure that the cable you purchase will allow the flash to keep its dedication facility with the camera (this normally means buying the same brand as your camera).

Thyristor The thyristor is a small circuit that is found inside automatic flashguns; the sole purpose of this piece of electrical wizardry is to store the unused energy after a picture is taken. This reduces the flash recycling time and saves expensive battery power. There is also a great hidden benefit, which dog photographers should use to their advantage: when the flash is charging, the thyristor makes a high-pitched whine that is very hard for humans to hear unless the flash is held close to the ear; dogs' hearing is far more acute than ours and quite often you will see the animal cock its head in an effort to work out where the noise is coming from – that is the time to take another photograph.

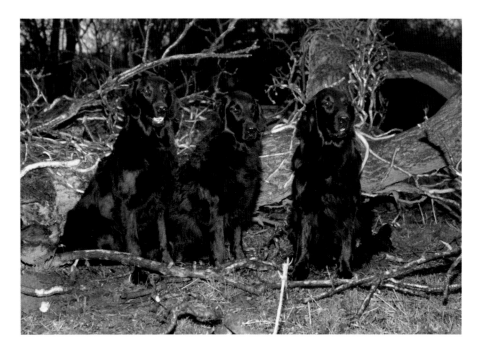

Because these dogs were black and the light levels low, an accessory flashgun was used to give some 'lift' to the image. Although the resulting picture is acceptable the lighting does not look very natural, but note the catchlights in the dogs' eyes.

FLAT-COAT RETRIEVERS
Canon EOS D30; focal length 43mm;
1/60sec at f/4.5; External flash E-TTL
Auto + Red eye reduction; ISO 100,

FLASH GUIDE NUMBERS

The guide number (GN) of a flashgun will indicate the maximum power output and the distance over which it will be effective – the bigger the number, the greater the output. Guide numbers are stated in metres for a film speed of ISO 100. Most built-in flash units will have a GN of around 10 (this will equate to a coverage distance of 10m (approximately 30ft) when used with 100 ISO film. This might seem enough for most photography but do not forget that the light will fall away as the distance increases. A useful GN to aim for is around 30; this gives enough power to allow some distance from the subject matter. Flashguns with high GNs are generally more useful, as they can be used over longer distances and in lower light, but they are more expensive.

Ideally, you will need a flashgun that is dedicated to your camera. This does not mean that you have to purchase one made by your camera manufacturer, but simply that the flashgun and the camera must be able to communicate with each other via tiny computers. This communication is vital to ensure that the film is correctly exposed and the right amount of light is transmitted from the flashgun. You can still purchase non-dedicated flashguns but, if you do, you will have to calculate the shutter speed and aperture settings manually.

Another factor to bear in mind when looking at a flashgun is that it must cover the focal length of the lens. The average flash beam will cover an angle suitable for a 35mm lens. However, if you buy one with a zoom head, this will allow the beam to cover a wider range of focal lengths, usually from 28–80mm.

More expensive flashguns come with a host of features, but for the beginner there are a few functions that it is really useful to have.

Many modern flashguns have autofocus sensors that detect how far away the subject is, and adjust the flash output accordingly.

A tilt-and-swivel head will allow you to bounce light off walls or ceilings to illuminate your subject without making the shadows as stark as they would be with direct flash (see box on page 51).

An exposure check lamp lets you know when the camera and flash have exposed the image of the dog correctly. If the exposure check lamp doesn't light-up, then you will know to move a few steps closer.

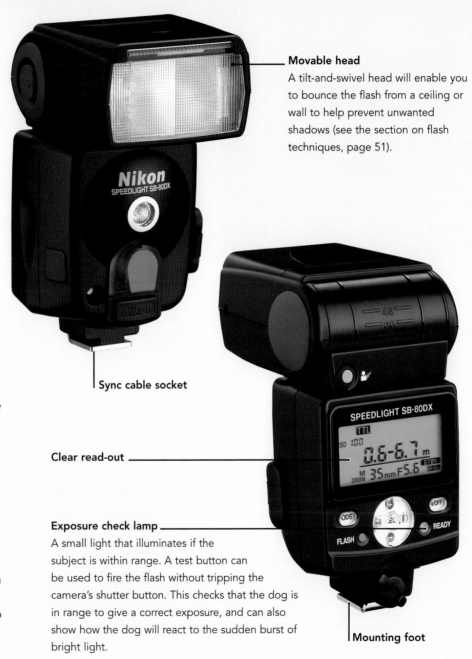

Movable head
A tilt-and-swivel head will enable you to bounce the flash from a ceiling or wall to help prevent unwanted shadows (see the section on flash techniques, page 51).

Sync cable socket

Clear read-out

Exposure check lamp
A small light that illuminates if the subject is within range. A test button can be used to fire the flash without tripping the camera's shutter button. This checks that the dog is in range to give a correct exposure, and can also show how the dog will react to the sudden burst of bright light.

Mounting foot

Other Useful Equipment

Tripods and monopods

Tripods can be invaluable, especially in a studio set-up. They are useful for preventing camera shake and for getting the sharpest pictures possible. The simple advice is to buy the best you can afford – a wobbly tripod is almost as bad as not having one at all.

The biggest disadvantage of a tripod is that it can restrict your movement. Because of this I rarely use a tripod outdoors, but I do sometimes use a monopod because, as it only has one leg, it is far more manageable.

Cable release

When you are using a tripod it is a good idea to use a cable release as well. This simply means that the camera will be more stable as you will not be pushing on the shutter release button. The price of cable varies depending upon the type your camera requires, check your manual to see if you need to use a specific model.

Beanbags

Cheaper than tripods and monopods, beanbags are very flexible and easy to use. All you need is a stable surface to set your camera up on.

I rarely use a tripod but will occasionally use a monopod, especially when using long lenses at working dog trials.

You can buy specialist camera bags to take care of your kit. These often have movable compartments so they can protect equipment of different shapes and sizes. The 'spare' cute dog is an optional extra!

Filters

Filters are very commonly used in photography. Most of the functions that they offer are more suitable for landscape photographers though. Having said this, it can be useful to screw a UV or skylight filter to the front of your lens for protection. These filters should clarify your pictures slightly, although whether the effect is visible in the final image depends on the conditions in which they were used.

By far the most important aspect of their use – as far as the dog photographer is concerned – is protection. It is far cheaper to replace a filter that has been damaged by an over-enthusiastic puppy, than a lens.

Camera bags

There is a wide range of camera bags available. These provide more protection than normal bags as they tend to be padded and have customizable interiors that you can change to suit your camera and accessories. Make sure that you buy a bag that has room to spare, as you may well buy more photographic equipment over time.

WORKING WITH DOGS: **A DOG PHOTOGRAPHER'S 'BAG OF TRICKS'**

My favourite 'tool' is a small plastic squeaker that imitates the sound of an injured animal. Over the years I have developed a huge repertoire of sounds which most dogs find irresistible. Some dogs will simply look and try and work out what and where the noise is coming from, others will rush over to investigate; occasionally, the noise scares them, so the secret is to try and read the individual dog and adjust your methods to suit its personality.

Another very useful tool you could try is an empty crisp (potato chip) packet. When scrunched up in a hidden hand you will find that even the best-behaved dog cannot resist cocking its head in an effort to work out where the noise is coming from.

Small plastic and wooden squeakers are guaranteed to get that classic 'cocked head' look from any dog.

The noise from a crunched-up crisp (potato chip) packet almost guarantees that appealing 'cocked-head' look.

DOGUE DE BORDEAUX
Canon EOS D60; focal length 35mm; 1/60sec at f/19;
ISO 100

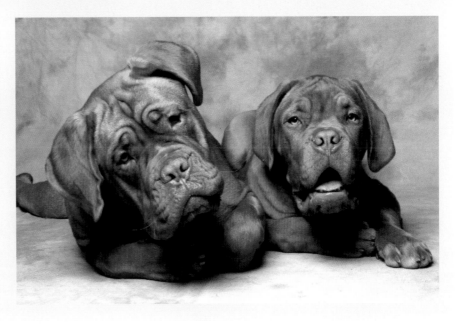

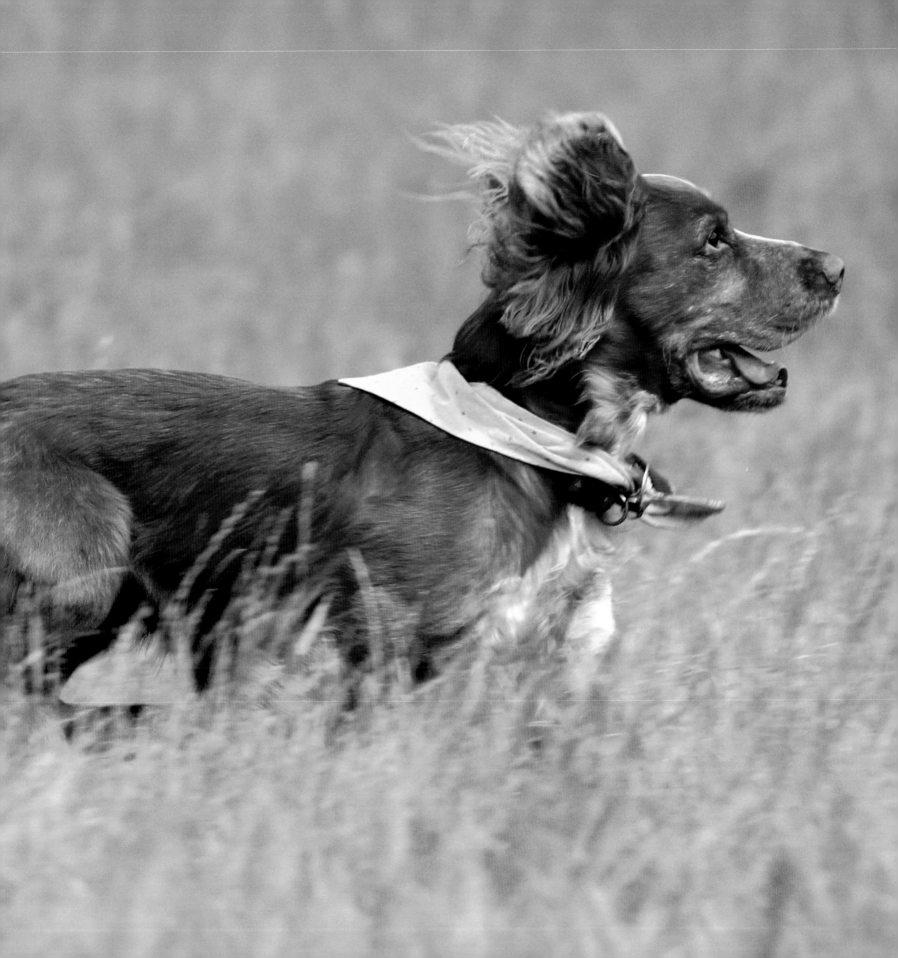

Outdoor Technique

Before setting off in search of the perfect location there are a few technical points that you should take into consideration, not least of which is how to manage natural daylight and picture composition. There are some 'in-camera' techniques that will also need to be mastered, if you hope to produce something more than an ordinary snap of your canine model.

Exposure

If you want to take great pictures of dogs you need to be in control of three factors: exposure, focusing, and composition. You don't need to get too technical, but just a little extra understanding of these subjects will lead to a marked improvement in your pictures.

Correct exposure

Exposure is the act of exposing a photographic film or photo-sensor to light through the opening in the lens (the lens aperture) for a certain amount of time (the shutter speed). If not enough light is allowed to hit the film or photo-sensor then the image will be underexposed, looking dull and dark and lacking detail in the shadow areas. If too much light hits the film or photo-sensor the picture will be overexposed, looking 'washed out' and lacking detail in highlight areas. However, a correctly exposed image will have a nice balance of shadows and highlights, with enough detail in all the important places.

The key to taking correctly exposed pictures is to balance the three elements of exposure: film or photo-sensor sensitivity, lens aperture, and shutter speed.

Film/photo-sensor sensitivity

A film or photo-sensor's sensitivity is often referred to as its 'speed'. Slow film or photo-sensors will take longer to react to light than faster ones. This has already been touched on when we looked at equipment in Chapter 1 (see page 18). However, as it is an important aspect of exposure, we shall revisit it here.

Film is given an ISO rating and digital photo-sensors have ISO equivalent ratings. One of the advantages of digital cameras is that some allow you to change the ISO rating between shots. These ISO ratings are simply a way of translating how fast or slow a film or a photo-sensor is into numbers (see the ISO rating table to the right). The lower the number, the slower the film or photo-sensor and the more light it will need to achieve a correct exposure. The higher the number the faster the film and the less light you will need to achieve correct exposure.

ISO RATING

50: Slow
This offers the best quality with the least grain or noise. Only really useful for indoor portraits with lots of light.

100: Slow-medium
A good choice for bright days, but not fast enough to use for action photos.

200: Medium
A good all-round speed for use in normal, everyday conditions.

400: Fast-medium
Sensitive to light; suitable for dim light and freezing action in your photos.

800: Fast
This speed will have visible 'grain' or 'noise' but is useful for bad light or for freezing fast-moving dogs.

Choosing the right film speed to capture your canine subject depends upon two things: what you want to photograph, and the light conditions. If you want to freeze a fast-moving dog in the picture, if there isn't much light available, try using fast film or setting your digital camera to a higher rating. So why not just choose a fast film all of the time? Well there is a pay-off between the speed of the film and the quality of the final image. Faster film tends to show more 'grain' and digital photo-sensors show more 'noise'.

Measuring exposure

Exposure values are often talked about in terms of 'stops'. When a shutter speed doubles, this is referred to as a one stop increase in shutter speed; likewise a widening of aperture by one f-number (see the table on page 28) is called a one stop increase in aperture. A doubling in the ISO rating of a film is also called a one stop increase in film speed.

THE LAW OF RECIPROCITY

This might sound a little daunting, but don't worry! The law of reciprocity is just a convenient way of explaining the balancing act that takes place between lens aperture and shutter speed.

If you want to change either the shutter speed or lens aperture then you can achieve the same exposure by making an equal but opposite change in the other variable. For instance, increasing shutter speed from 1/250sec to 1/500sec can be balanced by widening the aperture by one stop, for example from f/8 to f/5.6. This allows you to make creative adjustments to your photos and change the way the final images appear, without them becoming either over- or underexposed.

Autoexposure with your camera

Most modern cameras have autoexposure systems. This means that the camera will take a reading of the available light and recommend a suitable shutter speed and aperture for the conditions and subject.

Many amateur-level cameras come with a number of basic settings. These are exposure modes that suit a particular subject, for example portraits or action photos. To use these modes, all you have to do is select them and snap away. While these are a great starting point for your photography they can limit your creativity.

If you really want to get the best out of your camera it's worthwhile taking a closer look at the more creative exposure modes. These are available on most cameras that allow you to change exposure settings and can be found on all SLRs and many digital cameras. The modes are Programmed, Aperture-priority, Shutter speed-priority, and Manual.

In Programmed mode the camera chooses the shutter speed and aperture but lets you change them both – at the same time – while the camera keeps the exposure balanced. Aperture-priority mode lets you choose the aperture you want and the camera sets a suitable shutter speed. In Shutter speed-priority mode you can select the shutter speed and the camera chooses the appropriate aperture. Finally, Manual mode allows you complete creative control over shutter speed and aperture, while the camera only gives exposure recommendations.

By using these more advanced modes you can take control of the creative side of your photography. Try using them alongside the basic modes and soon you will notice an improvement in your photography.

Due to low light levels a fast film speed setting was used for this photo and as a consequence there is a lot of noise (digital grain) in the shadow areas. A large aperture was chosen to let in even more light and to throw the stone balustrade out of focus so that the viewer's eye is drawn to the main subject, the dog.

RED SETTER
Canon EOS-1D; focal length 90mm; 1/50sec at f/3.5; ISO 640

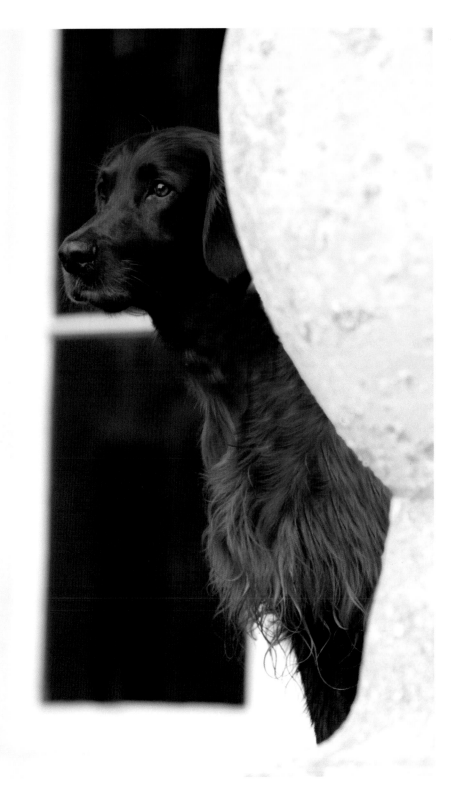

The Lens Aperture

The second element of exposure is the lens aperture. This is an opening in the lens of a variable size that allows light to enter the camera and hit the film or photo-sensor. You can change the size of the lens aperture and in doing so change the amount of light entering the camera. The wider the aperture the more light enters the camera; the narrower the aperture the less light enters the camera.

On some cameras the aperture can be controlled by rotating a ring on the lens itself, on others it is controlled by rotating a dial on the camera body. The aperture is altered in a series of steps called f-stops; the larger the number, the smaller the aperture, so the larger the number, the less light will hit the film. Increasing the aperture by one stop halves the aperture, and so halves the exposure, while decreasing the aperture by one stop doubles the exposure.

Depth of Field

The size of the aperture affects what is known as depth of field. The depth of field is the distance in front of and behind the point of focus that will also appear clear and sharply defined in the final image. With a small depth of field less of the image – from front to back – will appear in focus. With a large depth of field more of the image – from front to back – will appear in focus. The depth of field, however large, always extends one-third in front of, and two-thirds behind, the point of focus.

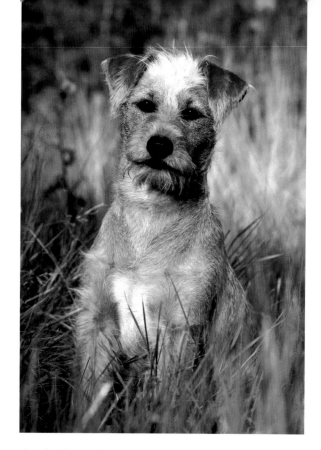

This dog has a short muzzle so a large aperture was used to throw the foreground and background out of focus while keeping his ears and the end of his nose in focus.

LAKELAND-CROSS-TERRIER
Canon EOS D60; focal length 90mm; 1/1500sec at f/3.5; ISO 400

The size of the depth of field is controlled by three variables: the focal length of the lens; the distance to the subject; and the size of the aperture. The longer the focal length is, the shallower the depth of field becomes; the closer the subject gets, the shallower the depth of field is; and the wider the aperture (the lower the f-number) is, the shallower the depth of field.

Most dogs have a muzzle that extends some way out from their eyeline and with a shallow depth of field you may find that the eyes are in focus but the nose, ears and chest will be blurred. For dogs such as greyhounds, that have longer muzzles, you may need to use a smaller aperture to get acceptable results.

If you are using an SLR, you may have a depth of field preview button. Depressing this allows you to see exactly what the depth of field will be through the viewfinder.

BELOW
The range of apertures available to you depends upon the combination of lens and camera that you use. The basic f-stops are shown in the chart below, each increase in f-number represents a one stop decrease in exposure. Note that as the f-stops increase the aperture decreases.

THE APERTURE RANGE AND ITS EFFECTS

Wide aperture							Narrow aperture	
f/2	f/2.8	f/4	f/5.6	f/8	f/11	f/16	f/22	f/32
Shallow depth of field							Large depth of field	

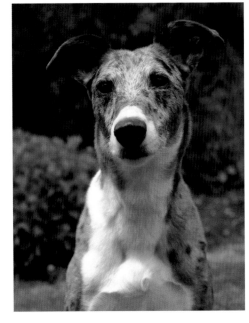

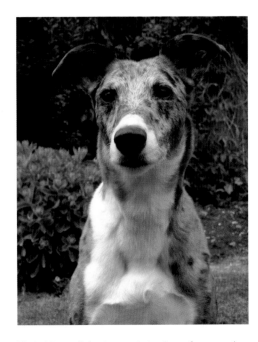

f/2 A shallow depth of field only leaves the eyes in sharp focus.

COLLIE-CROSS-LURCHER
Canon EOS D30; 1/4000sec at f/2

f/5.6 Medium depth of field renders the eyes and nose in focus, but the background and chest of the dog are still out of focus .

Canon EOS D30; 1/500sec at f/5.6

f/16 Most of this image is in sharp focus and the background is starting to compete with the main subject.

Canon EOS D30; 1/60sec at f/16

The combination of a relatively short focal length, an aperture of f/6.7 and a short distance to the dog gives a medium depth of field in this photo. This has rendered the whole of the dog's face and chest in focus, but has thrown the buildings behind slightly out of focus so that they don't detract from the main subject.

GERMAN SHEPHERD
Canon EOS D30; focal length 41mm; 1/1000sec at f/6.7; ISO 200

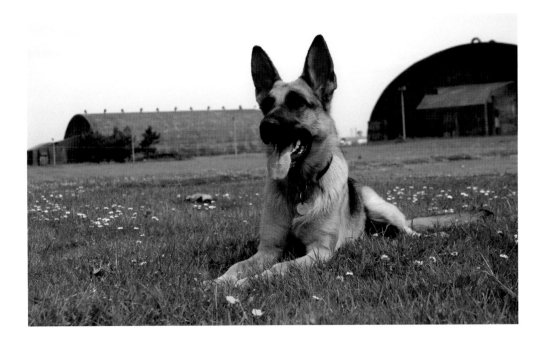

Shutter Speeds

The final element of exposure to look at is shutter speed. This controls the length of time that the film or photo-sensor is exposed to light and is measured in seconds or fractions of a second. Different cameras have different ranges of shutter speeds, although you should note that the basic shutter speeds double/halve with every increase/decrease (see table right). Each increase on the shutter speeds table to the right shows a one stop decrease in exposure, as less light is being allowed to hit the film/photo-sensor.

As well as controlling exposure, adjusting the shutter speed allows you to determine how movement is depicted in your images: a fast shutter speed will freeze action, while a slow shutter speed will create blur, and so emphasize movement. The exact shutter speed you need to create a particular effect depends upon the movement and speed of the subject in relation to you. For example if you want to freeze the motion of a running dog you will need a faster shutter speed the faster the dog runs.

PREVENTING CAMERA SHAKE

Camera shake can cause your final image to look blurry. To prevent this try not to use a shutter speed slower than 1 divided by the focal length of your lens. For example, when you use a 50mm lens you should try to keep shutter speeds faster than 1/50sec.

SHUTTER SPEEDS
Fast
1/4000sec
1/2000sec
1/1000sec
1/500sec
1/250sec
1/125sec
1/60sec
1/30sec
1/15sec
1/8sec
1/4sec
1/2sec
1sec
2secs
4secs
8secs
'Bulb'
Slow

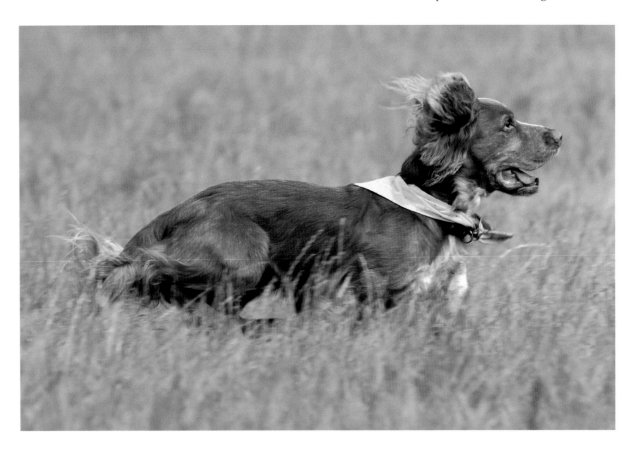

A fast shutter speed of 1/1000sec has literally stopped this cocker spaniel in its tracks.

*COCKER SPANIEL
Canon EOS D60; focal length 285mm; 1/1000sec at f/8; ISO 400*

Here I used a relatively slow shutter speed as the dog shook the rain from its head, to help record the movement of the fur. Note how the dog's nose appears sharp, because it is the pivotal point.

WORKING BEARDED COLLIE
Canon EOS D30; focal length 135mm; 1/60sec at f/5.6; flash; ISO 100

RIGHT When used properly, slow shutter speeds can give the impression of speed and movement.

TERRIER
Canon EOS D60; focal length 190mm; 1/30sec at f/9.5; ISO 400

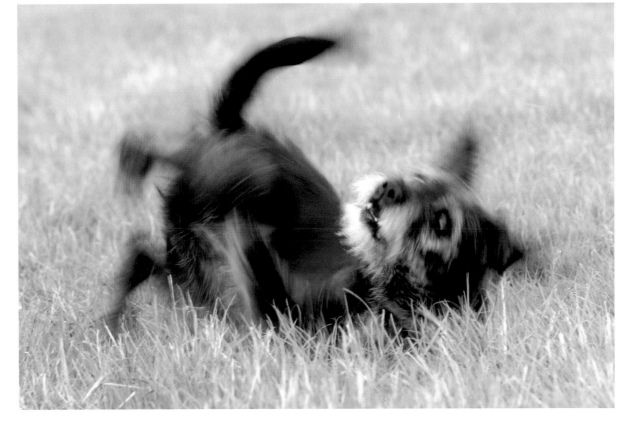

TECHNIQUE: **WORKING WITH EXTREMES OF EXPOSURE**

We have looked at the elements (film/photo-sensor sensitivity, lens aperture and shutter speed) that make up exposure, and how to use them together for a correct exposure. We have also seen the creative effect that these elements have on the final image. Now it is time to look at ways of taking good pictures in difficult exposure conditions.

Your first question may be 'What are difficult exposure conditions?'. Well, the most common problem is taking pictures of black or white dogs. This is because of the way a camera's light meter works. When a camera takes readings it assumes that the subject is mid-tone. It then sets the exposure to replicate this in the final image. If this assumption is wrong and the dog you're photographing is darker than mid-tone then the resulting image will look too light.

When you are photographing a dark dog try to use the following tips:

• Position the dog so that it faces into the light.

• Try to get the dog to lift its head slightly, so that the eyes catch as much light as possible.

• Check the viewfinder until you see the highlights in the dog's pupils then press the shutter button.

• If your camera allows exposure compensation try subtracting 1 stop (check your manual for details).

• If you are using a digital camera, take a picture and check the results immediately.

BLACK LABRADOR
Canon EOS D60; focal length 100mm; 1/60 sec at f/9.5;
ISO 400

Personally I find photographing white dogs more difficult than dark ones, as the camera's light meter will often underexpose the image, turning the dog a muddy grey.

So if you are photographing a light coloured dog here are a few tips for you to use:

- Try to use sidelighting. This will put more shadows and texture into the dog's fur (see page 35).

- Take a meter reading off the darkest part of the dog's coat (check your manual for details).

- If your camera allows exposure compensation try adding 1 stop (check your manual for details).

- If you are using a digital camera, take a picture and check the results immediately.

Bracketing

Another technique is to take a number of different photos at slightly different exposure settings. This is known as bracketing and some cameras can be set to do this automatically. Then you are able to choose the final image that you prefer.

Finally, it is always worth taking a note of your exposure settings. You can compare them with your results, and you should gain a better understanding of how to achieve the effects you desire.

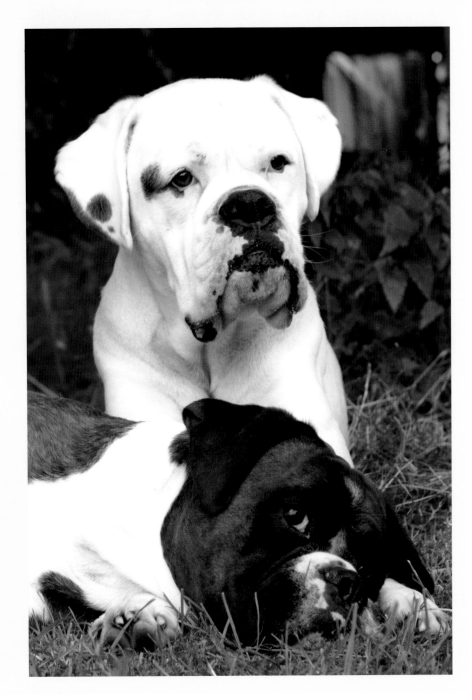

Because of the tricky issue of a light- and dark-coloured dog in one frame, I bracketed and chose the best result.

BOXERS
Canon EOS D30; focal length 105mm;1/45sec at f/11;
ISO 400

33

Working with Available Light

When photographing dogs outdoors, in their natural environment, the main source of light will be the sun. Most inexperienced photographers automatically assume that the best time to take photographs is when the sun is high in the sky and at its brightest. This isn't necessarily true and you should experiment with the effects that are caused by different light conditions.

Front Lighting

The direction of the light falling on the dog has a major effect on the final image. The most common advice given to photographers is that they should have the sun behind them, so that the light falls directly onto the subject; this is known as front lighting. This is sound advice for beginners but can often result in an image with that looks a little 'flat' and uninteresting. It can also cause all sorts of problems when taking pictures of dogs as, just like humans, the bright light will make them squint. It is worth noting that dogs with light-coloured eyes are particularly affected by bright sunlight.

There are, however, plus points to front lighting and while the image can look 'flat' it does provide good detail and help to avoid tricky shadows. The effect of front lighting also depends upon the time of day. Evening light can take on a wonderful warm and soft glow which is reflected in the dog's coat; however, light levels will be low, so you may have to use a faster film or photo-sensor setting if you use digital (see page 26). Try to remember to keep your shadow out of the photo, especially when the sun is low in the sky behind you.

Front lighting is safe but can be boring. The light source (normally the sun) will come from behind the photographer and fall directly onto the dog. The resulting image can appear very flat with little or no contrast.

TERRIER
Canon EOS D60; focal length 135mm; 1/60sec at f/6.7;
ISO 100; exposure compensation of +1

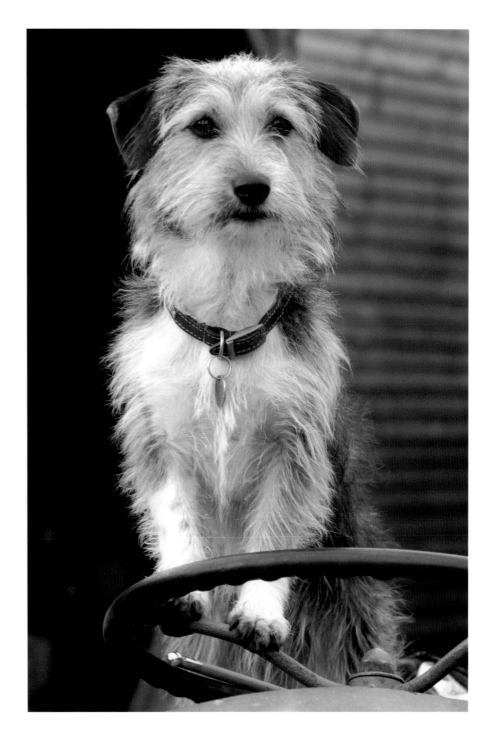

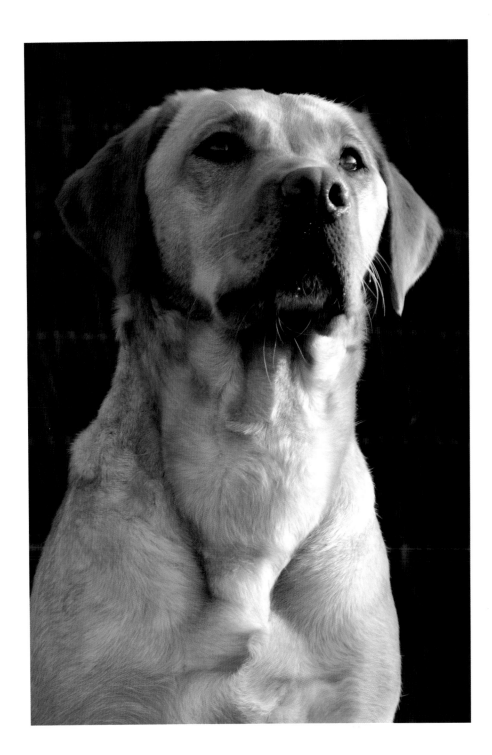

Side Lighting

Lighting your subject from the side can really emphasize the texture of a dog's fur. It also produces an image with a high degree of contrast between the shadow and highlight areas. If this effect is too strong and you find that some of the dog falls in heavy shadow, then you can reduce it by using a flashgun to add some light in the shadow areas. This technique is known as fill-in flash and most modern dedicated flashguns will automatically emit the correct amount of light that is needed to lift the shadows. You can also use a reflector (see below).

EQUIPMENT: **REFLECTORS**

Reflectors are used to bounce light into areas of shadow. A reflector can be any flat surface that reflects light. You can buy them from camera shops or you can even improvise your own. Common colours for reflectors are white, silver and gold. Try experimenting with different colours as they reflect different colours of light. A gold reflector will produce a warming tone in your pictures, while a silver reflector produces slightly colder colours. You may need a handler to position the reflector and some dogs may be distracted by a bright silver reflector.

This dramatic black and white photo was lit from the side, resulting in a strong contrast between the shadow and highlight areas.

GOLDEN LABRADOR
Canon EOS D60; focal length 135mm; 1/90sec at f/9.5; ISO 200

Back or Rim Lighting

Back or rim lighting is one of the most difficult techniques to perfect; however, with the increasing use of digital cameras, the ability to view the image immediately after it has been taken makes a huge difference to the final result. To achieve this effect you will have to place the dog between you and the light source. If you are taking the photo in natural conditions this means that the sun must be fairly low in the sky.

When back lighting works well, the outline of the dog will have a lovely glow of light which works particularly well with a light-coloured, long-haired dog against a dark background. The main problem is that the side of the dog closest to you will be in shadow, and you may lose all of the detail in its face or body (a problem already discussed in Side Lighting on page 35); again you can use a flashgun to 'lift' the shadow, or try using a reflector to bounce light into the shadow areas.

Another method to try, to ensure that the detail is not lost, is to use exposure compensation. Check your manual to see if your camera has an exposure compensation function. If it does, try increasing the exposure by 1/2 to 1 stop. Like a lot of the techniques you can use, this needs some experimentation as you want to achieve a balance between getting some detail back without losing the overall effect of the rim light.

WARNING

Never look into the sun, either with the naked eye or though the lens of a camera.

To achieve this level of rim or back lighting you will have to shoot into the sun. In this example the late evening sunset has created a glowing edge to the dog's fur. The unusual viewpoint has emphasized the effect.

COLLIE-CROSS-LURCHER
Canon EOS D60; focal length 95mm; 1/45sec at f/5.6; ISO 200

TECHNIQUE: **CREATING A SILHOUETTE**

Silhouettes can create some really striking images, but they can be difficult to achieve. A silhouette is similar to a rim-lit picture, except that all the surface detail is lost in a silhouette, rendering the subject as a black shape. Like rim-lit pictures, silhouettes need to have the subject between the light source and the photographer. Try to move your subject against a clear background to give the shape a chance to really stand out.

To make a silhouette you will need a camera that will allow you to control the exposure settings. First take a meter reading from the brightest part of the sky (although never point your camera directly at the sun). Then – using those meter readings –

recompose the image as you would like it to look. Finally depress the shutter and take the photo.

I think silhouettes work best when there are strong cloud formations to add some shape and texture to the image. Some breeds can look very regal when photographed in this way.

BELOW Hilltops are perfect for trying some artistic silhouette portraits.

WEIMARANER
Canon EOS D30; focal length 50mm; 1/1000sec at f/8; ISO 100

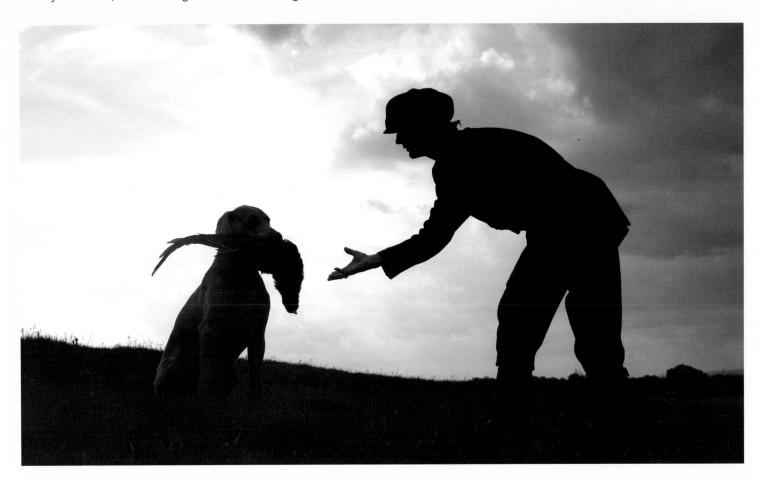

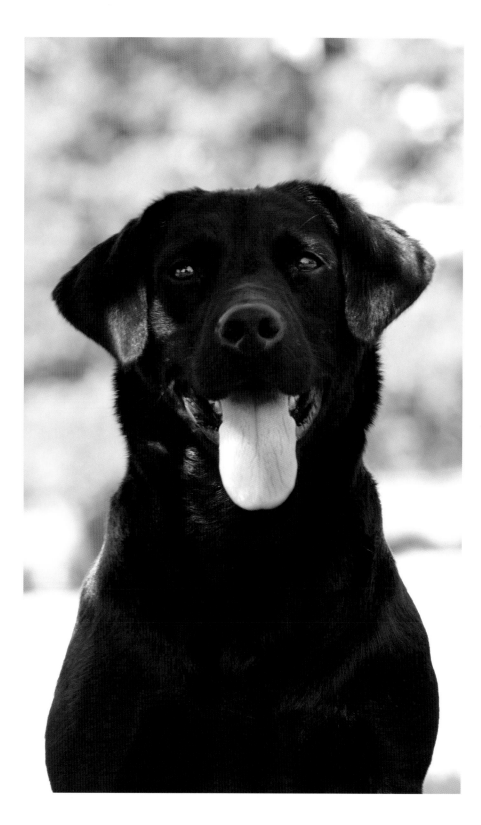

Working with Shadow

Just because the sun isn't shining doesn't mean that you have to leave your camera in its case! In fact using shadows creatively can be a really good way of getting some great effects.

Two of my favourite options are 'open shadow' and dappled light. 'Open shadow' is created when the sunlight is diffused completely by tree cover – or even a building – and so there is little or no contrast. The light is even, but obviously not as bright as direct sunlight.

You can use 'open shadow' to get some really nice portraits of dogs with bright backgrounds. Bring the dog into the shadow area and fill the viewfinder with it, leaving enough of the background visible to frame the dog. Try using a wide aperture or a long lens to ensure that the background is out of focus (see pages 28–9).

Working with dappled light does take some skill and practice to achieve effective images. Dappled light is normally created when the sunlight falls through the tree canopy but is not completely blocked. Small shafts of light reach the ground, and the aim is to position the dog so that one or more of these natural spotlights illuminate the dog's face.

You can produce some great photos using this effect. Just be aware that the lighting conditions may be quite difficult for your camera to handle. So, if you can possibly bracket your images you should do so (see page 33). As with any photography in low light, it is worth keeping a couple of rolls of faster film handy or setting your digital camera to a higher ISO rating to prevent camera shake (see pages 26 and 30).

This dog was positioned under an open tree canopy, which created an area of open shadow. The background was in full sunlight, so that the image has a soft, almost dream-like quality.

BLACK LABRADOR
Canon EOS D30; focal length 200mm; 1/30sec at f/9.5; ISO 200

Dappled light can be very difficult to master. The dog has to be positioned in the right place so that a shaft of light illuminates its face, and the exposure has to be spot on. This image was shot through a fork in a tree to frame the dog and to accentuate the lighting effect.

GOLDEN RETRIEVER
Canon EOS D60; focal length 200mm; 1/20sec at f/6.7; ISO 400

Focusing

Getting the subject in focus is vitally important and, while modern autofocus cameras can help, you should still be aware of the importance of correct focus.

Choosing a Focus Point

The focus point you choose will depend upon the type of photo that you are taking. You should decide what the most important part of the image is before you take your photo; what do you really want to be in focus?

If you are taking a portrait of a dog, the dog's eyes should usually be the main point of focus, and if they are slightly unsharp the image will lose impact. For stunning close-ups of the dog's head and eyes your focusing technique must be spot on.

When taking action shots you may focus on other points of the dog, its flank – if it is side on to you – perhaps, but as a rule of thumb the head and eyes are the most important things to be in focus.

Once you have chosen the point you want to focus on, you should combine this with the depth of field (see page 28). Think about how much of the image you want to be in focus and which are the most important parts. A large depth of field will mean that all (or at least most) of your subject is in focus, while a shallow depth of field means that what is in focus will be limited. Try taking the same image at different exposure settings to see how the focus is effected.

LEFT The eyes of this dog are the photo's main point of focus, but sufficient depth of field has been used so that the rest of the head and ears are also sharp.

GREYHOUND
Canon EOS D60; focal length 135mm; 1/60sec at f/16; two studio flash units; ISO 200

If you really want to impress the owner/handler, try to position them so that they are reflected in the dog's iris and pupil – it's not as difficult as it may at first appear.

CROSSBREED
Canon EOS D30; focal length 135mm; 1/20sec at f/11; ISO 400

Manual Focus

Some cameras rely on manual focusing, although increasingly this is not the case. However there are some situations in which autofocus fails to work, so it's useful to know how to use manual focus.

The most common way of focusing manually is to rotate a focus ring on the lens. You should rotate this slowly and evenly. The focus ring will normally have a scale on it, indicating the distance at which the image will be in focus, and you should align the appropriate distance with the marker. If your lens has the ability to switch between manual and autofocus, you should never rotate the focus ring when it is switched to autofocus.

With some cameras you will have to rely on the distance scale on the focus ring. If you use an SLR then you will be able to see whether the image is in focus through the viewfinder. While you can normally rely on autofocus systems, manual focusing is a useful back-up.

Autofocus

As I've already said, most modern cameras have autofocus mechanisms of some sort. While you might not be able to change the way autofocus operates on a simple camera, most autofocus SLRs and some digital cameras will allow you some control. Different cameras have different autofocus systems so read your manual to see how yours works and what its limitations are.

The majority of autofocus cameras have a focusing point in the centre of the viewfinder; some advanced models can have anything up to 45 focusing points. Many cameras allow you to choose between focus points; so you can position the dog within the frame and choose the most relevant focus point. If your camera has only one focus point, you may be able to use 'focus-lock'. This is where you place the central focus point over the subject, semi-depress the shutter (to lock the focus) and recompose the picture. Check your manual for details.

The camera's central autofocus point (highlighted in red) has picked up on the body mass of this dog. For this action portrait a fast shutter speed has been selected to freeze the dog in mid-air.

HUNGARIAN VIZSLA
Canon EOS D60; focal length 90mm; 1/1500sec at f/8; ISO 400

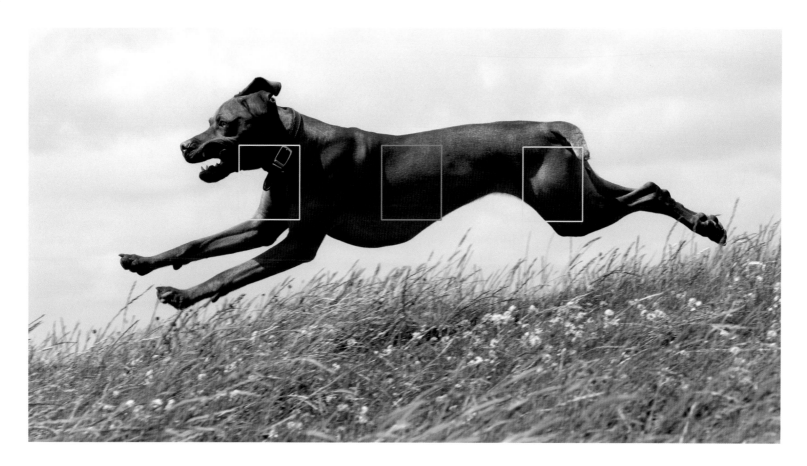

Composition

Landscape or still-life image-makers have plenty of time to consider their composition, but dog photographers have to react quickly and deal with a living and sometimes restless subject. However, you do have some control over how the picture is composed, especially if you have already imagined the picture in your mind's eye.

Positioning the Dog

When taking images of dogs the surrounding environment is almost as important as the dog itself. It would be easy to sit the dog on a grassy bank and take a nice full-length portrait. However, this tells the viewer very little about the dog, its role in life and the occupation it has been bred and trained for. One solution is to position the dog in a large open field with expansive views and then to frame the photograph to include a backdrop of the countryside that complements the particular breed. This applies to all dogs, and carefully positioning the elements that make up a picture will greatly enhance the final result. Most people will automatically frame the image with the main subject – in this case the dog – in the centre of the viewfinder with the animal looking straight at the camera. Changing the point of view and putting the dog slightly off-centre can dramatically change the way a picture looks.

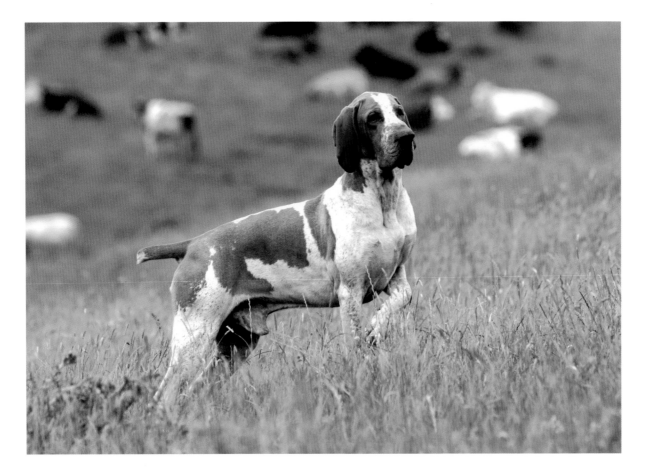

This particular image has many components that come together to make it something special: the position and pose of the dog, the even spread of light, and the way that the colours of the cattle in the background complement the colour of the dog.

BRACCO ITALIANO
Canon EOS D60; focal length 350mm; 1/1500sec at f/8; ISO 400

Landscape or Portrait Format?

If you are using 35mm film (or an equivalent digital camera) you will have two choices of format, landscape (horizontal) or portrait (vertical), and both will give a different perspective to the final image.

Generally speaking the landscape format is good for a standing dog, especially if you want to include plenty of background. Landscape is also the format to use when the owner wants to show off the conformation of the animal, especially if it is used for showing or studwork.

I find the portrait format useful for dogs that are either sitting or lying down, or when I want a close-up of their head and chest.

As with everything photographic, there are no fixed rules and the best thing to do is to try varying your camera positions. Some cameras – for example APS cameras – will offer you panoramic formats as well.

At work with the camera in the portrait format. Take note of the 'magic' squeaker in my mouth.

Canon EOS 10D; focal length 135mm; 1/250sec at f/8; ISO 400

TECHNIQUE: **THE 'RULE OF THIRDS'**

Imagine a grid placed over your picture consisting of two vertical and two horizontal lines. When looking through the viewfinder, positioning the main point of focus (normally the head or eyes), over one of the vertical or horizontal lines will often produce a visually more pleasing image.

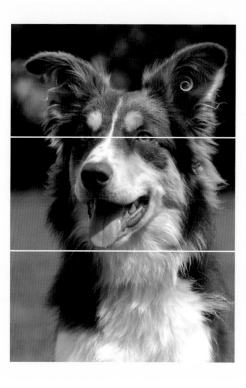

LEFT
ENGLISH POINTER
Canon EOS D60; focal length 300mm; 1/1000sec at f/9.5; ISO 400

RIGHT
BORDER COLLIE
Canon EOS D30; focal length 130mm; 1/1000sec at f/6.7; ISO 200

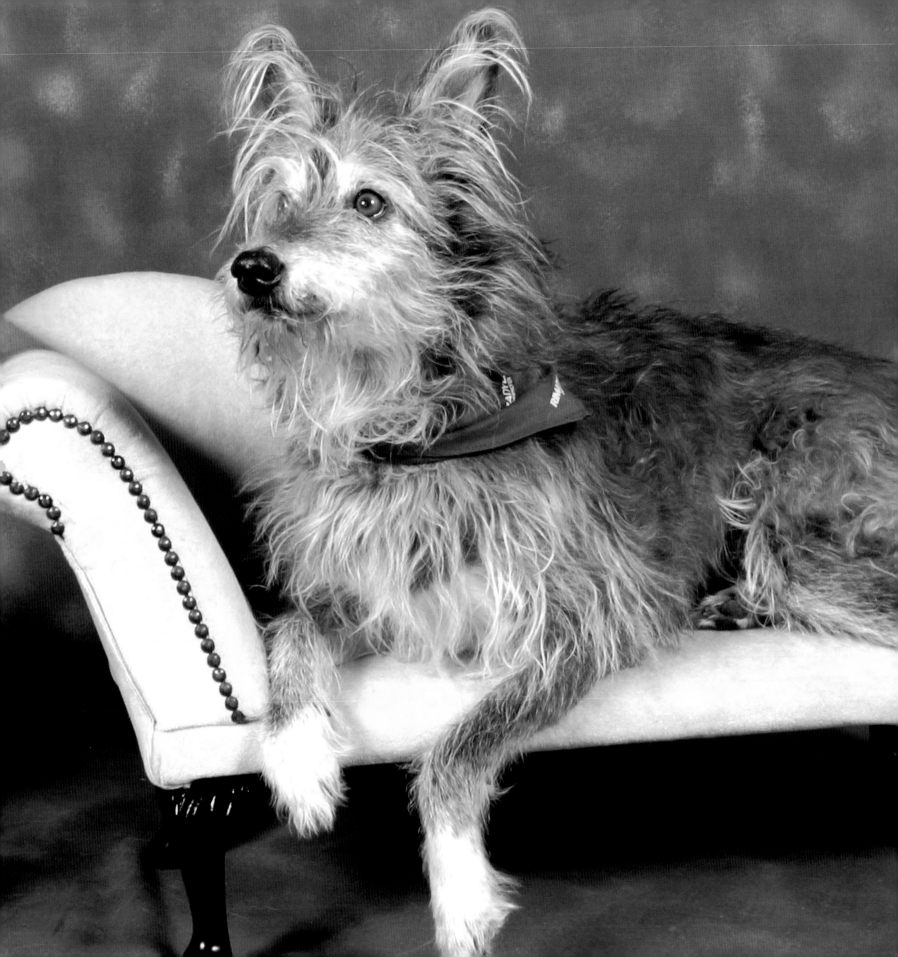

The Home Studio

Several years ago, when I first started photographing dogs, many people said to me that they would love a 'proper' photograph of their dog, but that it would never cope with the stress of being taken to a studio. Dogs are like children, take them to a strange place and the chances are they will misbehave and rarely will they relax. Signs of stress in a dog normally result in constant panting and they can become very clingy to the owner. It is possible to tell how relaxed or wound-up a dog is by simply looking at its eyes, and from a portrait point of view they are the very things that need to appear calm. Obviously there are certain dogs that will cope quite easily with an external studio sitting, but for the majority a sitting at home is the answer.

HOW TO PHOTOGRAPH DOGS

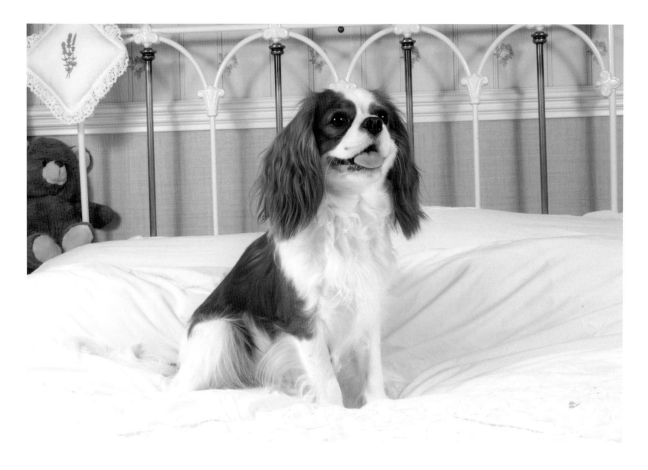

For many amateur dog photographers existing furnishings will make ideal backgrounds. They have the added advantage that the dog is already familiar with the surroundings it is being photographed in.

KING CHARLES CAVALIER SPANIEL
Canon EOS D30; focal length 38mm; 1/60sec at f/16; ISO 100

Setting up a Studio

The home studio can be as simple or as complicated as you wish, but whatever route you decide to take you will eventually want to master the use of artificial light. Backgrounds can either be part of the existing furnishings, homemade, or manufactured. For amateur dog photographers existing furnishings are a good starting point, and lend a personal touch to the pictures.

Dogs often have their own seating and sleeping arrangements and these can form an ideal backdrop to formal and informal portraits. When taking images of dogs sitting or lying on armchairs or sofas, try to exclude as much extraneous background as possible, as this will help to keep the image clean and uncluttered.

Homemade Backdrops and Backgrounds

A variety of materials can be used for homemade backgrounds, ranging from old sheets and blankets, to curtains and lengths of fabric. The main criteria when choosing suitable material is to try and use one with some kind of subtle pattern or tone printed on it, to prevent the background from looking too stark. I like to use a backdrop with a mottled effect (similar to a cloud pattern) but, if you cannot locate something suitable, you could try dyeing a light-coloured plain sheet, or even better, use fabric spray-dye. Take a look at some manufactured backgrounds, to get an idea of how to create the right effect.

When calculating the length of the backdrop, remember to allow enough to cover the floor, so that it will accommodate any dogs that want to lie down.

Manufactured Backdrops

If you are really serious about your dog photography, sooner or later you will need to purchase one of the manufactured backdrop systems that are readily available on the market. There are two basic designs, but my preferred system is one that is very easy to transport, comes complete with a floor train, and can be purchased in a multitude of colours and designs. The printed canvas is attached to a sprung frame and, when opened, the background is approximately 2.1 x 1.5m (7 x 5ft), with an ample train long enough to accommodate a large dog lying down. There are numerous advantages to this system, not least that it is quick to set up, and the material does not crease easily. You can buy special clamps that attach to a standard light-stand to hold such a background in place, but I find it is just as easy to lean it against a convenient wall.

The second system is just as portable but, ideally, should be used in a situation where it can be left in place permanently. The constant folding and the consequent creasing of the canvas background becomes a real nuisance, and as much time can be spent ironing the material as photographing the dog. The system uses two vertical poles (such as heavy-duty light-stands) and then a horizontal pole is fixed between these and a canvas backdrop sheet is attached to this. The biggest advantage of this system is that the canvases can be bought in varying widths and heights, so even large groups of dogs can be accommodated.

My preferred manufactured backdrop system consists of a canvas backdrop attached to a sprung frame. It is easy to transport and very convenient to set up.

The system below consists of two upright stands, and a cross-pole to which the canvas is attached. This photo also shows the positioning of the studio lights.

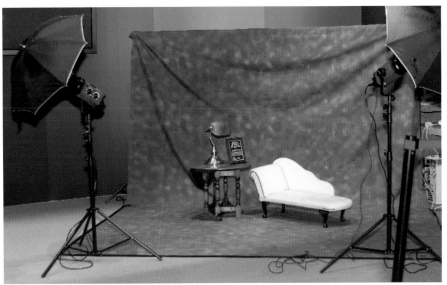

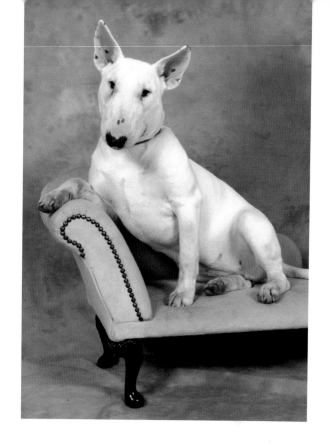

Props

I tend to use very few props in my formal portraits
but one item that I did purchase recently has proved
to be very versatile and extremely popular with the
dogs and owners alike. This chaise longue was originally
designed for use as a prop for photographing young
children, but I have found it very useful for dogs of
all shapes and sizes. If they are used to sitting on the
family sofa they seem to relax instantly and make
themselves at home. Bear in mind, however, that if the
dog is not normally allowed on the furniture at home,
it may not be comfortable doing something which is
normally forbidden.

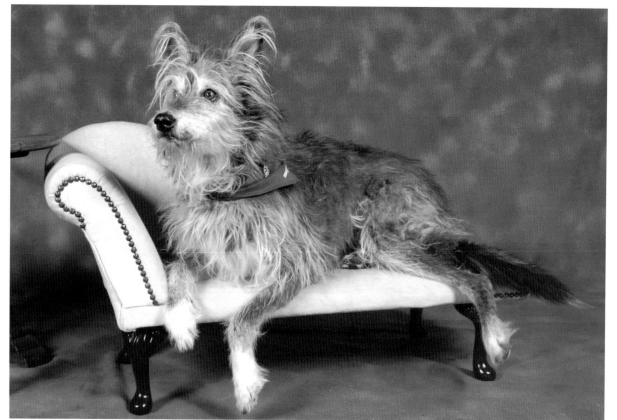

This chaise longue has
proved very popular with
the dogs. If they are used
to sitting on the sofa at
home they instantly relax
and make themselves
comfortable.

ABOVE
ENGLISH BULL TERRIER
Canon EOS D60; focal
length 33mm; 1/60sec at
f/22; ISO 100

LEFT
CROSSBREED
Canon EOS D60; 1/60sec
at f/16; two studio flash
units; ISO 100

Posing

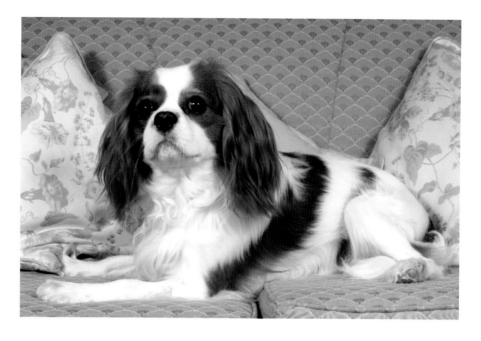

When taking studio portraits of larger dogs it may be better to concentrate on a three-quarter pose (i.e. head and shoulders). Get the dog to sit at a slight angle to the camera and, if you have set the lights to equal power, it will not matter which direction it faces.

The dog should be positioned fairly close to the backdrop as, if it is too far forward, the backdrop will not receive enough light and will appear very dark in the picture. You could also light the background with another flash unit, but try to keep things simple to start with.

The eyes should be the main point of focus and, if your lighting is set up correctly, you will see telltale catchlights in the dog's pupils. Most dogs will not be concerned with the flash, in fact be prepared to take another picture very quickly as they quite often cock their heads in an effort to work out where the pop from the bulb came from, and one advantage of studio flash units is that they charge very quickly (see page 52).

Lying Down

Space is often at a premium in the studio and you may not be able to get the whole dog in the frame lying down unless you use a wideangle lens. The dog's legs may also overhang the backdrop if it is not large enough. If your subject is on a sofa or chair, then it really shouldn't be so much of a problem, but lower the height of your lights, otherwise you will lose the all-important catchlights and the underside of the dog will be in deep shadow.

KEEPING YOUR 'MODEL' HAPPY

Keep the sessions short: studio lights create a lot of heat and this can make a dog feel very uncomfortable. Always make sure that there is a bowl of clean drinking water available, and stop if the dog shows any signs of stress.

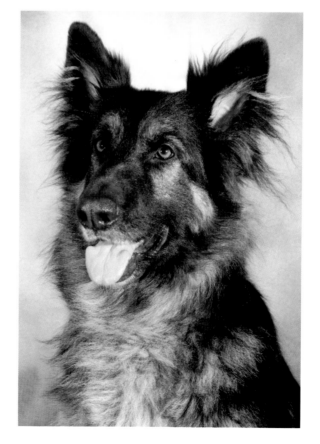

ABOVE If the dog is small a sofa or chair will provide a large enough natural backdrop to fill the frame.

KING CHARLES CAVALIER SPANIEL
Canon EOS D30; focal length 53mm; 1/60sec at f/13; ISO 100

LEFT Unless you have plenty of space take head-and-shoulder portraits of larger dogs. Sit them at a gentle angle, so they look slightly off-camera.

GERMAN SHEPHERD
Canon EOS D30; focal length 50mm; 1/200sec at f/8.0; two studio flash units; ISO 100

Indoor Lighting

There is usually plenty of available light around, especially if you are lucky enough to have glass doors or large windows. However, for the majority of indoor photographs you will need to use some kind of artificial light source, such as an accessory flashgun or the more powerful studio flash units. Whether you use natural or artificial light, you may need to modify it by the use of reflectors, umbrellas or softboxes (see page 52).

Accessory Flashgun

The most common and the most convenient source of artificial lighting available to the photographer is the accessory flashgun. Nearly all consumer-specification cameras come with a built-in flash but, although these are getting ever more powerful and sophisticated, in truth they are not going to produce professional-looking portraits. The main problem with the built-in flash units is that they are normally positioned directly over the axis of the lens and, although this may be convenient from a manufacturing point of view, it can cause a phenomenon in animal photography known as 'green eye' and will almost certainly cast strong shadows behind the subject. Green eye is the equivalent to 'red eye' in humans, although some light-eyed dogs can also give off a red glow.

Green eye is caused when the flashlight is fired directly at the dog and the light reflects off the retina (at the back of the eye). There are ways of avoiding this, for example some cameras offer a red-eye-reduction function, where the camera fires what is known as a pre-flash (a small burst of light before the main flash is fired), which is enough to close the dog's pupil and reduce the amount of reflection from the eye; also, most image-manipulation software programmes offer a 'one-click' red-eye removal tool (see page 130). However, it is always better to try and avoid these problems in-camera rather than in the computer and the most efficient way of avoiding green eye is to ensure that the light source does not come from directly above the lens axis; this is best achieved by using a studio flash unit or an accessory flashgun, and bouncing the light from a suitable surface.

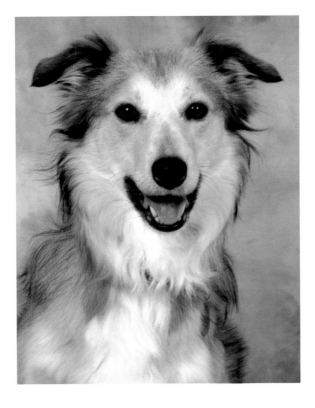

LEFT If your lighting set-up is correct, you should see the telltale catchlights in the dog's eyes. Set your lights at the same output, as this allows you some flexibility when positioning the dog.

CROSSBREED
Canon EOS D60; focal length 105mm; 1/60sec at f/22; two studio flash units; ISO 100

BELOW Using an accessory flashgun attached to the hotshoe of the camera. Note that the head of the flash gun is pointing towards the ceiling to help soften the shadows.

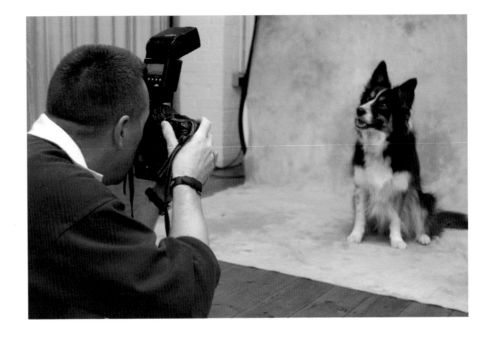

TECHNIQUE: **BOUNCING FLASH**

Bounced flash is, very simply, bouncing the light from your flashgun off a surface before it hits the subject. There are several reasons for using bounced flash: it weakens any shadows that may be cast behind the subject; the light is more flattering and it will eliminate green eye. To use bounced flash you will need a flashgun with a tilt-and-swivel head; there are plenty of models on the market, so locating one will not be a problem.

Tilt the head of the flashgun towards the ceiling at a 45° angle and aim it roughly halfway between you and the dog; if you are going to use the camera in the portrait format, you will have to swivel the head upwards. There will be some loss of light, due to the extra distance the light will have to travel from the flashgun to the ceiling and back down to the dog.

If you use an automatic or dedicated flashgun, all of the complicated calculations will be made for you and the camera and flashgun will ensure that a correct exposure is made. Check your flashgun's exposure check lamp (see page 21) to see whether enough light has been given.

Bear in mind that any surface you bounce the light from must be a neutral colour, as a coloured surface will inevitably cause a colour-cast which will spoil the picture.

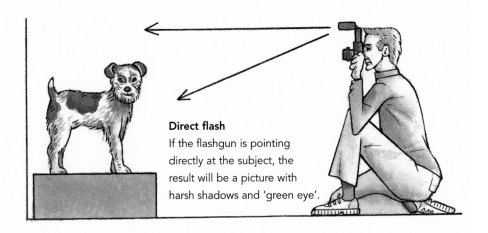

Direct flash
If the flashgun is pointing directly at the subject, the result will be a picture with harsh shadows and 'green eye'.

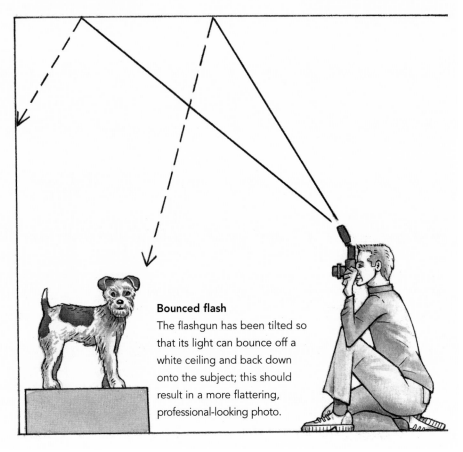

Bounced flash
The flashgun has been tilted so that its light can bounce off a white ceiling and back down onto the subject; this should result in a more flattering, professional-looking photo.

Studio Flash

As your understanding of using flash as a light source increases, you may decide to invest in some studio flash units. There is plenty of choice on the market, and you can even purchase complete kits (flash units, umbrellas and stands). For the average dog portrait you will not need very high-powered units and some superb results can be produced using very modestly priced equipment. However, bear in mind that the more expensive units, as well as outputting more light, tend to recharge quicker than cheaper models and this can be a distinct advantage if you want to take a series of shots in quick succession.

Studio flash units do call for an in-depth understanding of flash photography, as they are not automatic and the shutter speed and aperture on the camera must be set manually. There is no facility to allow the camera and flash unit to 'talk' to each other as with a dedicated flashgun: the photographer has to use a light meter to establish these settings. There are many good books and courses available and it is recommended that, if you plan to invest in one or more studio flash units, you spend time learning the art of using this type of equipment.

Modifying the Light
When using studio flash units you will need some method of modifying the light and the most convenient is the flash umbrella or 'brolly'. These come in two main designs, 'shoot-through' and 'reflective'. You could also use a softbox; however, although these are used a great deal for people portraits, to give a more flattering light, they do not offer any real advantage over the brolly for dog photography.

The main purpose of a shoot-through brolly is to soften the light output, thereby reducing any resulting shadows – as the name suggests, the light from the flash unit is fired through a translucent material. On the other hand, with a reflective umbrella the light is fired into the modifier; the silver, gold or white surface spreads the reflected light and once again this softens any shadows. I would suggest that either the white or silver surfaces are best for photographing dogs, as the gold surface tends to give a colour cast. Although umbrellas tend to be used on studio flash units you can buy adapters that will allow them to be fixed to accessory flashguns.

REACTIONS TO FLASH

I find most dogs are not bothered by a sudden burst of the flash; they may cock their heads in an effort to work out what is going on, but they don't appear to be frightened. But, as, all dogs are different, always check first with the owner or handler how the dog may react.

EQUIPMENT: **MONOBLOCS**

My favoured type of studio flash unit is known as a monobloc. This is a studio flash unit that has all of the controls built-in. All you have to do is plug it into the mains and attach it via a sync lead to your camera. The main advantage of monoblocs is that they are more powerful than accessory flashguns and recharge faster, allowing you to take photographs more quickly, which is vital if the subject is getting bored and wants to wander off and play. Another useful feature is the modelling light, which will show you where the shadows will fall when the flash is fired. Flashguns tend not to have this facility.

If you plan to use monobloc units you will also need a flash meter (to read the light output) and lighting stands. Also, your camera will have to have a PC socket so that a synchronization cable can be attached. This will make sure that the flash unit fires when you press the shutter button.

In the majority of cases, there is no need to use more than one monobloc unless you plan to photograph large groups of dogs, in which case you may need anything up to three separate units.

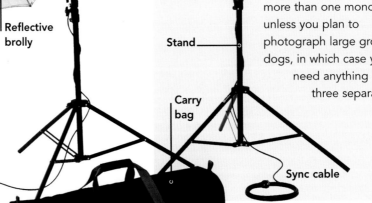

Monobloc

Softbox

Reflective brolly

Stand

Carry bag

Sync cable

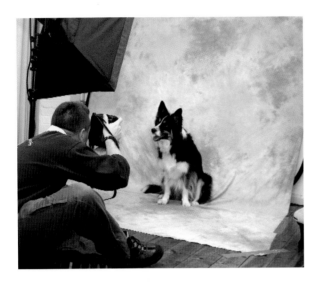

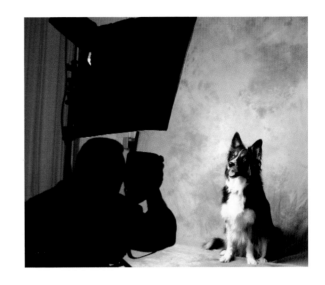

A studio portrait being taken with monobloc flash. The flash unit is positioned immediately next to the photographer. The left-hand picture shows a softbox being used to diffuse the light. In the right-hand picture the dog is illuminated by the modelling light, allowing the photographer to preview where the shadows will fall when the flash fires.

TECHNIQUE: **POSITIONING THE LIGHTS**

Lighting dogs in a studio environment is fairly straightforward – you can use one, two or even three lights but, in any event, the best advice is to keep it simple and use two. If you only have one light unit the best position is directly next to the left or right of the camera. It will need to be set at a height above the dog's eye level so that any shadows are thrown behind the dog's body and towards the floor, as this helps to keep them out of the frame. When using two units, place them either side of the camera at an angle of about 45° towards the dog, once again setting them slightly above the dog's eye level.

I tend to use two lights and set the output so that they are both at the same level (normally f/16, 1/60sec). This is slightly different from human portrait photography where you would usually have a main, or key light, and a fill light. The key light would be set to a higher output level (one–two stops) than the fill light. The consequence of this is that the variation in light levels gives some modelling or contrast to the image. This is all well and good when you know exactly where your model is going to sit or stand. However, quite often the dog will decide where it wants to be, so having a broad bank of evenly balanced light allows some considerable flexibility.

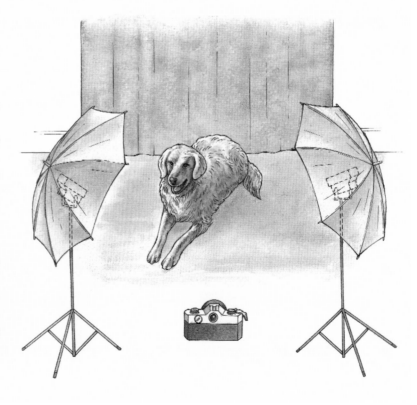

Dog Behaviour

Mentally, dogs are not as complex as their human owners but each one is, nevertheless, an individual with a personality of its own. Learning more about what makes a dog 'tick' can be a very useful skill when attempting to photograph your own dog – if the dog belongs to someone else, it can be vital.

Understanding Dogs

Understanding dog behaviour is a complex science and studying the interaction of dogs with their human owners is big business. To be a successful dog photographer you will need to be aware of such matters, but more importantly you will have to have an affinity and be comfortable with your canine models.

Does the Dog Understand Humans?

How many times have you heard dog owners claim that their dog is so clever that it understands every word they say? In truth dogs are very good at 'association' and at detecting subtle signals from humans that we may not be aware that we are giving off. My own dogs get very excited when I open the cupboard where their leads are kept.

UNCONSCIOUS SIGNALS

Dogs can detect unconscious signals given off by humans, whether these are signals of pleasure, distress or – most importantly in the photographer's case – fear. Generally, if you act in a calm manner and speak in an even, reassuring tone, dogs will respond well. Also, avoid making sudden or unexpected movements or loud noises that my startle or frighten a nervous dog (see box on page 58).

Observe any wild dog and it will soon become obvious that it is able to respond to unconscious signals; the domestic dog is no different. Wolves are especially skilled at detecting fear or distress in their prey.

WOLF
Canon EOS D60; focal length 135mm; 1/125sec at f/11; ISO 200; exposure compensation of +1/2

If I get out a particular coat that I often wear when I take my dogs out, they seem to know that it's time for a walk. Why? In my case it is because I also start to tell them to calm down and I rarely do that at any other time. The dogs have learnt that the association between my coat and my behaviour means that they are going to be taken out.

Basic Instinct

The most basic instinct that any dog possesses is to protect its home and its fellow 'pack-members' from interlopers – human or canine – while often ignoring other animals and birds. It is believed that a dog regards familiar humans and other canines as its own kind and unknown members of these species are viewed with suspicion. The dog's owner is normally seen as the leader of its pack and responsible for the wellbeing and defence of the territory. If the human pack leader greets a stranger such as a photographer quietly and calmly, the dog will generally accept them.

Breed Temperaments

Different breeds of dogs have behaviour and character traits that are particular to their ancestry. In general terms the gun-dog breeds (such as spaniels and retrievers) are very good with people, whereas some of the guarding breeds (such as German shepherds and Rottweilers) are very loyal to their owners but can be aggressive towards intruders or strangers. Having a basic understanding of breed temperaments can make a huge difference to the way you first approach the animal and your initial interaction with it. One important thing to remember is that big does not necessarily mean nasty.

The empathy that has developed over the years between dog-owners and their dogs – and also, to a large extent, selective breeding – has changed a wild pack animal into one that is relatively dependant on its two-legged owner for food, water, and in some cases even its access to the outside world. If you aspire to be a successful dog photographer you should learn to read the signs given off by the animal. Understanding a dog's posture or its behaviour may be easier if you're working with your own pet, but if it is an unknown dog then these skills become even more important.

The empathy that has developed between humans and dogs is to a large extent due to selective breeding. Understanding how a dog is motivated is a vital skill that the budding canine photographer should endeavour to develop.

JACK RUSSELL TERRIER
Canon EOS D30; focal length 70mm; 1/250sec at f/8; ISO 200

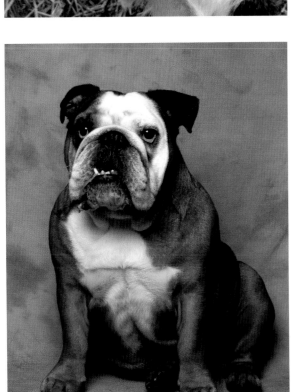

Some breeds just have a laid back attitude to life and no matter how hard you try you will not get a reaction showing alertness and inquisitiveness!

ENGLISH BULLDOG
Canon EOS D60; focal length 50mm; 1/60sec at f/16; ISO 100

Nice to Meet You …

Your initial reaction when first meeting a dog will depend on a number of factors. If you already know the animal, or it is your own, there should be very little problem persuading it to relax and accept you. However, if you are a stranger and enter the house armed with photographic paraphernalia, or if the dog is visiting your premises for a portrait sitting, you may encounter a different reaction. Leave the bags in the car, or go outside of the studio to meet the owner and dog and say hello first.

When meeting and greeting a new dog you will need both hands to start that vital bonding. Initially the dog will want to sniff and may even bark excitedly at you, and a few moments of mutual grooming will do wonders in forming a new friendship. Once the greetings have subsided and the inevitable presents of chewed slippers, old tennis balls and a bone have been accepted, then collect your camera gear and start snapping.

Smell is a vital component in the dogs 'greeting armoury'. Be prepared to get sniffed all over, and then a few moments of mutual grooming will help to create a relaxed atmosphere ready for a picture-taking session.

ITALIAN SPINONIE
Canon EOS D60; focal length 28mm; 1/90sec at f/11; ISO 200; exposure compensation of +1/2

WORKING WITH DOGS: **THE DOS AND DON'TS OF MEETING A NEW DOG**

DO:

✔ Always ask the owner to introduce you to the dog.

✔ Play before taking out your photographic gear.

✔ Take your cue from the dog and let it sniff or lick your closed hand.

✔ Keep talking quietly, to reassure the dog.

✔ Gently scratch the dog's head and behind its ears, if the dog accepts you.

✔ Once the greetings have subsided, collect your gear and start snapping.

DON'T:

✗ Take your camera out until the dog is calm or playful.

✗ Look a dog in the eye – in the dog world that is a sign of aggression.

✗ Make sudden hand movement or loud noises.

✗ Put fingers or an open hand out to a dog – a bite to the back of a closed hand is better than a lost finger!

✗ Allow the owner or handler to be heavy-handed with the animal. Dogs cannot be expected to act like robots and it is never worth upsetting the animal for the sake of a photograph.

Canine Body Language

Dogs cannot use speech to express their feelings, despite what some owners may think. However, they do have a range of body signals that can express fear, aggression, pleasure or playfulness. Some of these signals are very easy to read and understand, others are not so clear. To be a successful canine photographer you should be aware of these signs and how to react accordingly; if you have shared your life with dogs, you will already react instinctively to their body language.

Telltale Signs There are eight basic components that make up a dog's body language (see box on right). However, any body language is a complex mixture of many elements and an overall view is the best way to understand what the dog is trying to say.

THE 8 BASIC COMPONENTS

- Body posture
- Eyes
- Ears
- Vocalization
- Lips
- Tongue
- Hair
- Tail

Body Posture

Generally speaking, if a dog is happy and comfortable with the photographer, its body will be relaxed and it may stand or sit, showing no tension. Sometimes, if a dog is too relaxed it can make the session harder, as you want it to show some alertness in its posture, not to slouch, or doze off. A happy dog carries its tail well, moves freely and holds its head high; the tongue may well loll out and its jaws are relaxed. Often, if a dog wants to play, it will dip down at the front into a crouch. It may give off little yips and growls and jump backwards and forwards. The head will be looking up at you and the tail will be wagging. For the budding dog photographer these are all good signs and you can be quite confident that your 'model' will be at ease when you start taking pictures.

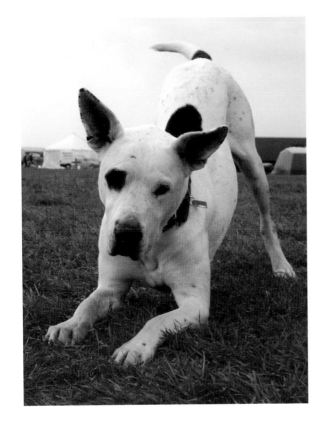

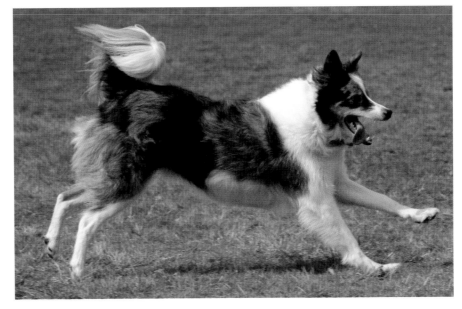

LEFT
CROSSBREED
Canon EOS D60; focal length 44mm; 1/250sec at f/11; ISO 200

A happy dog may dip down at the front; its jaws will be relaxed and its tongue may well loll out. These are all good signs.

ABOVE
BORDER COLLIE
Canon EOS D60; focal length 135mm; 1/1000sec at f/9.5; ISO 400

Aggression

The body posture of the aggressive dog is quite different from that of the happy, confident dog. The two basic types of aggression are fearful aggression and dominant aggression. These can be recognised by the dog's slightly different body postures.

Fearful Aggression
Fearful or nervous aggression is quite difficult to read: the dog shows its teeth and may growl or bark; its ears are laid back, and the whole body is tense; the tail is carried straight out and is rigid, and quite often the hair on the dog's back will stand on end. The dog is not sure what to do, it is a classic case of 'fight or flight' and if the photographer is not careful and makes a wrong move the animal may attack.

 The best way to deal with this type of dog (depending on your level of experience and confidence) is to talk quietly to it and try to avoid eye contact; given time and patience, the dog may well calm down and come over to investigate. Avoid any quick movements and don't even think about getting the camera out until the dog is totally relaxed and happy to be in your company.

Dominant Aggression
If a dog is showing dominant aggression it is probably better that you do not contemplate taking any pictures, and that you look for a more sedate subject on which to practise your skills. Rather than trying to warn you off, the dog showing dominant aggression will advance confidently with its tail and ears held high. It will normally look straight at you with its teeth bared, snapping and ready to bite.

 The good news is that this type of behaviour quite often takes place between rival dogs rather than involving human beings, but when it does it can be serious, and evasive action should be taken.

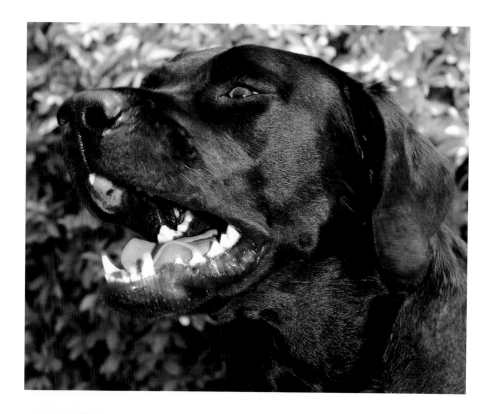

ABOVE
BLACK LABRADOR
Canon EOS D30; focal length 117mm; 1/350sec at f/5.6; ISO 200; exposure compensation of +1/2

There is no mistaking the signs with these two dogs and their bared teeth. The dog photographer needs to be able to recognize this kind of aggressive behaviour and know how to take appropriate action.

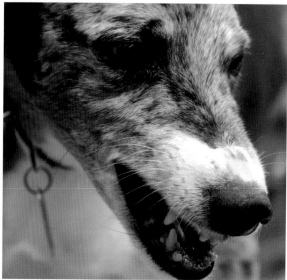

ABOVE
COLLIE-CROSS-LURCHER
Canon EOS D30; 1/350sec at f/5.6; ISO 200

FOLLOW YOUR INSTINCTS

The initial observations that you make about a dog and its body language when you first meet it can give a number of clues as to how it will react during the photography session. When you start pointing shiny lenses and flashing bright lights at a reluctant or aggressive model you will not achieve the relaxed, intimate pictures that you set out to create.

The Fear Circle

All animals and birds have what is known as a 'fear circle'. In humans it is known as 'personal space' – an undefined area in which we feel uncomfortable if someone comes too close without our invitation. In dogs it is the most basic survival instinct and the ultimate reaction is to flee or to fight should a predator come too close.

Fortunately, in most cases you will not have to worry about the fear circle when photographing domestic dogs, as they have become quite accustomed to human contact. You may come across dogs that feel uncomfortable when you point the camera at them, however, and the normal reaction will be for them to either turn their head away or to lean in the opposite direction. They will try to increase the distance between them and you (the staring aggressor) and therefore reduce the perceived threat.

The easiest way for the photographer to deal with a situation like this is to take a few steps away from the dog and use a slightly longer lens whilst at the same time, speaking softly and continually to reassure it that you and the camera are not a threat.

RIGHT This spaniel's fear circle is being invaded and it is baring its teeth as a clear warning to the photographer.

ENGLISH SPRINGER SPANIEL
Canon EOS D30; focal length 135mm; 1/350sec at f/8; ISO 200

This dog is showing classic signs that its fear circle is being invaded by the photographer. It is leaning away in an effort to increase the distance between itself and its perceived threat, and is averting its eyes from the camera lens.

GOLDEN RETRIEVER
Canon EOS D30; focal length 135mm; 1/60sec at f/16; 2 studio flash units; ISO 200

Reading a Dog's Eyes

The eyes of a dog can be very expressive and, as we have already seen, they should usually be the main focal point of a portrait. When a dog is happy there can be a distinct brightening of the eyes; some dogs will even raise their eyelids when surprised or quizzical, perhaps accompanied by a tilt of the head.

The eyes can also cause the photographer problems, however. In the canine world staring at a fellow pack member is a sign of aggression or dominance. Under normal circumstances a person staring at a dog will cause the dog to look away and become submissive, but try it with an aggressive or overly confident dog and you could be in trouble. Fixed, staring eyes can be very intimidating and this is not a reaction you want to create during a relaxed photographic session.

Quite often when taking photographs your eyes are hidden behind the camera, so you may consider that there is little or no threat to the animal. However, the bright reflection of the camera's lens can resemble a huge staring eye and this will quickly unnerve even the most confident of dogs. To remedy this, keep talking to the dog as you work, dropping the camera down so that the dog can see your face – it will soon realize that the square-headed one-eyed monster is in fact a nice friendly photographer that just wants to take its picture.

There is no mistaking the relaxed look in this border collie's eyes. This is my favourite dog pose, head on paws, and a look of total loyalty.

*BORDER COLLIE
Canon EOS D30 ; focal length 135mm; 1/90sec at f/9.5; ISO 200*

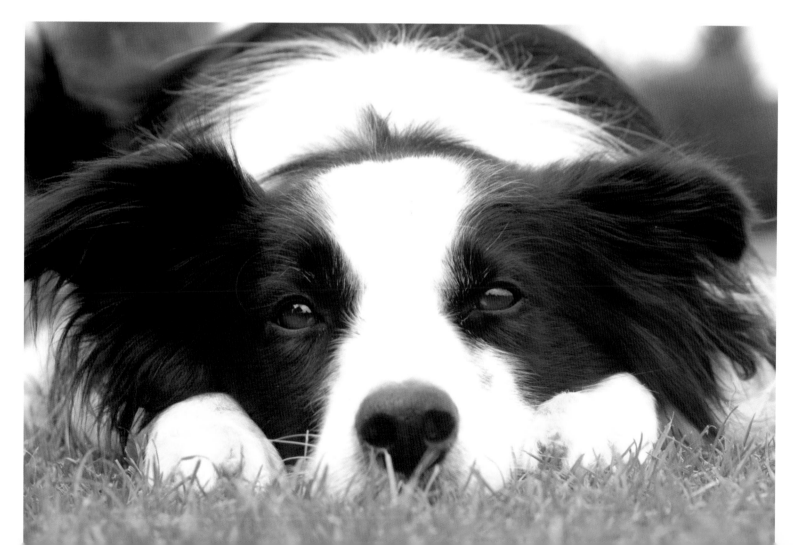

The Ears as a Means of Expression

Ears are a good and very visible way of assessing how a dog is reacting to a situation; they are also vital to the dog photographer, as even a slight movement – up or down – can totally change a dog's expression.

The problem is that a dog's ears are basically cocked or flat, so you will have to develop and employ various techniques to make minute movements to its ears to give that extra look of inquisitiveness and alertness.

Show Dog Portraits

When shooting images of dogs that are specifically used for showing bear in mind that although, photographically, cocked ears may make for a more visually pleasing image, the breed standards as laid down by the breed society may not consider it 'correct'. It is always worth checking on what is appropriate to the breed of dog before starting the session (see page 85).

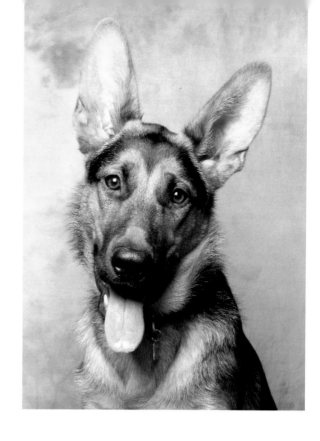

RIGHT A good set of ears can make all the difference to a dog portrait. You will need to practise your techniques and develop a repertoire of noises to get the dog to cock its ears.

GERMAN SHEPHERD
Canon EOS D60; focal length 60mm; 1/60sec at f/16; ISO 100

Sometimes ears give very mixed signals!

BRACCO ITALIANO
Canon EOS D60; focal length 65mm; 1/180sec at f/8; ISO 200; exposure compensation of +1

WORKING WITH DOGS: **THE TELLTALE SIGNS OF A TAIL**

The dog's tail is the most important part of its communication system and any dog photographer should have some understanding of the various ways that the animal uses it. The dog wags its tail to show pleasure, or as an invitation to play. Its tail can also be lowered as part of a display of aggression, or even tucked under the body as an expression of fear.

Many dogs, such as beagles, use their tails to indicate the presence of scent.

BEAGLE
Canon EOS D60; focal length 15mm; 1/250sec at f/9.5; ISO 200

Aggressive/dominant

Confident/happy

Nervous/scared

Some dogs, such as this terrier, have their tails docked and so the photographer will have to use other body signals to understand the dog's demeanour.

TERRIER
Canon EOS D60, focal length 155mm, 1/500sec at f/8, ISO 400

There are some simple and general conclusions that can be drawn that will be beneficial to the photographer. A dog's tail will normally be carried in one of three positions, upright, mid-way or between its legs. All three positions give out different signals.

If a dog greets you with its tail in a very upright position (almost like a flagpole) it is displaying an aggressive, dominant posture and may be quite protective of its territory. A mid-way wag is a good wag and it indicates that the dog is happy and quite confident in your presence and will be pleased to participate in your quest for a stunning photograph. A tail between the legs indicates that the dog is nervous and not sure of your intentions. A dog displaying this kind of reaction will need time to gain confidence and it would be highly irresponsible to try and take any pictures until the dog is feeling comfortable in your presence.

Photographing Puppies

What better subject can there possibly be to photograph than a playful puppy? Well the answer to that question is quite simple – a healthy, inquisitive and naughty litter of puppies. If you want a challenge, have the stamina and agility of an Olympic athlete, and the patience of a saint, then this is the chapter for you. Puppy pictures are guaranteed to get an 'ahhhh' from the viewer and commercially there is a good market for this type of image. As well as needing the physical attributes to spend many hours on your knees or stomach, you will need to hone your photographic skills to be successful.

LEFT At around six weeks old, pups are up to all sorts of mischief. Everything has to be 'tasted' – this may include rope toys, slippers, or bits of grass.

COLLIE-CROSS-LURCHER
Canon EOS D30; focal length 38mm; 1/90sec at f/6.7; ISO 100

What is a puppy?

From a practical point of view, a canine may be considered to be a puppy from birth to the age of around 12 months, and during this time there will obviously be a huge difference in its overall level of training and the way in which the dog responds to the photographer.

Unless you wish to record the pup's very early life, the best time to start taking pictures is when the young dog reaches the age of around six weeks. At this age they are very inquisitive, constantly getting into mischief and 'tasting' all sorts of new things, from slippers to grass.

Before taking the camera out of your bag, sit on the floor and watch the puppies playing. This will not only give you the opportunity to identify good backdrops and props, but it could also help to identify individuals that may play up to the camera.

A puppy's early life is not very photogenic, but it is always worth capturing a few memories.

COLLIE-CROSS-LURCHERS
Canon EOS D30; focal length 115mm; 1/60sec at f/5.6; accessory flashgun; ISO 100

ABOVE A litter of puppies will test your patience to the limit, but the results will be worth the effort.

ENGLISH SPRINGER SPANIELS
Canon EOS D30; focal length 28mm; single studio flash unit

THE IMPORTANCE OF OBSERVATION

A good photograph is made long before the shutter button is pressed. Physically taking the photograph is the last and final act in creating a visually pleasing image. Wildlife photographers probably spend as much time observing and studying the behaviour of their subjects as they do taking pictures of them, and the budding puppy-photographer should follow their example.

BELOW
COLLIE-CROSS-LURCHER
Canon EOS D60; focal length 135mm; 1/350sec at f/6.7; ISO 400

ABOVE GOLDEN LABRADOR
Canon EOS D60; focal length 135mm; 1/125sec at f/9.5; ISO 400; exposure compensation +1/2

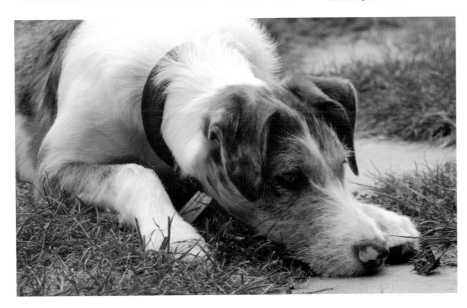

The Photographer's Body Language

When greeting our canine companions we instinctively bend or crouch down to stroke the animal. There are two main reasons for this:

- it helps to avoid the dog jumping up at you when it greets you;

- it encourages a young dog to come towards its owner, because it reduces the dominant body language that towering over a young dog can have. This is especially important if the pup is nervous.

This can, however, be a potential problem for the puppy photographer. Imagine this scenario: you have been asked to photograph a litter of seven-week-old puppies; you arrive at the location and you take a few minutes to greet the prospective models; you crouch or even sit down and the pups all come running up to investigate this new 'toy'. Laces get chewed, ears get licked and everyone has a great time saying hello.

Soon it is time to get to work: camera out of bag, film loaded and you have earmarked some suitable backdrops. You remember the golden rule that, when photographing dogs, you must get down to their eye level. You slowly start to lie down and, before you know it, you are the latest white-knuckle ride for juvenile dogs who want to jump all over you, and your lens is smudged by puppy tongues. But do not despair – on the following pages there are some very simple techniques and special hints and tips that can turn a nightmare scenario into a successful one.

Crouch down and the chances are that the pup will run towards you, usually too quickly to focus correctly.

COLLIE-CROSS-LURCHER
Canon EOS D30; focal length 35mm; 1/250sec at f/5.6;
ISO 100; exposure compensation +1/2

Most owners will start very basic training from an early age, and the first thing a pup will have been taught is house training. The breeder may have already 'conditioned' the pups to come when they are called, especially at feeding time, and it is worth enquiring if there is also a certain phrase or whistle that is used, as this could be a useful tool in your armoury.

The chances are that, as the pup gets older, it will be taught the 'sit' command. Puppies have a particular way of sitting, with their back legs folded under their bodies – normally both legs on the same side; they rarely sit upright, as they prefer to slouch. This can make an endearing picture and during your observation period it is worth watching to see if the pup adopts this pose.

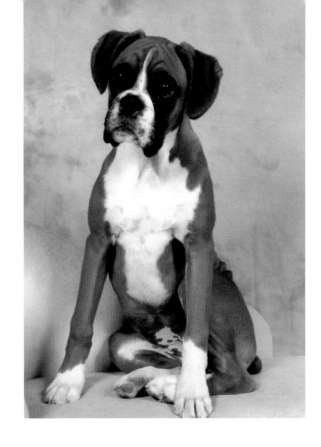

A typical position for a seated puppy, with back legs folded to one side under its body.

BOXER
Canon EOS D60; focal length 50mm; 1/60sec at f/19; two studio flash units, umbrellas; ISO 100

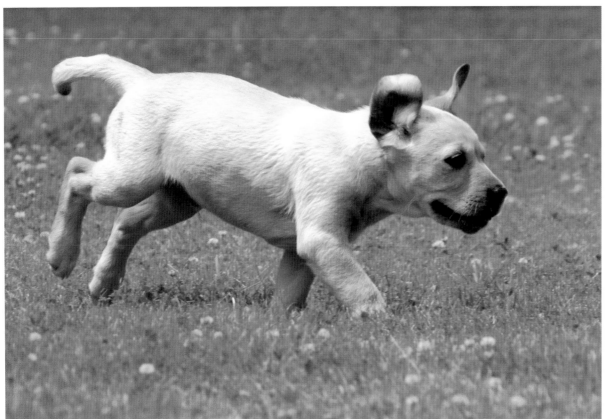

A young pup may have been trained to come when called.

GOLDEN LABRADOR
Canon EOS D60; focal length 210mm; 1/1000sec at f/8; ISO 400

Choosing a Location

While studio or indoor portraits are all well and good and, if the weather is bad you may have little choice in the matter, the great outdoors has several advantages:

- it is a far more natural environment for the pup and you have a limitless choice of backgrounds;

- also, puppies are far more relaxed in less formal surroundings;

- they will settle down much quicker than if you try and put them in front of a couple of high-powered flashlights and all the other paraphernalia that goes along with studio sittings.

RIGHT Studio or indoor portraits will require an artificial light source and, although the bright lights do not normally cause the young dogs any problems, most pups will be far more relaxed in less formal surroundings.

ITALIAN GREYHOUND
Canon EOS D60; focal length 44mm; 1/60sec at f/16; two studio flash units, umbrellas; ISO 100

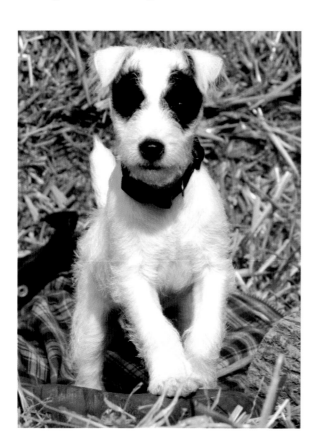

LEFT Although this image appears to have been taken outside in a barn, it was in fact taken in the studio under controlled conditions. If the weather is bad you may have little choice in the matter.

JACK RUSSELL TERRIER
Canon EOS D60; focal length 100mm; 1/1500sec at f/8; ISO 400

The shed and brick wall form a very simple and uncluttered backdrop in the portrait of these two black Labrador pups.

BLACK LABRADORS
Canon EOS D30; focal length 80mm; 1/90sec at f/6.7;
ISO 100

Posing a Pup

It can be very difficult to pose young dogs aged between eight and 16 weeks as they will, quite rightly, have had little or no basic training and their attention span is almost nil. My favourite 'tool of the trade' is a small plastic squeaker. Its original use is to imitate the squeal of an injured rabbit, but with a bit of practice the noise can be varied in a number of ways and it is almost guaranteed to get that quizzical look that is so appealing.

TECHNIQUE: **PUPPY TRICKS**

- First, get the owner or handler to settle the pup in the area that you want to take the photograph and ask them to hold the dog while you get into position.

- If they want to keep the pup on a lead, ask them to drape it over the back of the animal so it cannot be seen.

- When you are ready and have pre-focused on the pup, ask the handler to move their hand out of the frame and, at the same time, give a quick blast on the squeaker.

- Usually the pup will look straight at you and, if it cocks its head in an effort to work out where the noise came from, fire the shutter button. This technique does take some practice and you need to have quick reflexes.

- You may only manage to fire off a couple of frames before the pup gets used to the noise. Try varying the sounds by using short little blasts in succession, and never get cross with the pup as it runs over to investigate.

The surprised look on this pup's face was caused by the noise from a small plastic squeaker. The lead (seen to the left of the dog) was attached to a small peg in the ground to prevent it from running off.

TERRIER
Canon EOS D60; focal length 30mm; 1/90 sec at f/9.5; ISO 100; exposure compensation +1/2,

Simple Control Techniques

Tying the pup by its lead to a suitable peg is another useful technique that can be employed. However, this method should only be used if the photographer is confident and experienced enough to know if the puppy is getting stressed – no photograph is worth harming or causing unnecessary stress to any animal. Even the most energetic pup will quickly settle down once it knows it can't go anywhere. Position the lead behind the pup so it can't be seen and keep the owner close by to reassure the animal. Most pups will sit down once they realize they can't go anywhere and some may even lie down, so keep your wits about you and get ready to take as many pictures as you can.

If the puppy is older, and has undergone some basic training, the chances are that it will have been trained to sit; most dogs are taught this discipline, even if the owners do not pursue any other form of training, so ask the owner to constantly give the 'sit' command as you get into position to take the picture. I have been in situations where there has been a complete family of five all giving the 'sit' command to a very confused pup – this is the time to either give the command yourself, or nominate a particular person to take control.

The leads in both these images have been hidden behind the backs of the puppies so that they cannot be seen.

RIGHT BORDER TERRIER
Canon EOS D60; focal length 50mm; 1/350sec at f/11; ISO 400

LEFT TECKEL
Canon EOS D30; focal length 185mm; 1/750sec at f/5.6; ISO 200

WORKING WITH DOGS: **KEEP CALM**

Owners or handlers can get quite impatient if their pup doesn't behave like a little robot, so always be prepared to stop a session and give everyone time to calm down. As a professional dog photographer, I always retain the right to suspend or cancel a sitting if I think that things are getting out of hand and the animal is becoming worried or anxious.

Stalk and Shoot

Photographing young dogs is very much the same as photographing children: you need to keep the sessions short as they soon run out of energy. A good time to set up a session is immediately after feeding time; the puppy will have a mad half hour and then get a bit sleepy and this can be a great time to get some intimate close-ups. 'Stalk and shoot' – that is waiting until the pups are lost in their own game/playtime – is my favourite way of capturing images of pups,.

The Pup's Eye View

If you are physically able, lay flat out on the ground to get a 'pup's eye view'. The chances are that the pup will be charging around all over the place and at times the light and composition may not be quite right, but this should not prevent you from taking plenty of pictures. Every now and again you will strike lucky.

EQUIPMENT: **YOU WILL NEED:**

- A slightly longer lens so that you can keep some distance from your model. A zoom lens with a focal length of between 28–135mm is the best option, as it gives you a level of flexibility without the necessity of continually getting up off the ground to get closer or further away.

- A selection of toys, or even an old cardboard box for the pup to play with, it will soon ignore you and get lost in its own little world.

Not the most flattering of images! Forget spending money on lots of dog toys just give them a cardboard box and get ready with the camera.

COLLIE-CROSS-LURCHER Canon EOS D30; focal length 80mm; 1/15sec at f/11; built-in flash; ISO 200

Using the 'stalk and shoot' technique has caught this pup playing in a flower trough; her expression is one of total innocence. The built-in flash unit has just lifted the colours and put a couple of catchlights in the dog's eyes.

COLLIE-CROSS-LURCHER
Canon EOS D30; focal length 135mm; 1/45sec at f/11; ISO 200

Sleep-time

A young dog's life is basically made up of three elements: playing, sleeping and eating. The photographic opportunities are obvious during playtime, but don't overlook the period just before they drop off to sleep, when they become oblivious to the outside world, yet they still have their eyes open. They will often allow you to get quite close, and take frame-filling images which are very appealing.

GOLDEN LABRADOR
Canon EOS D30; focal
length 135mm; 1/125sec
at f/3.5; ISO 100

COMPOSING THE IMAGE

Get in close to fill the frame with the pup's head. An aperture such as f/3.5 will really draw the viewer's attention to the eyes and throw the rest of the head and body out of focus. A little squeak just before you take the picture can get the pup to lift its ears very slightly, but only do this if you are sure it will not disturb the dog.

ABOVE
GOLDEN LABRADOR
Canon EOS D30; focal length 127mm; 1/750sec at f/8;
ISO 100

Soon after feeding, most pups will be extremely active for half an hour or so, then settle down for a doze; this is a good time to get up close as quite often they become oblivious to the outside world.

BELOW GOLDEN LABRADOR
Canon EOS D30; focal length 135mm; 1/180sec at f/3.5; ISO 100

Your observation of the pups' behaviour will start to pay off as they settle down for their siesta. If it is a warm day they will normally look for a shady spot; quite often they like to rest their heads on toys, railings or anything else that is convenient. Look out for that classic 'head on paws' look, and be prepared to adopt a commando crawl technique to get close enough without unduly disturbing the slumbering canine.

Puppy photography really is a joy and the resulting photographs always bring an immediate smile to the viewer's face. As with all creatures, puppies soon grow up and quite soon they lose that appealing cuteness. However, as they mature they continue to offer the photographer endless opportunities to capture endearing and visually varied images.

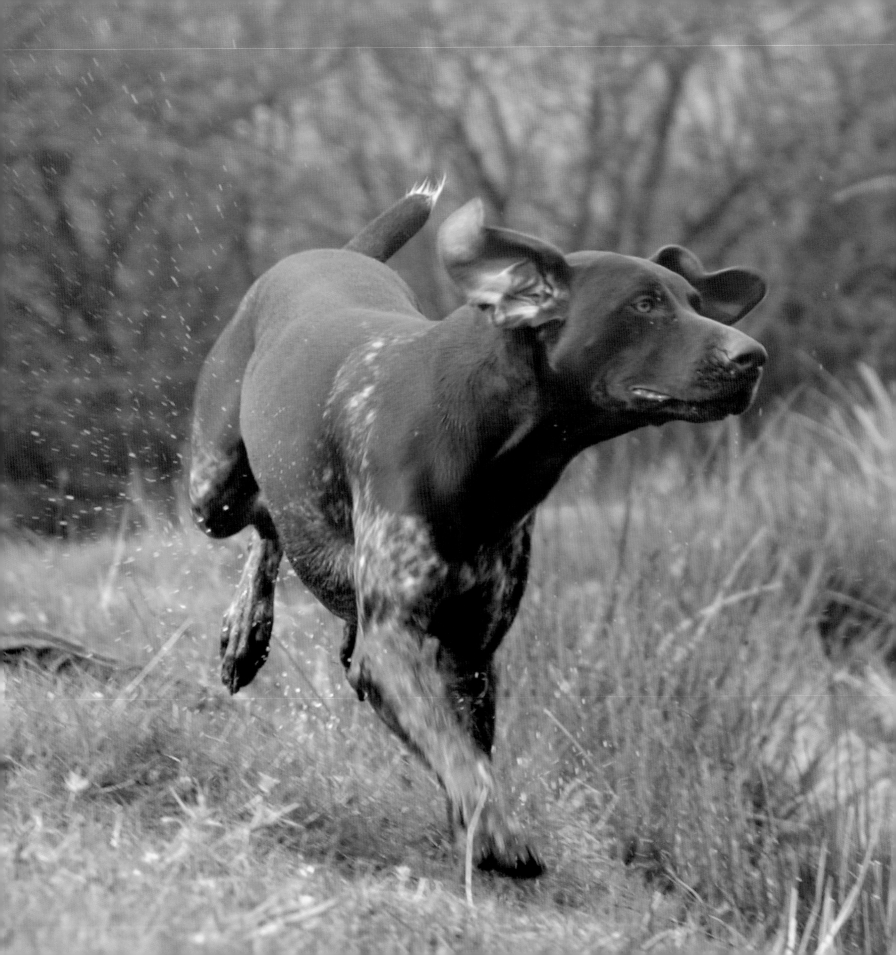

Working Dogs

Today, the working attributes of the dog have been developed to such a degree that they can literally be our ears and eyes. They can retrieve shot or injured birds, herd sheep from a mountainside and even rescue lost or stranded people. Dogs are a truly remarkable animal. The working breeds are superb subjects for the canine photographer, even if the dog is a pet and never actually works. With a bit of forethought and an understanding of some basic camera techniques it really isn't difficult to create some stunning photographic portraits. Although the following chapter refers to specific breed types, the photographic techniques can obviously be used for any type of dog.

Finding a Location

Terriers, lurchers, hounds and many, many more types and breeds of dogs have all been bred to work and offer the dog photographer an ongoing challenge. If you are undertaking a commissioned shoot, enquire what the dog's role is within the family and try to picture the animal in the right context. For example, if the dog lives and works on a farm then it might be a good idea to include some farm machinery or animals in the frame.

Finding a suitable location for one of the herding or gun-dog breeds shouldn't be very difficult: even the most built-up cities will have parkland or areas of open ground that can be used. Look for areas of rough grass with a fairly uniform background, such as a hedge or line of trees.

BELOW Even in a city you should be able to find a natural-looking location for photographing working dogs in.

GOLDEN RETRIEVERS
Canon EOS D60; focal length 90mm; 1/350sec at f/8; ISO 200; exposure compensation of + 1/2

ABOVE Even if the dog is a pet and never actually works, it can still be photographed in a natural and interesting environment.

CROSSBREED
Canon EOS D60; focal length 60mm; 1/500sec at f/5.6; ISO 400; exposure compensation of +1/2

LEFT
BORDER COLLIE
Canon EOS D60; focal length 53mm; 1/350sec at f/9.5; ISO 200

Some straw bales, logs, an old coat and a pair of rubber boots are all it takes to create the illusion of a farm setting.

BELOW
PARSONS JACK RUSSELL
Canon EOS D60; focal length 90mm; 1/350sec at f/11; ISO 200

Try to avoid structures such as telegraph poles and tall buildings, and always check the viewfinder for anything that would give the urban location away.

If you have access to woodland or a more rural location then all the better. The herding breeds, such as the Border and bearded collies and many of the terriers, are obviously most at home in a rural environment and, even if you are a long way from the nearest farm, you can still create a background that will give the impression that the dog is 'right at home'.

Artificial Settings

If you are having trouble finding a suitable location, or for some reason the dog cannot travel, consider creating an artificial setting. However, bear in mind from the outset that if you are going to make a 'rural' set, it must look authentic, and the best way of ensuring that is to use as much natural material as possible. You can buy artificial logs and tree stumps but they do look false and, if used outside, would probably not last very long. There is the further problem of male dogs doing what dogs do to anything that resembles a tree!

Ideally you will need around eight straw bales to form a backdrop, including one to sit or stand small dogs upon. Some loose straw on the floor, an old waxed coat and a pair of rubber boots, and the illusion is complete – and this kind of set-up can even be used indoors.

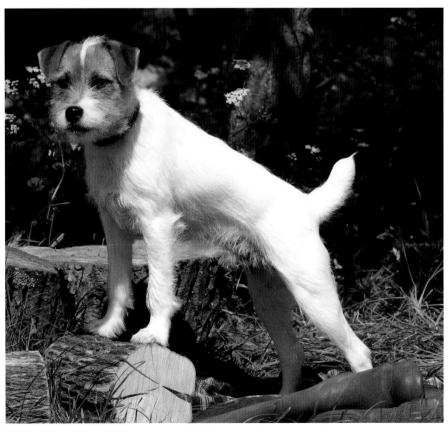

Posing a Working Dog

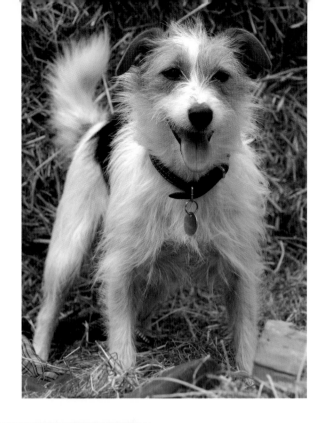

The whole essence of a working dog is that it should be alert and give the impression that it is ready and able to do the job for which it has been bred. However, on occasions the photographer has to resort to some tricks of the trade to get that slight change in stance or ear carriage that will make all the difference.

Standing

Unless the owner wants a classic show pose, as shown opposite, the best angle to position a standing dog is with its tail at about 10 o'clock or 2 o'clock – depending on the direction of the light – and the head facing slightly off-centre to the camera position. The handler can stand just to one side of the photographer so that the dog is looking to either the right or left of the lens, and preferably looking towards the light. If the dog looks straight at the camera its profile becomes flattened and it is more difficult to make out the dog's features. The main point of focus should be the dog's eyes and you will need to use an aperture setting of at least f/5.6 if you want the whole of the dog to be sharp but with a softer background. If you want the background to be more prominent, then use a smaller aperture such as f/11. When the dog is standing, it can also be a good opportunity to use a zoom lens and to take some close-up side shots of the head; aim to keep a uniformed colour to the background, as this can help to improve the visual impact of the picture.

RIGHT A dog standing with its tail at either 10 or 2 o'clock to the camera, will help to give a better outline.

JACK RUSSELL TERRIER Canon EOS 10D; focal length 125mm; 1/500sec at f/8; ISO 400

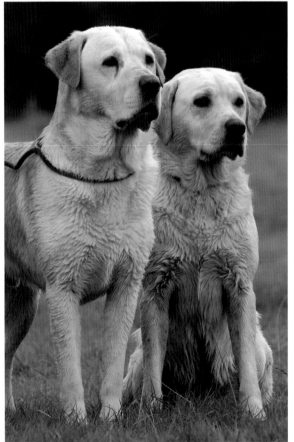

LEFT It can be difficult to pose a dog unless it is used for showing, and then it will quite happily stand stock still. The majority of dogs will want to stand or sit – or even a mixture of the two. When photographing two dogs together this will leave you with the dilemma of which format to use, landscape or portrait.

Golden Labradors Canon EOS D60; focal length 235mm; 1/500sec at f/8; ISO 400

THE IMPORTANCE OF ANGLE

Be aware when taking standing shots of dogs that at some angles they can appear to have only three legs (see right). This is more likely to happen if the two rear ones are in line – another good reason to stand the dog at a slight angle so that all four legs can be seen.

TECHNIQUE: **PHOTOGRAPHING THE CLASSIC SHOW POSE**

Before undertaking a show portrait, do your homework; all pedigree breeds have conformational standards that are laid down by the Kennel Club, including various attributes that the particular breed should possess, such as ear and tail carriage. I photograph a lot of Italian Spinonies which have their ears forward when working and, to my mind, this gives their head a better shape; when I was invited to take show portraits of the dogs at a Championship show, however, the owners were most insistent that the ears stayed hanging down. This was because the breed standard (as laid down by the Kennel Club) states that this is how the ear carriage should be.

Occasionally owners may want their dogs photographed for stud cards. These are simply 'doggy' business cards containing the dog's name, stud number and other details including stud fees. There is not a standard card, but the image should show the dog at its absolute best (example below).

Ears flat, conforming to the Kennel Club standards for this breed.

ITALIAN SPINONIE
Canon EOS D60; focal length 112mm; 1/250sec at f/11, ISO 200

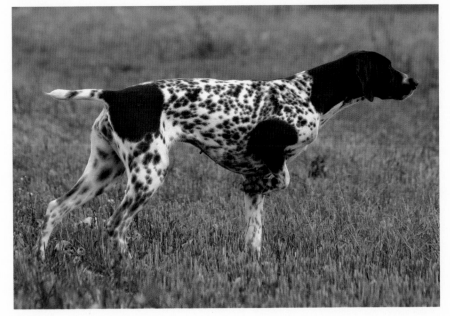

This is a classic shot of a German short-haired pointer. The dog has been photographed sideways on to the camera, using the landscape format to show its conformation, as the owner wanted to use the image on a stud card (see example below).

GERMAN SHORT-HAIRED POINTER
Canon EOS D60; focal length 195mm; 1/180sec at f/8; ISO 400

QUADET CATERIN
STUD NUMBER: CL3261
4 FIELD TRAIL AWARDS 2002 / 2003
Owner : David Pilkington

This particular group of working dogs lived together on a farm so they were sat in front of old farm machinery to fit with their lifestyle.

JACK RUSSELL, BLACK LABRADOR AND BORDER COLLIE

Canon EOS D30; focal length 47mm; 1/90sec at f/9.5; ISO 100

Sitting

Sitting comes naturally to most dogs but it is amazing how different dogs will adopt different positions. Legs will stick out, shoulders become hunched and of course there is always the slouch pose. Show dogs are rarely taught to sit, as they are required to stand whilst being examined by a judge. Dogs such as greyhounds do not like sitting, they much prefer to stand or lie down and it is, once again, a case of knowing your subject and how to make it look comfortable and relaxed.

To the uninitiated, taking a photograph of a dog sitting down would at first appear to be very straightforward, but there are some simple guidelines that can help to make all the difference: many of the breeds are quite narrow in the chest and so, if you sit them face on to the camera, the perspective can look very strange, this is made worse if the dog is in its teenage years and is a bit gangly; positioning the dog so that it is slightly sideways-on to the camera will immediately improve the composition and give a better shape to the dog.

Left or Right?
Some dogs prefer to sit or lie with their rear end off to the right or left and, if you try and get them to change sides, they will shuffle back to what must be their natural and most comfortable position. Be aware of this and be prepared to adjust your camera angles, rather than continually trying to move the dog, otherwise you will end up with a stressed animal and no hope of a good photograph.

Avoiding the Slouch
Dogs can be like humans – when they sit, they slouch – and the whole essence of taking images of working dogs (or indeed any dog) is to give the impression of alertness and awareness. There are various tricks that can be employed to persuade the dog

to straighten its back and cock its ears: I find that small squeakers work wonders, but you must be ready to fire the shutter button as soon as you give the first squeak, as some dogs can lose interest in the noise and the moment can be lost. You may find that some gun dogs are oblivious to squeakers as they are used to loud noises when working in the field but, if you get the handler to hold a retrieving dummy, you will instantly see the dog straighten up ready for the command to 'fetch'.

Crackling an empty crisp (potato chip) packet can work well, as can a variation of human clicks and whistles. If the dog is proving difficult I find that my secret weapon – a small shepherds' whistle which I keep in my pocket and sometimes use for the purpose for which it was made – normally works. However, I find that if I get the owner to throw it up in the air and catch it, the dog will inevitably lift its ears as it tries to work out what's going on – a trick that will work nine times out of ten.

A three-quarter angle is the best position for a sitting dog, as it widens the chest and gives a better shape to the dog.

ENGLISH SPRINGER SPANIEL
Canon EOS D60; focal length 105mm; 1/250sec at f/5.6; ISO 400

WORKING WITH DOGS: **A DELICATE MATTER**

When sitting, male dogs can present the photographer with a problem, and this can be worse when they are un-neutered and a particular part of their anatomy becomes very apparent. Although a delicate matter, this is one that needs addressing. I don't think I need to go into graphic details but it is something that you should bear in mind, and how it is possible to exclude it from the photograph. You will basically have two options:

- the first is to take the picture and remove the offending appendage using the power of the clone tool in your image-manipulation software;

- the other option is to avoid photographing it in the first place. The technique I use is quite straightforward: I position my camera angle so that 'it' is hidden by one of the front legs. Simple and effective.

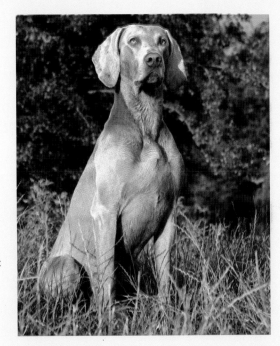

An un-neutered male dog can present the photographer with a delicate problem. Careful positioning of this dog's front leg has helped to hide the offending appendage.

WEIMARANER
Canon EOS D30; focal length 60mm; 1/250sec at f/5.6; ISO 100

Lying Down

Some dogs prefer to lie down and, once again, you will find that some will lie on their right side and some on their left. It can be a very difficult job to get them to change sides. This is the one position that I think can look good if the dog is facing the photographer straight on, although do not dismiss the side view, especially if you can get the dog at a slight angle. What does look strange, and can make the dog look very uncomfortable, is when the animal lies on its chest with its back legs either side of its body. If you observe a dog when it is relaxed at home it very rarely adopts this position, they much prefer to lie with both legs off to one side.

One big advantage of photographing dogs lying down is that it takes them that much longer to get up and run or wander off.

Some working dogs prefer to lie down. This can be an advantage to the photographer, as it will take the animal longer to get up and run off. Both the portrait and landscape format can work well.

ENGLISH SPRINGER SPANIEL
Canon EOS D60; focal length 50mm; 1/90sec at f/8; ISO 400

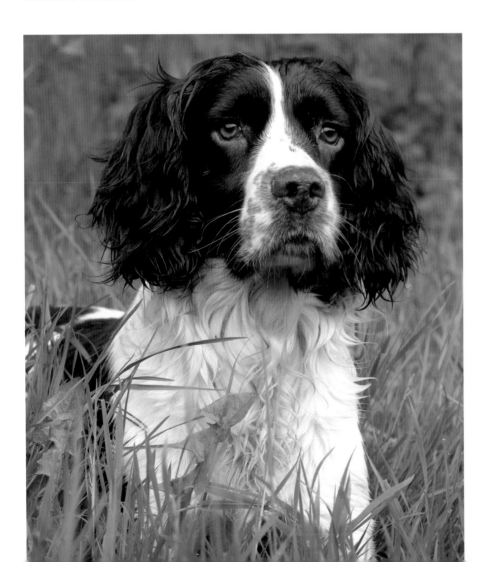

TECHNIQUE: **'HEAD ON PAWS'**

From the smallest to the largest breeds, all dogs have some common behaviour traits and one of them, my favourite, is the 'head-on-paws' pose. Some highly trained dogs can adopt this pose on command but, in reality, you will have to wait until your subject is relaxed enough and decides that it is time for a quick doze.

Commercially, this pose is a guaranteed sale; for the owner the subsequent image is one that oozes loyalty and faithfulness.

To Achieve the 'Head on Paws' Pose:

- lie down on your stomach, with the camera as low to the ground as possible;

- spread your elbows at a 45° angle, to create an improvised human tripod and provide a very stable platform for the camera;

- if the dog comes over to you, try giving the 'stay' command. Alternatively, use a zoom lens with a focal length of between 70–200mm; this will give you some room to manoeuvre without unduly disturbing the dog, and allow you a degree of flexibility when composing the image in the viewfinder;

- as the dog is static the shutter speed is not important, but do try and keep it equal to, or above, the value of the focal length of the lens: for example, a lens set at 200mm would need a shutter speed of 1/200sec. This will help to prevent camera shake (see also page 22);

- if the dog is lying slightly sideways-on to you, the main focus point will be the eye nearest to you. However, try and include the other eye in the picture as well, as it is more pleasing visually. If the dog is lying straight on, obviously both eyes then become the point of focus;

- aperture is critical and the nose and ear tips must be sufficiently in focus: long-nosed dogs such as greyhounds may need a narrow aperture for greater depth of field, whereas a short-muzzled dog, such as a boxer, may only need shallow depth of field.

RIGHT You will need to get right down to the dog's eye level, which will mean lying flat out on the ground. Use a longer lens to help prevent disturbing your subject.

ITALIAN SPINONIE
Canon EOS D60; focal length 117mm; 1/125sec at f/11; ISO 200

LEFT The mottled-grey colouring of this dog blended perfectly with the rocks and stones on a beach. As soon as I spotted this I knew that it would make a good black and white image.

COLLIE-CROSS-LURCHER
Canon EOS D30; focal length 145mm; 1/125sec at f/8; ISO 200

Gallery of
Working Dogs

From the beginning of time humans saw the dog as a working animal. It could be trained to hunt with its human partners, it could be trained to guard, and it could even be trained as a draught animal to pull carts.

Gun Dogs

I have to confess that I have a passion for photographing the gun-dog breeds: they are the largest group of dogs so they are in plentiful supply, and they come in all colours and sizes and demand to be photographed in the great outdoors. This gives the photographer endless opportunities to practise and perfect their techniques in both straight and artistic portraits, as well as more challenging action shots.

Fast reactions and tremendous stamina will be needed to keep up with these hard-working dogs, and time spent just observing them at work will pay dividends in the long run. The gun-dog breeds can be split roughly into three groups: retrievers, spaniels and HPRs (hunt, point, retrieve), the latter is a large group and in many ways is the most interesting to photograph.

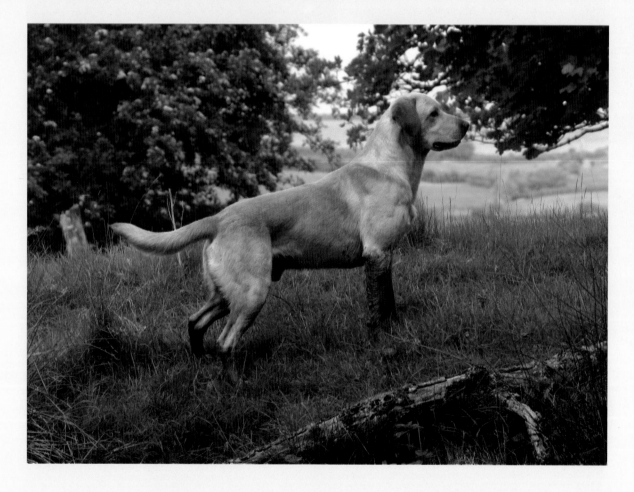

Gun dogs are in their element in the countryside.

GOLDEN LABRADOR
Canon EOS D60; focal length 210mm; 1/500sec at f/13; ISO 800

If you are photographing a working gun dog and you have good reflexes and understand the body language and behaviour of the dog, you may be able to capture a shot of the bird as the dog flushes it from its cover, and increase the chances of achieving a once-in-a-lifetime picture. Try varying the aperture setting to draw the viewer's eye to the main subject (the dog) and to throw the background slightly out of focus. The aim is to give a true 'dog's eye view'.

ITALIAN SPINONIE
Canon EOS D60; focal length 85mm; 1/500sec at f/6.7; ISO 400; exposure compensation of +1/2

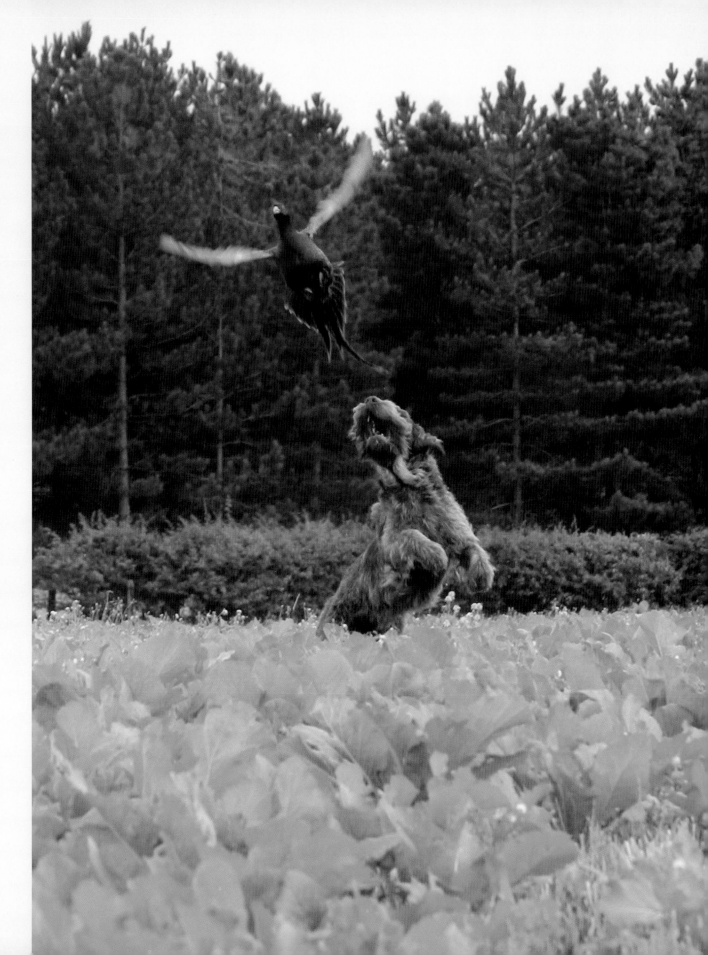

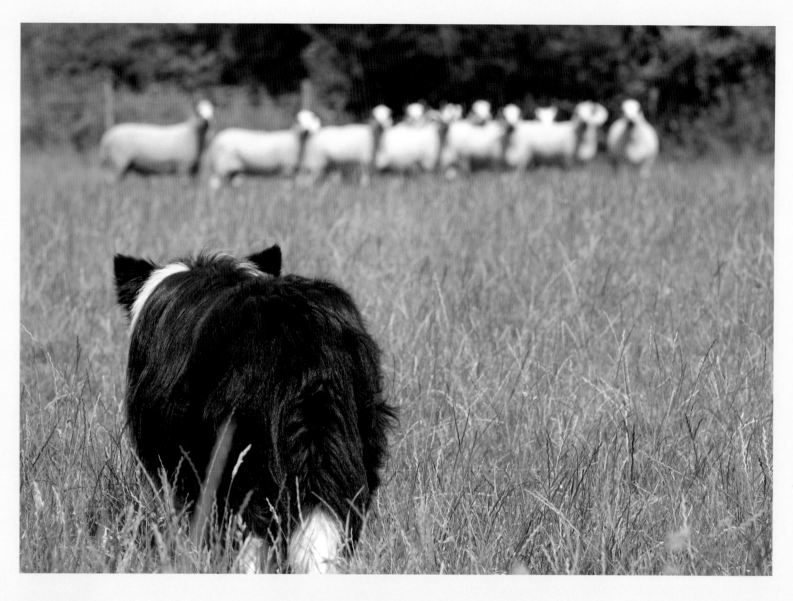

Herding Dogs

Over many hundreds of years the natural hunting urge that all dogs possess has been refined and breeds like the Border collie have been used to herd livestock. Instead of finding and killing the prey (sheep, goats or cattle), they bring it back to the leader of the pack (its human leader).

Today some of the traditional herding dogs, such as German shepherds, are known more for their guarding instincts, and there are probably more collies taking part in agility and obedience tests than there are herding livestock.

A low viewpoint is needed to capture the intensity of a herding dog at work.

BORDER COLLIE
Canon EOS D60; focal length 135mm; 1/180sec at f/8.0; ISO 100

Security Dogs

Unless you are very comfortable with dogs,
photographing the guarding or security breeds such
as German shepherds, Dobermans and Rottweilers,
can be a bit unnerving and even foolhardy. However it
is well worth the effort, as they are amongst the most
handsome of all the dogs.

BELOW
GERMAN SHEPHERD
Canon EOS D30; focal length 28mm; 1/250sec at f/9.5; ISO 200

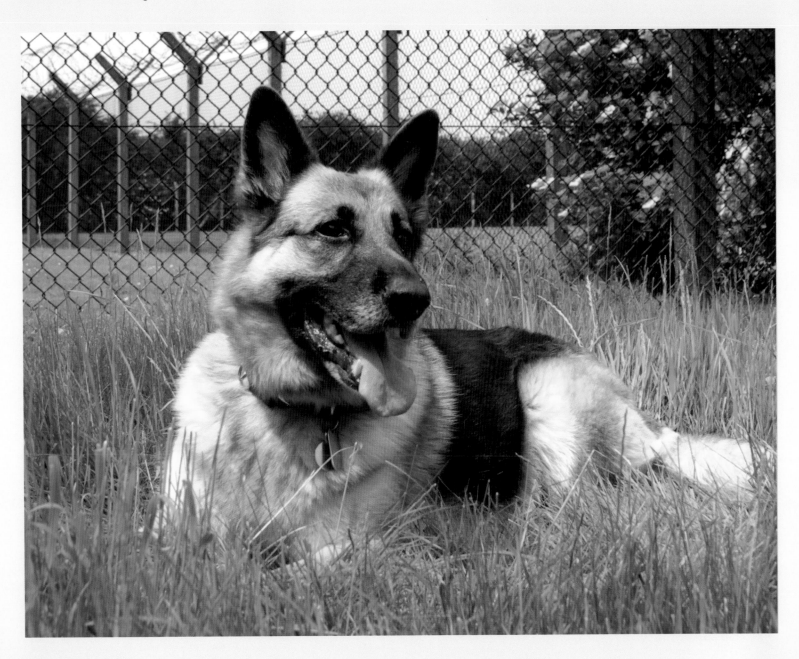

On the Move

Photographing working dogs working is all about fast action and intensity: dogs working at full speed or showing total concentration on the job at hand. Whether hunting, chasing, or herding, the dog is capable of moving at considerable speed, so you need to have very quick reflexes.

Body Shape

Ideally the running dog should be in full flow with front and back legs outstretched, or with its legs bunched up under the body. My perfect picture is when all four legs are off the ground and the dog is at full stretch, but this takes a lot of practice and a touch of luck to achieve on a regular basis.

Use a fast shutter speed of around 1/1000sec initially, as this freezes the dog in mid-action; then, as your timing and technique improve, try panning (see box on page 97) and using slower shutter speeds to increase the background blur and give a sense of movement.

Depth of field is not so critical if the dog is running parallel to the photographer; it is possible to get away with a wide aperture, providing the dog is running in a straight line across the frame. Lighting conditions and film speed will all have an effect on what aperture you use, so will the type of dog that you are photographing, as some dogs will run much faster than others. Practise, and be prepared to burn a lot of film to achieve good results. You will soon hit upon a formula that works for you, and will be able to pre-judge the final image.

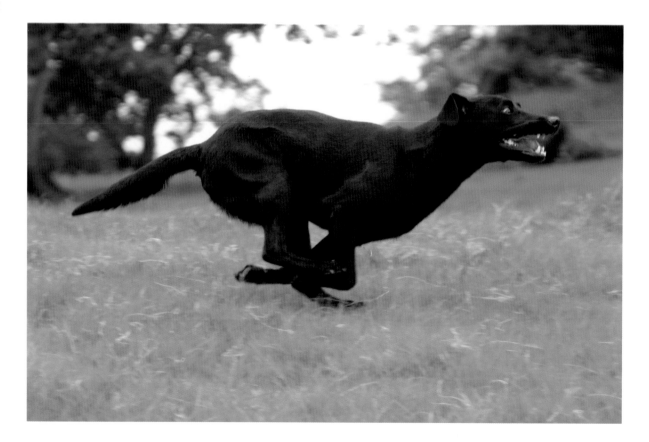

Aim to capture the dog with its legs tucked up under its body, or with all four feet off the ground and the legs at full stretch.

*BLACK LABRADOR
Canon EOS D60; focal
length 120mm; 1/750sec at
f/4.5; ISO 400*

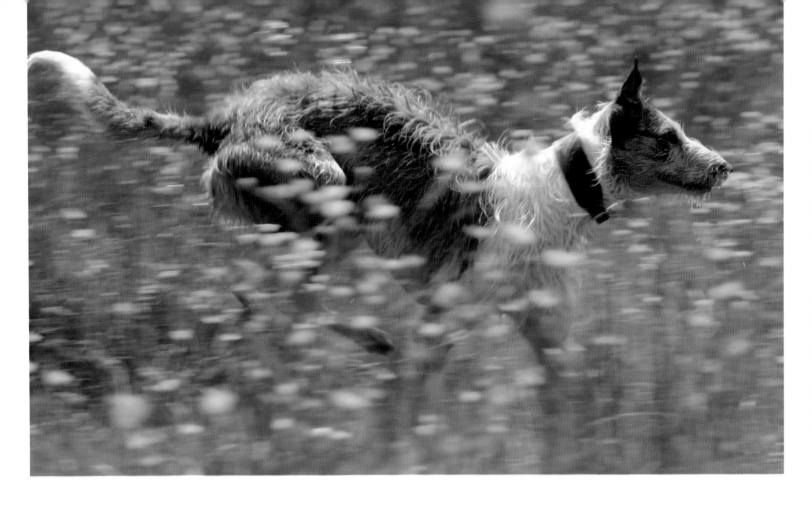

Tracking

This is the process of following the subject with the camera, or the camera's artificial intelligence, and keeping the focus on the subject up until the moment when you depress the shutter. The aim is to keep the subject in focus, so that you can take a photo at exactly the point you want. Most modern cameras are autofocus and some of the more advanced models have an autotracking mode. Depending on the manufacturer of your camera, this function may be given different names, but in essence it does the same thing: the focus point or points will pick up the subject and automatically adjust the focus of the lens in accordance with the speed and direction of the dog. If you camera doesn't have this facility, make sure the focus point remains over the subject.

Tracking side to side
When photographing dogs hunting, bear in mind that most experienced and well-trained dogs hunt in a quartering pattern (from side to side). Once the dog has settled, track it as it comes back past the handler and pick the right moment to take the images. Aim to shoot the dog as it runs into the direction of the light as, if you take the pictures with the sun at its back, the eyes and head fall into deep shadow and the images loses a degree of impact.

SHUTTER LAG

Some consumer-level cameras can suffer from what is known as shutter lag; this is a phenomenon where there is a delay in the shutter opening after the shutter button is pressed, which can result in the dog moving within the frame before the image has been recorded. Higher-specification cameras can work out where the dog will be at the point of the shutter opening, this obviously takes milliseconds to calculate but can significantly increase the success rate.

When using autofocus and tracking be aware that, should the ground cover be higher in places than the dog, the camera may shift the point of focus and you could well end up with great images of grass stems and an out-of-focus dog.

COLLIE-CROSS-LURCHER
Canon EOS D60; 1/250sec at f/8; ISO 100

95

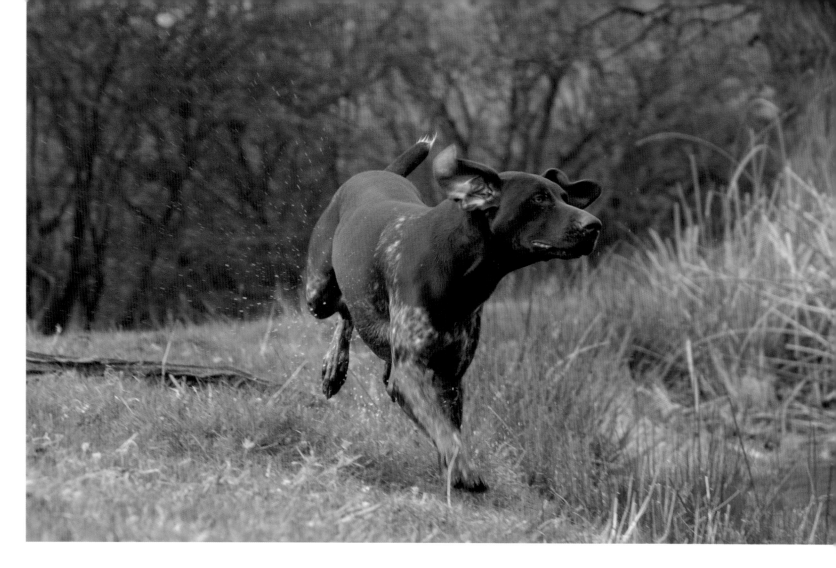

Tracking head-on Once you have mastered the skill of tracking and photographing a dog moving parallel to your position you can move onto one that is running straight towards you, which is significantly more difficult. The head-on viewpoint is really dramatic, especially if the dog is just about to turn and has started to lean over – for a really dramatic shot, aim to get at least one paw off the ground and watch out for some major ear movement.

If you are using an autofocus camera, the first problem you will find is that there is far less body mass for the focus points to lock onto, and this may cause the lens to 'hunt' as it tries to lock focus; obviously professional specification cameras deal with this situation better than cheaper models.

If there is little contrast between the dog and the background, this can also cause problems with autofocus; the classic example of this is a black Labrador against a dark

hedge or tree line – a problem further exacerbated if the light levels are low. The easiest solution is to try and find a different position (to increase the contrast), or you could use manual focusing, providing your camera and lens combination allows you to switch off the autofocus function.

Another factor to take into consideration when the dog is running towards you is that you will need a greater depth of field to make certain that the head and body are acceptably sharp. Use a narrow aperture to increase the depth of field, and remember that the closer the dog gets, the less depth of field you have available. Once again be prepared to experiment until you hit upon a combination that works. If you want to freeze the action, make sure that the shutter speed is at least 1/500sec. Slow shutter speeds and this perspective simply will not work, as the resulting image will merely look as though it is out of focus.

When tracking a dog that is running straight towards you there is less body mass for the camera to lock onto.

GERMAN SHORT-HAIRED POINTER
Canon EOS D30; focal length 135mm; 1/500sec at f/6.7, ISO 200

96

TECHNIQUE: **PANNING**

Now you've had the chance to practice your tracking technique you can move on to more exciting ground. The technique used for panning is similar to that used for normal tracking. Although it may take a while to get the results you desire, it is worth persevering as panning can really add life to an image.

Panning is simply a matter of following the subject from side to side with the shutter open. The aim is to keep the dog in the same part of the frame so it appears relatively sharp, while blurring the background to provide a sense of motion. You need to use a slower shutter speed than normally, as in this instance you want to show motion rather than freeze it, and follow the dog's movement with the camera.

- Stand with your legs slightly apart and swivel from the waist, turning to either the right or left so that you face an angle of about 45°. With your legs and feet firmly in place, twist from the hips while pressing the shutter button.

- Keep the moving dog in the same part of the camera frame as you follow its movements. Practise until you feel comfortable with the swinging movement and then load up with some film and start taking pictures.

As you become more proficient you can develop this technique to pan whilst kneeling. This can produce some extraordinary images as you will be at the dog's eye level. Panning can be quite addictive so be warned!

Perfect the technique of panning and you will be able to capture some stunning action images. Here I used a relatively slow shutter speed to emphasize the feeling of speed and motion and, as the light conditions were very poor, a fast film setting.

ENGLISH SPRINGER SPANIEL
Canon EOS D60; focal length 117mm; 1/125sec at f/8; ISO 800

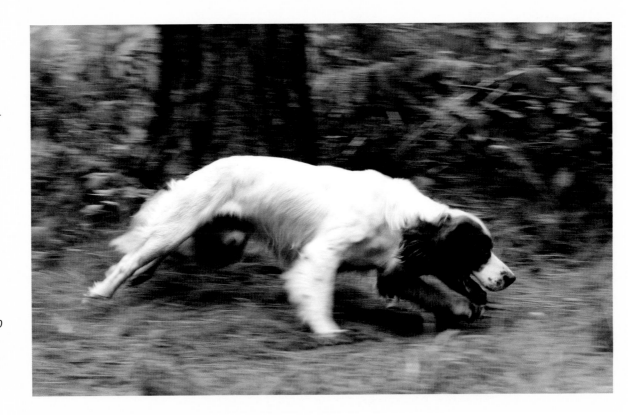

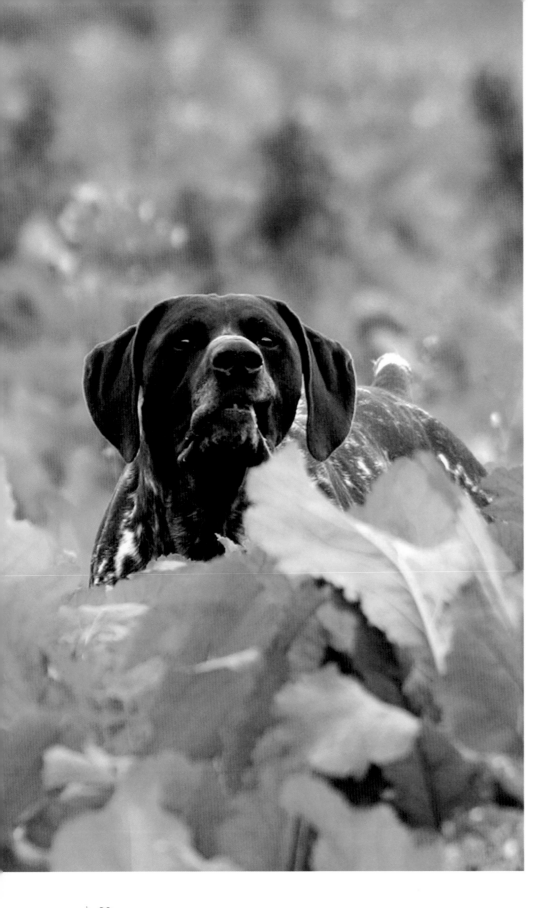

Capturing Mood

Whether a dog is herding sheep or hunting a rabbit, it does it with great intensity, and this is what the photographer should always strive to capture. Some breeds of gun dog, such as pointers, naturally stand transfixed when they get wind of their quarry. Even the most inexperienced dog person will acknowledge that there is something special about the way that collies and other herding breeds use the strength of their stare to hold or move a flock of sheep. Capturing this on film is not difficult, but you need a good understanding of the dog and its work, and the ability to anticipate and read its body language.

Alertness and Concentration

The obvious viewpoint for this kind of image is into the dog's face, showing the intense concentration. In most cases this will produce a first-class image, but constantly be on the lookout for something different.

Dogs work with great intensity and this is something that the photographer should try and capture on film.

GERMAN SHORT-HAIRED POINTER
Canon EOS D60; focal length 270mm; 1/500sec at f/5.6;
ISO 400

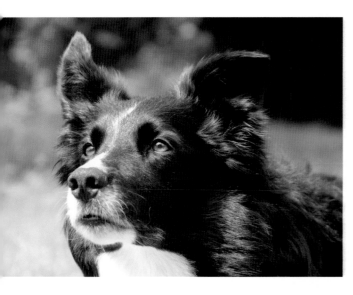

ABOVE This dog is totally focused on a flock of sheep and is using the strength of its stare ('the collie eye') to move them towards the shepherd. A head-on viewpoint has increased the visual impact of the image.

BORDER COLLIE
Canon EOS D30; focal length 109mm; 1/350sec at f/6.7; ISO 400

RIGHT A dog herding sheep is the perfect scenario for including the wider environment. Try to position yourself towards the back of the dog, looking forwards, and use a wideangle lens. Here a wideangle lens and a different viewpoint give a dog's eye view of events.

BORDER COLLIE
Canon EOS D60; focal length 35mm; 1/180sec at f/8; ISO 100

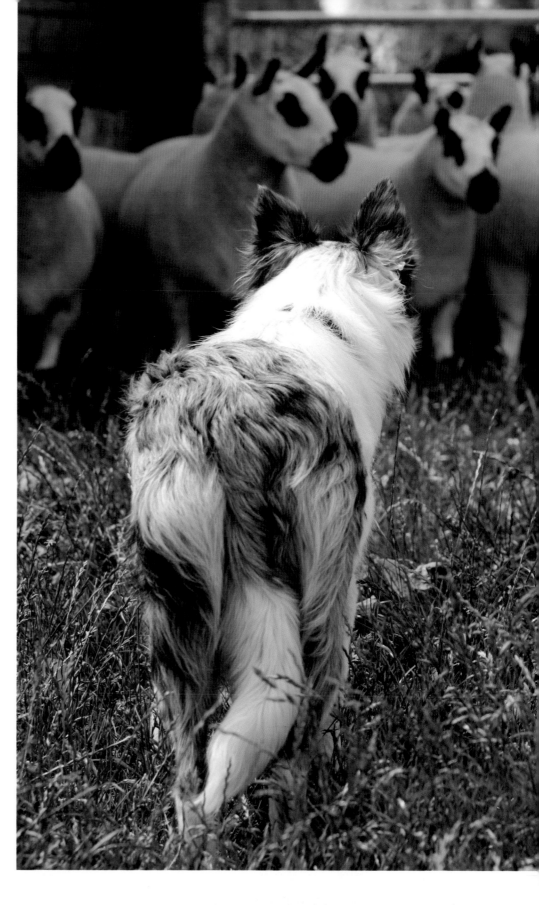

Working in Water

This can be the most exciting and visually spectacular of all the working dog images. The dog doesn't have to be working, however; it could just be having fun, so these techniques can apply equally well to a pet.

The Right Spot

Finding the right location is important. If you are covering a working test involving water, then you will obviously have to work within the parameters of a chosen spot, which in truth may not only be testing for the dog but also for you. Ideally you want a sloping bank with little, or preferably no, vegetation to obscure the dog as it jumps into the water; this also makes panning with the dog easier (see page 97). Find a firm and safe location close to the waterside and ask the handler to position the dog at least 5m (15ft) away from the water, giving you enough time to

(see page 97)

SAFETY WARNING

Water and camera electronics must not mix, so take great care when photographing near water, especially if you are standing on a bank which is slippery or unfirm.

lock onto the dog and track with it as it runs towards the water. It is normally better if the handler throws either a ball or a retrieving dummy into the water straight ahead of their position. Most dogs will tend to run in a straight line to retrieve the object, so this will increase the odds that you will be able to follow the dog with the camera.

Most dogs like water and the canine photographer should take full advantage of this desire to get wet.

GOLDEN LABRADOR
Canon EOS D60; focal length 260mm; 1/500sec at f/9.5; ISO 800

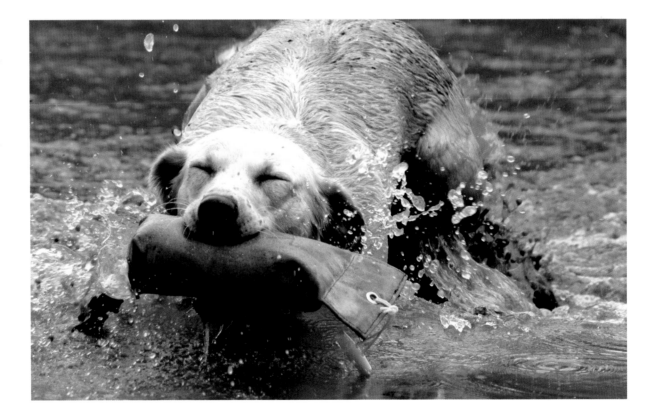

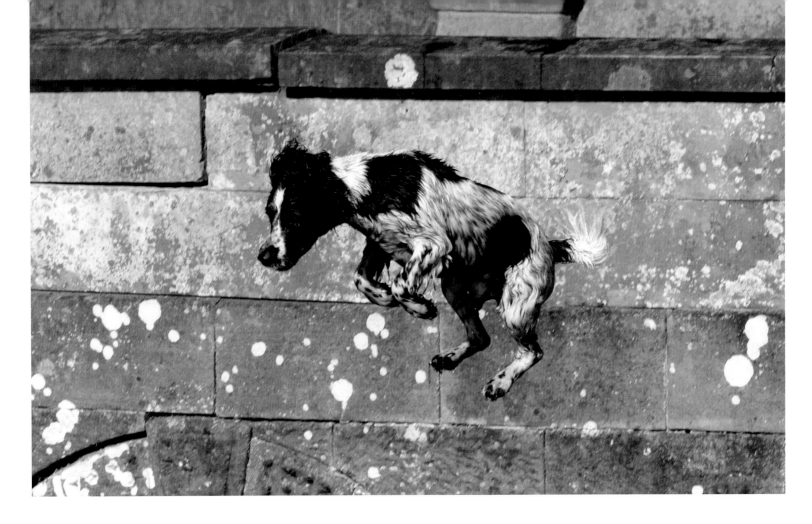

The Launch

Photographing dogs working in and around water can give three distinct groups of shots – the launch, the swim and the landing. If you want to produce images with the 'wow' factor, then capturing a dog in mid-air as it launches itself into a river or lake will almost guarantee admiration from fellow photographers and dog owners alike. To be consistently successful at this does take a lot of practice, and even then the hit rate may not be particularly high. Fast reflexes and sound photographic techniques will be needed, but once mastered the images will speak for themselves.

Viewpoint Getting the right viewpoint can make all the difference to this kind of photo: position yourself too far behind the dog and all you will see is its back and little else. By far the best position is either in front or directly to the side, as this will enable you to photograph the dog as it lands or as it is suspended in mid-air over the water. If the location is a river – and providing it is

not too wide – you could take your photographs from the opposite bank, but you will almost definitely have to use focus-lock (see page 40). The position of the sun can also have an effect: ideally, persuade the dog to jump into the light; failing that, position yourself so that the sun comes over your shoulders, to get as much light on the dog's face as possible.

EQUIPMENT: **WHICH LENS?**

Ideally, you should use a medium telephoto lens with a focal length of between 70 and 200mm for this type of shot. This will help to give you sufficient working distance from the dog, and also help to prevent water splashes on your camera.

Fast reflexes and sound photographic techniques are needed when photographing dogs in and around water but, once mastered, the images will speak for themselves. The launch is especially challenging.

ENGLISH SPRINGER SPANIEL
Canon EOS D60; focal length 170mm; 1/1000sec at f/11; ISO 800

TECHNIQUE: **HOW TO GRAB THE PERFECT 'LAUNCH' SHOT**

One problem that can occur when a dog launches itself into the water is that the point of focus (i.e. the dog) can shift and the camera lose contact, resulting in an out-of-focus photo. There are a couple of ways to help combat this: the first is predicting the shot, the second is to use what is known as 'pre-focusing'.

Predicting the Shot

'Getting your eye in' is a phrase that many sports people use; it simply means that when you start your chosen discipline it takes a few minutes for the body and mind to coordinate, and photographing dogs in action is no different. Once you have seen the dog jump you can pre-judge how high and how far it will leap, and the autotracking mode of your camera – if it has one – can be used quite successfully, as you will be ready for the focus shift and able to follow the dog.

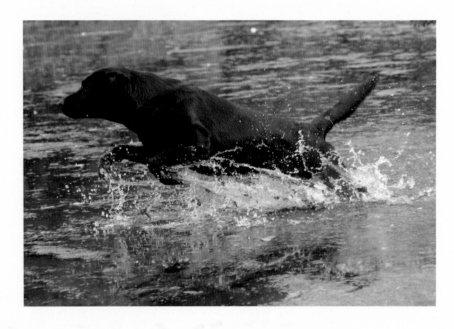

ABOVE Some dramatic images can be taken as the dog powers itself through the shallows of a lake or river. Track the dog and try and time the shot just as the front legs leave the water.

BLACK LABRADOR
Canon EOS D60; focal length 75mm; 1/1500sec at f/5.6; ISO 400

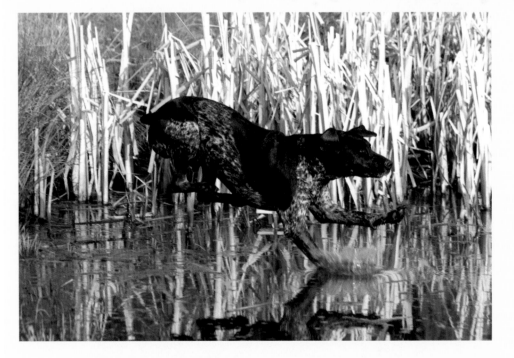

LEFT 'Walking on water': a bit of luck, plenty of practice and perfect timing. Get it right and your pictures do the talking.

GERMAN SHORT-HAIRED POINTER
Canon EOS D60; focal length 100mm; 1/1000sec at f/5.6; ISO 400

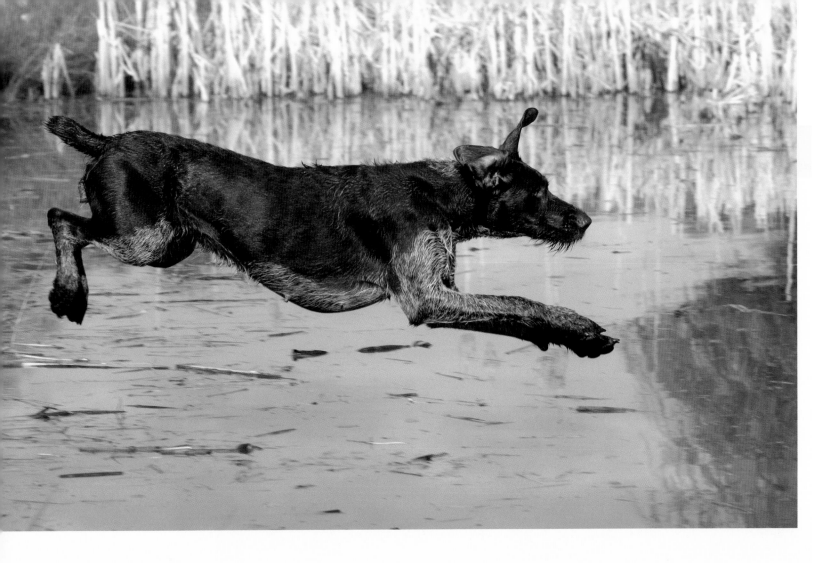

'Pre-focusing'

Another technique that you can use, if autofocus fails in this situation, is pre-focusing. In fact pre-focusing is a useful weapon in your armoury for any photograph, especially where dogs on the move are concerned.

'Pre-focusing' involves focusing the camera on the place where you think the dog will be when you take the picture. Depending on your camera this can be done either manually or automatically, by choosing an object at the same distance and focusing on that (see pages 40–1). In the case of the launch this can be tricky as it can mean focusing on thin-air. Once you have 'pre-focused' all that remains to be done is to press the shutter button when the dog reaches the right point. After a few attempts you should be better at gauging distance and your results will improve.

As the dog jumps into the water the point of focus will shift, so you may need to pre-focus to help increase your hit rate.

GERMAN WIRE-HAIRED POINTER
Canon EOS D60; focal length 90mm; 1/1500sec at f/8.0; ISO 400

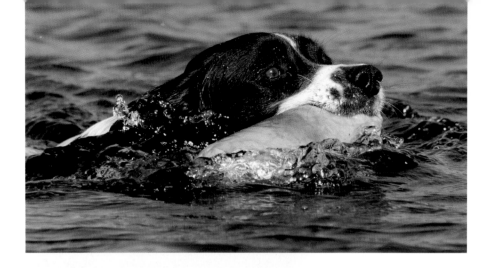

The Swim

Dogs use a lot of power when they're swimming, and photographers should endeavour to capture this in their pictures. Dogs do not normally swim very fast, so following them with the camera is not difficult; focusing should not really be an issue, and whether you are using an autofocus or manual lens, it should be possible to achieve sharp images without much difficulty.

Shutter speeds do not have to be very fast but, if you do use speeds of faster than 1/500sec you can visually freeze some of the water movement, and this can really add another visual dimension to the image.

The Retrieve
If the dog is swimming out for a retrieve, time your shot so as to include the object in the picture. Another good photographic opportunity is the moment when the dog opens its mouth to grab the article – timing is all important. Unlike the launch shots, photographing the back of the dog as it swims can be quite effective if you include the retrieve in the picture.

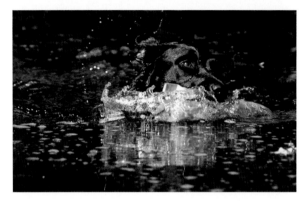

Try to get down as low as you can and aim to include the retrieve in the image. Use a fast shutter speed to freeze the water drops.

ABOVE
ENGLISH SPRINGER
SPANIEL
Canon EOS D60; focal length 300mm; 1/750sec at f/9.5; ISO 400

ABOVE LEFT
BLACK LABRADOR
Canon EOS D60; focal length 275mm; 1/1500sec at f/5.6; ISO 400

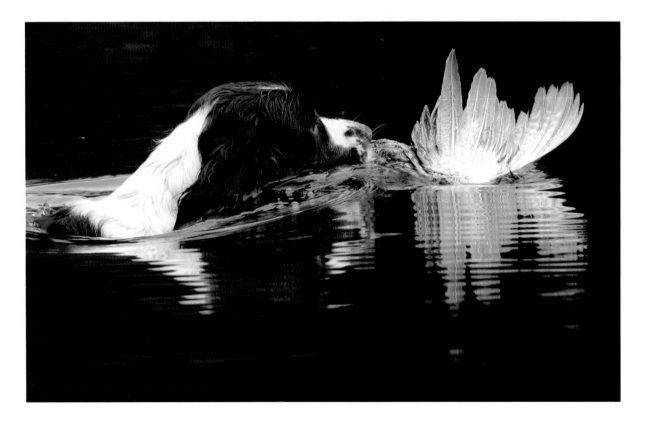

LEFT
ENGLISH SPRINGER
SPANIEL
Canon EOS D60, focal length 220mm, 1/500sec at f/6.7, ISO 800

Rescue Dogs Dogs have been trained to undertake all kinds of tasks, and this has resulted in selective breeding to enhance the dog's physical attributes. Newfoundland dogs, for example, have been specifically trained and bred to rescue people from the water and even to tow stranded boats. There are numerous tests held throughout each year, and these can be good opportunities for photographers. Focus on the dog and use a wider aperture setting that will throw the human slightly out of focus.

BELOW
NEWFOUNDLAND
Canon EOS D60; focal length 260mm; 1/500sec at f/8; ISO 400

RIGHT
NEWFOUNDLAND
Canon EOS D60; focal length 400mm; 1/750sec at f/8; ISO 400

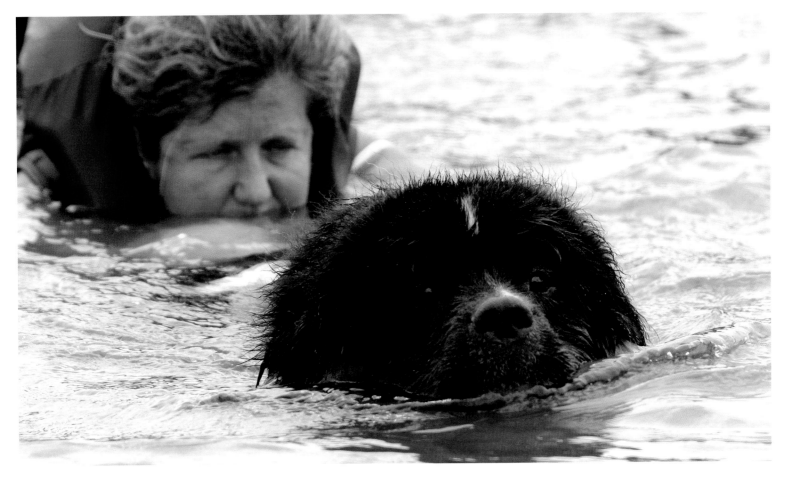

TECHNIQUE: **REFLECTIONS**

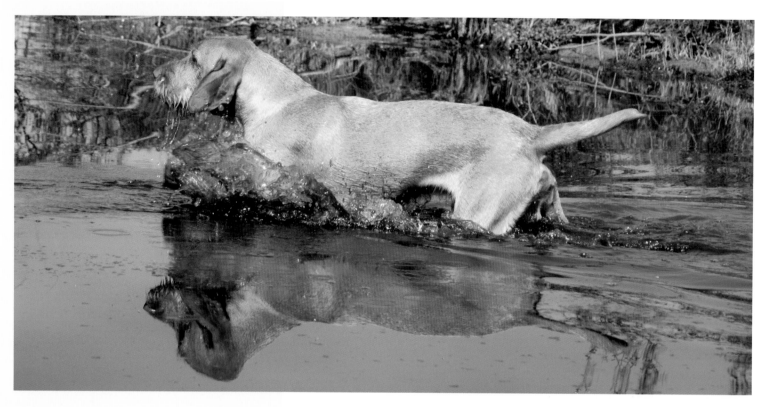

HUNGARIAN VIZSLA
Canon EOS D30; focal length 300mm; 1/250sec at
f/9.5; ISO 200

When the dog is in water, always look out for a good reflection. These work best when the light is bright, but the base reflection in the water is dark; this normally occurs when there is heavy vegetation on the banks and this is reflected in the water surface. If the conditions are right, you can produce an image with a perfect copy of the dog in the water. It can be great fun to ask people which way they think the picture should be displayed – normally the giveaway is the wake in front of the dog that is created as it swims.

EQUIPMENT: **POLARIZING FILTERS**

Polarizing filters are available as linear or circular polarizers. Always buy the circular type, as autofocus systems will not work with a linear polarizer. Polarizing filters work in the same way as polarizing sunglasses, and cut out reflected glare. By reducing this glare you can make reflections look clearer. Fit the polarizing filter to the front of your lens and – while looking through the viewfinder – rotate it until you get the desired effect. You should also be aware that polarizers can darken the image slightly so it's a good idea to experiment with different levels of polarization.

The Landing

Trained gun dogs are conditioned not to shake as they leave the water but sometimes they just cannot resist it, and many other dogs will shake as soon as their feet touch terra firma.

If you have a choice of position, try to get a dark backdrop and then the water drops will be highlighted, especially if the sun is shining; once again, use a fast shutter speed to freeze the water in mid-air.

Another, slightly different approach is to face into the sun then, as the dog shakes the surplus water from its coat, the drops will be backlit and look as though they are glowing. Use a slower shutter speed of around 1/30sec to give the picture a feeling of movement (see pages 30–1).

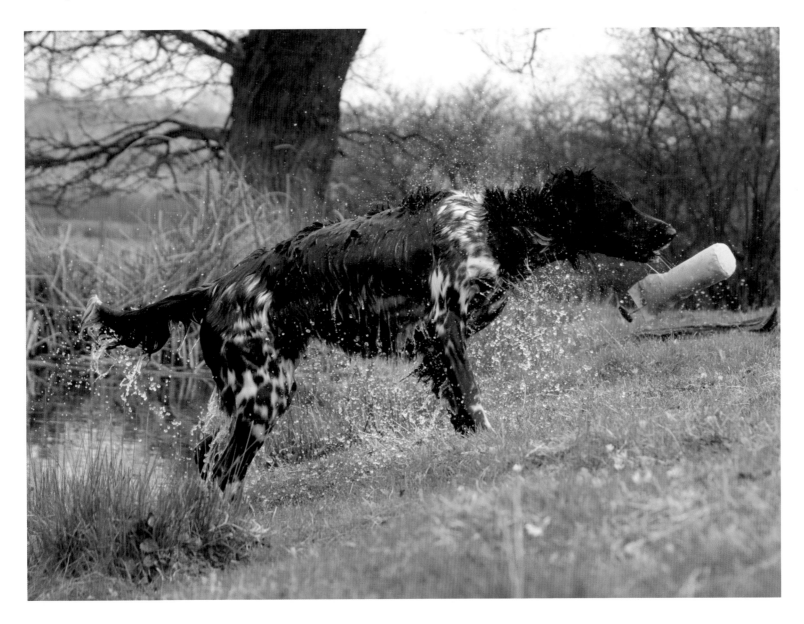

GIANT MUNSTERLANDER
Canon EOS D30; focal length 75mm; 1/750sec at f/5.6; ISO 400

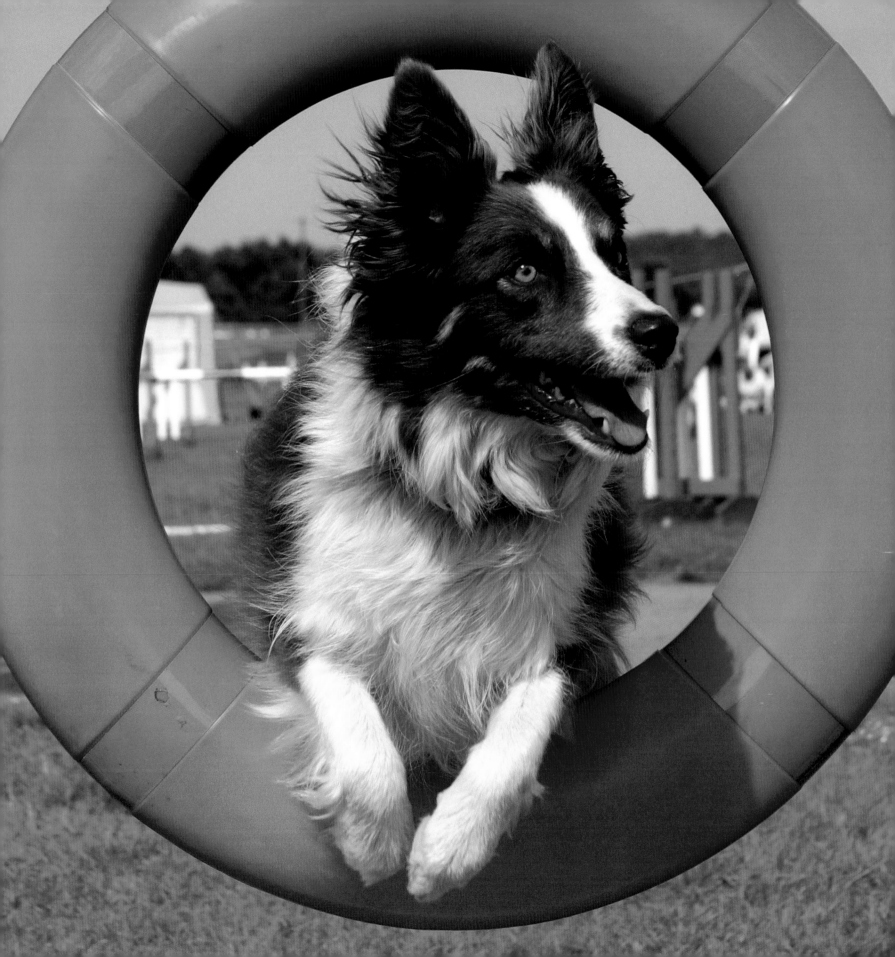

Dogs Having Fun

One of the greatest joys of having a dog is that at some point during the day you can take them out to the local park or woods for some exercise. Quite often this will involve a game of chase the ball or catch the frisbee. If you are a bit more serious about 'playtime', you and your canine companion may be involved in one of the numerous agility or flyball clubs and competitions that take place each weekend. For the photographer, these activities really stretch the skill level to the limit, as they are normally undertaken at breakneck speed and they give little margin for error. There are some techniques that can help improve the hit-rate, but at the end of the day it is practice and practice alone that will increase your success rate, so be prepared to use a lot of film.

Chasing a Ball

The technique of photographing a dog chasing a ball is similar to photographing any dog on the move (see page 94). However, your timing will have to be razor sharp; not only will you want to ensure that the dog is captured in full flow, but you will also want to record the ball in the image, preferably just as the dog tries to grab it from the air.

As mentioned in the Introduction to this book, the increase in digital imaging has made it very easy to 'copy and paste', and so create illusions. Personally I derive more enjoyment and satisfaction by trying to get the shot right the first time, rather than manipulating it on computer afterwards. I'd also recommend beginners to try the traditional methods first, as this is the best way of improving your technique.

Your timing and technique will have to be spot-on to capture the dog in full flow as it tries to grab a ball out of the air.

BORDER COLLIE
Canon EOS D30; focal length 135mm; 1/1000sec at f/8; ISO 400

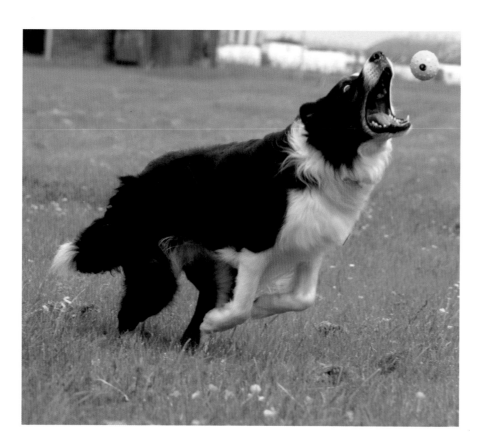

TECHNIQUE: CATCH SHOTS

To achieve this shot, you will need help in the form of a handler/ball-thrower. Ask the handler to take the dog to one side of you at an angle of about 45°. Position them at least 10m (30ft) in front of you and at least 15m (45ft) to one side, so that you have enough time to focus on the dog.

To freeze the dog and the ball, set a shutter speed of no less than 1/1000sec; if the dog is very fast, you may need to increase this to prevent any motion blur.

Stand with your feet slightly apart and swivel your hips so you are facing the handler and dog. When you are ready, ask the handler to throw the ball parallel to you so that the dog will run across in front of your position. If your camera has an autotracking function, make sure that it has locked-on to the dog before it starts to run. Now comes the tricky bit. To make sure that you have a chance of including both the dog and the ball in the picture, the handler will have to throw the ball and allow the dog to give chase straightaway. Preferably, the ball should be thrown quite hard towards the ground, so that it bounces in front of the dog. Pan with the dog and press the shutter button; if your camera has a motorized film advance keep firing until the dog has the ball.

It is also worth experimenting with another method: persuade the dog to stand in front of the thrower, get level with the dog and pre-focus on the dog's body, then ask the handler to throw the ball high into the air towards the dog. Quite often the dog will jump up to catch the ball: this is the time to take the picture, once again use a fast shutter speed (see pages 30–1).

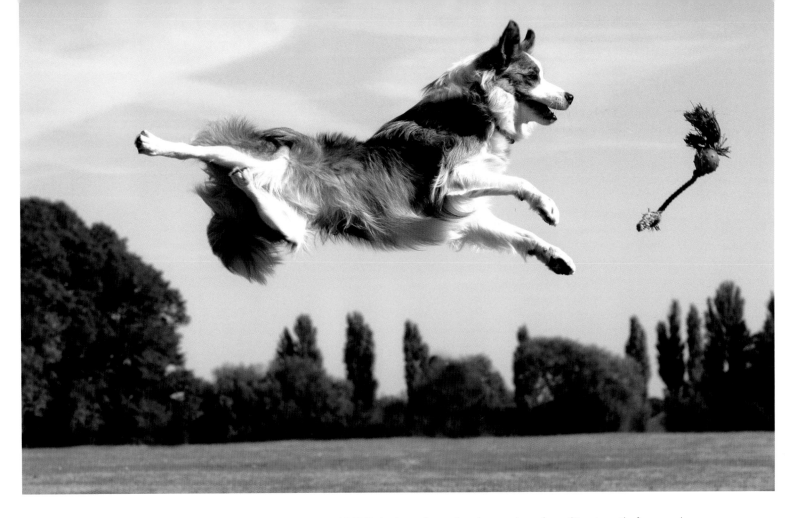

ABOVE A picture is worth a thousand words: agility, strength, fun, suppleness – this picture says it all.

BORDER COLLIE
Canon EOS D60; focal length 100mm; 1/750sec at f/9.5; ISO 400

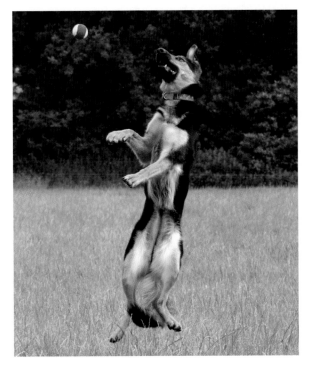

LEFT Try photographing the dog as it jumps up to catch a ball. Use a fast shutter speed for this and be prepared for the ball to shoot out of the dog's mouth if it misjudges its strike.

GERMAN SHEPHERD
Canon EOS D60; focal length 100mm; 1/1000sec at f/8; ISO 400

EQUIPMENT: **WHICH LENS?**

Ideally you will need to use a zoom lens with a focal length of between 70 and 200mm, as this will give you some flexibility when framing the dog running. If you only have a shorter lens, then simply reduce the distance between yourself and the dog.

The Flying Frisbee

In the USA it is commonplace for dogs to catch frisbees as a sport and national competitions are held throughout the year. In the UK this sport isn't as widespread, so the opportunities to photograph dogs chasing these plastic disks is limited but, if you have the chance, it is possible to take some fantastic pictures.

Although you will need to have mastered the skill of tracking and understand the relevance of shutter speeds to be successful, it is probably more important to understand how best to set up your shots. It took me a long time to realize that to ensure that I could consistently photograph a dog in mid-flight trying to catch a frisbee required two things: a good thrower and a very slight breeze. The thrower needs to be able to fling the disk so that it flies very level; it does not need to travel very far and the lower to the ground the better. The disk should be thrown into the breeze, as this helps to hold the frisbee in the air and gives the dog more chance of catching it. Position yourself exactly the same as photographing a dog chasing a ball (see page 110) and set a fast shutter speed. Once again, be prepared for the frisbee to fly out of the dog's mouth if it misjudges its strike.

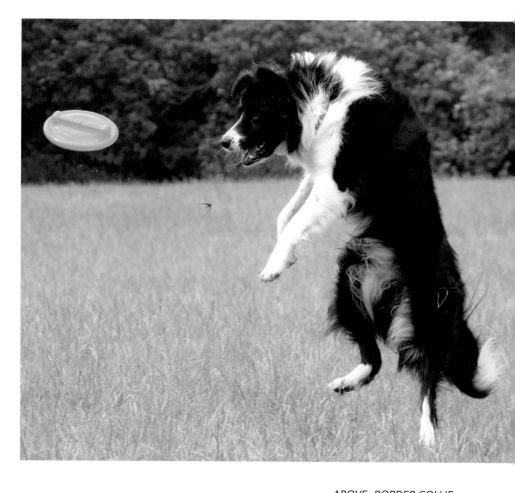

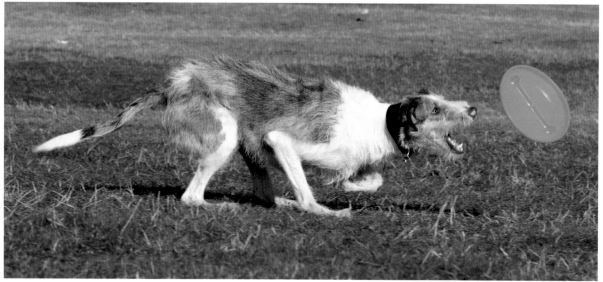

ABOVE BORDER COLLIE
Canon EOS D60; focal length 115mm; 1/750sec at f/8; ISO 400

Capturing good frisbee images depends not only on good photographic skills, but also sound flinging techniques.

LEFT
COLLIE-CROSS-LURCHER
Canon EOS D60; focal length 70mm; 1/1500sec at f/8; ISO 400

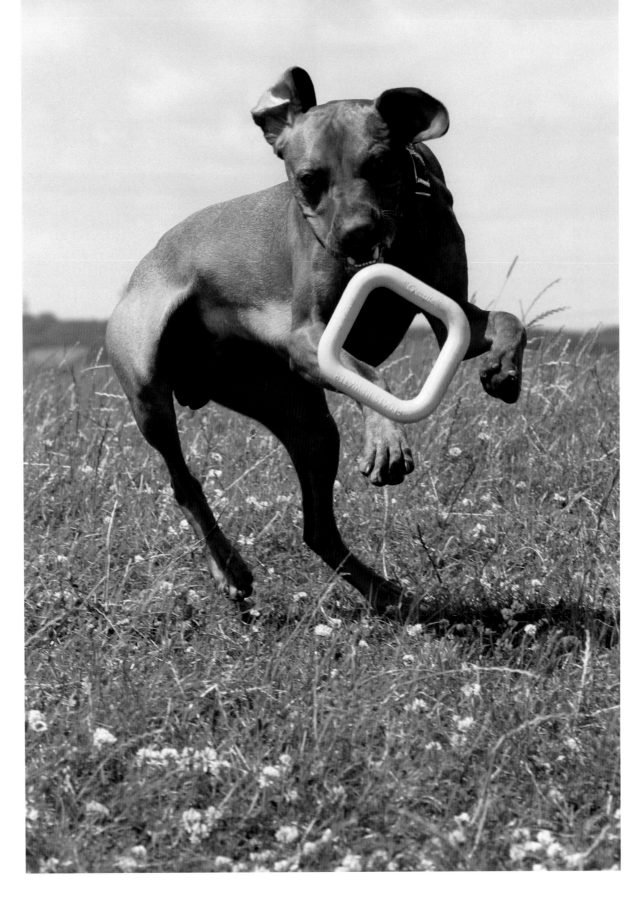

HUNGARIAN VIZSLA
Canon EOS D60; focal
length 90mm; 1/1000sec
at f/8; ISO 400

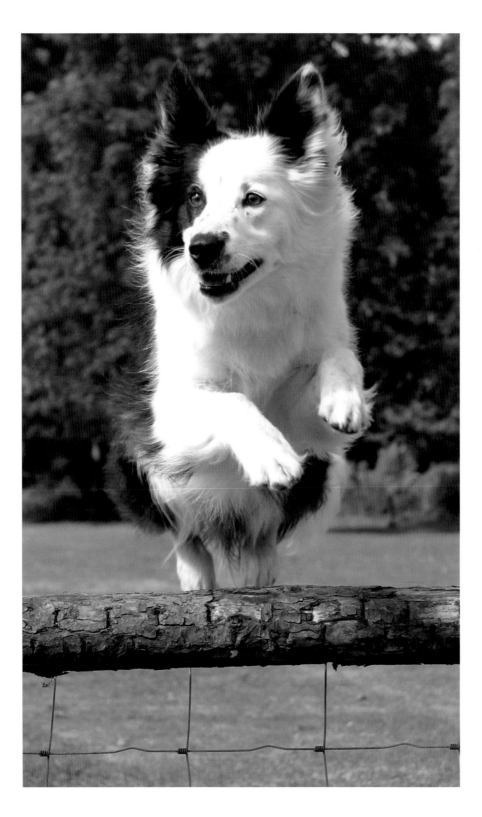

Agility and Flyball

Anybody observing the dogs at agility or flyball competitions will be left in little doubt that they consider these high-octane activities as simply another doggy game, although the owners may take a slightly different view. Both disciplines involve the dogs running at full speed and jumping over or through a series of jumps or obstacles. At the end of the flyball course the dog hits a small ramp and a tennis ball flies out, the dog catches it and runs back to the owner.

Whether you are at an agility or flyball competition, the best way to increase your success rate is to pre-focus on a jump and fire the shutter button as the dog leaps into the air. With agility competitions you can focus on the horizontal bar and, assuming your camera has a focus-lock function, recompose the picture and wait for the dog to arrive. You will need a shutter speed of at least 1/1000sec and preferably a medium aperture; this will give a slightly increased depth of field to accommodate the dog coming over the bar and keep it in focus. The best images are taken just as the dog takes off, or when they are on top of the jump; with practice you will be able to pre-judge when to fire the shutter button.

The agility of the dog is tested to the limit during the speed and excitement of these high-octane events, and you will need to muster all your skill and experience to achieve a successful shot.

BORDER COLLIE
*Canon EOS D60; focal length 44mm; 1/500sec at f/4.5;
ISO 200*

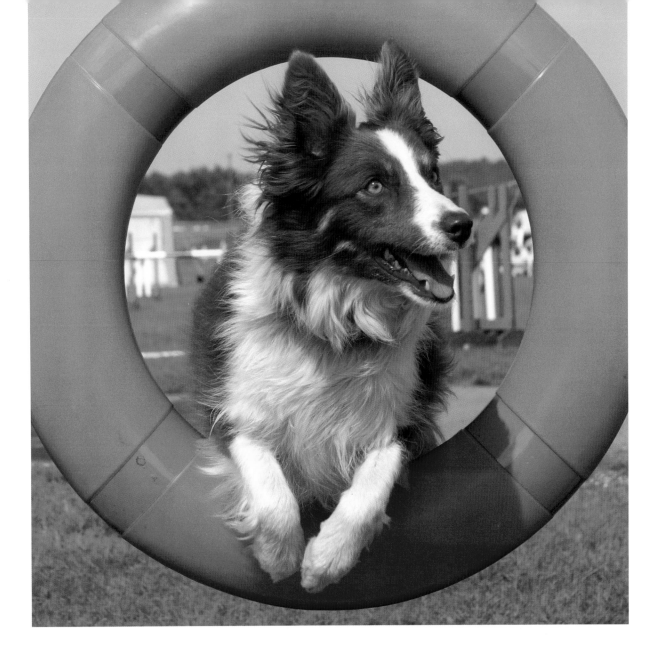

It is quite difficult to achieve a good composition with a tyre-jump picture, as the dog needs to jump through the middle of the tyre and the photographer must fire the shutter button before it drops its front legs – a tricky combination.

BORDER COLLIE
Canon EOS D60; focal length 60mm; 1/1000sec at f/8; ISO 400; exposure compensation of +1/2

Agility

There are a number of different obstacles in an agility course, apart from hurdles: tyre and long jumps and, the most difficult of all, the weaves; all are worthy of the photographer's attention. The tyre jump can be a difficult one to get right, not because of the photographic skills that are needed, in fact that side is very easy, but compositionally it can look clumsy so, if you have the opportunity, it is better to set up the shot. Ask the owner to sit the dog in front of the jump and then to stand immediately behind you on the opposite side. Pre-focus on the lip of the tyre and ask the handler to call the dog, then press the shutter button just as the dog enters the tyre. Any sooner and a shadow will be cast over the dog, any later and you will find they drop their front legs ready for the landing.

The best images are produced when the dog jumps slightly high and comes right through the centre of the tyre, but many competition dogs are trained to be as fast as possible and jump tight to the base of the jump in an effort to save time, which doesn't make such a good photograph.

Long jumps can produce extraordinary images of a dog in mid-air stretching to reach the end of the jump. Use the panning technique along with a fast shutter speed and, if your camera has a motor wind, keep the shutter button pressed until the dog lands.

Weaves

The weaves are the hardest agility discipline to photograph. The first problem is that the dogs travel as fast as they can, the second is that in most cases the handler stays very close to the dog to guide it through the poles. And finally, and probably the most difficult to deal with, is that each dog will start the obstacle from a different side. Therefore it can make pre-focusing on a particular weave awkward as, if you misjudge it, you will only end up with the back of the dog. On the other hand, if you are successful the resulting image can be quite dramatic.

The best way to photograph the weaves is to pre-focus on one of the last poles and set as fast a shutter speed as the conditions allow. Timing is crucial and you need to fire the shutter button just as the dog turns into the focus area. This is one discipline that needs plenty of practice and can be very hard to master on a regular basis.

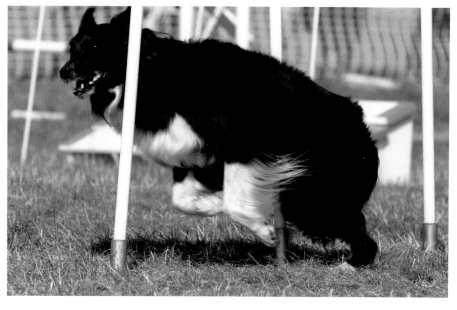

Of all the agility obstacles, it is most difficult to obtain consistent results with the weaves.

BORDER COLLIE
Canon EOS D60; focal length 180mm;
1/1000sec at f/6.7; ISO 200

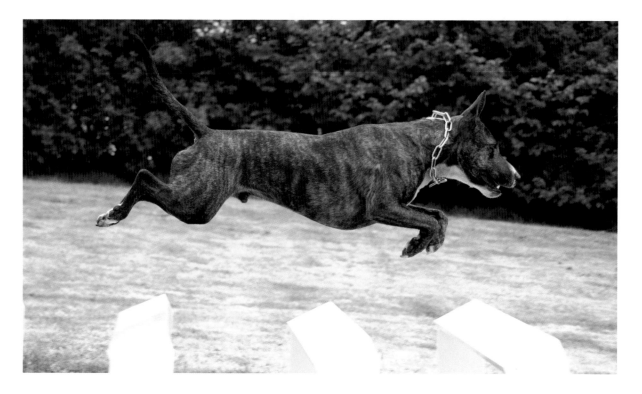

Use a panning technique and fast shutter speeds to capture the dog as it leaps to clear the long jump. If your camera has a motor wind, keep firing until the dog lands.

ENGLISH BULL TERRIER
Canon EOS D30; focal length 56mm; 1/1000sec at f/4.5; ISO 40

Pre-focus on the bar and this will help to increase your hit rate. Keep the shutter speed to at least 1/1000sec and practise until your timing improves.

BORDER COLLIE
Canon EOS D60; focal length 180mm; 1/1000sec at f/11; ISO 400

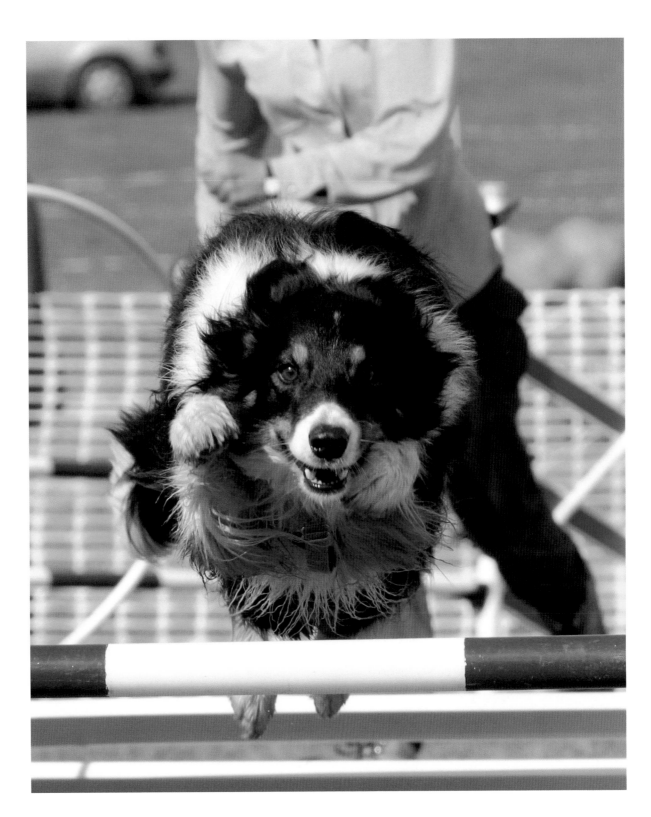

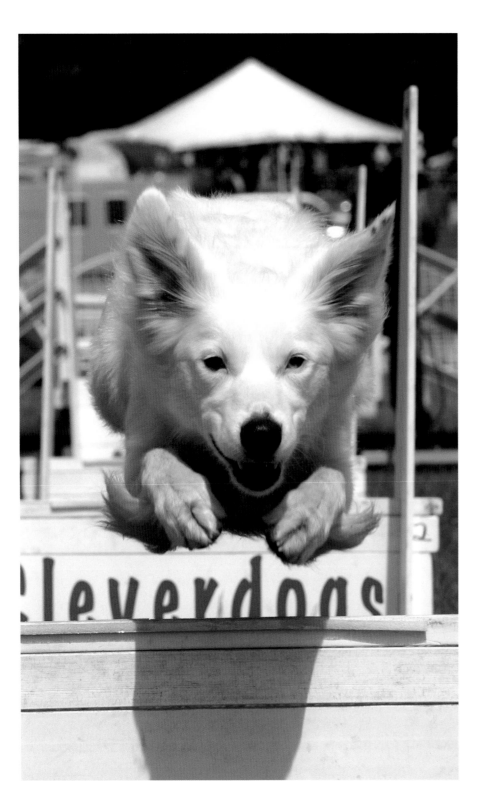

Flyball

Flyball needs a slightly different approach. I would suggest that the most dramatic images are taken head-on as the dog runs towards the box, and I always use the second-to-last jump as my point of focus. Unlike agility, you will need to pre-focus just in front of the jump, say about 8cm (3in) (see page 110). If you don't do this the dog's head may be out of focus. This is because the hurdles are lower and the dogs only take three or four strides between each one and, by the time they have jumped their heads will be past the focus point. You should also think about setting a narrower aperture to increase the depth of field (see pages 28–9) although this may not be possible if you are using a fast shutter speed to freeze the action (see pages 30–1).

Timing is critical, so do not wait until you see the dog at the jump before firing the shutter button, or it will be gone before your brain has sent the message to your finger. You need to fire the shutter button just as the dog lands at the previous jump – it takes a spilt second for it to reach your hurdle, but you can pre-empt its arrival and the more you practise the better your timing will be and your success rate will soar.

Flyball really is fast and furious and the best images can be obtained as the dog runs towards the ball box and is in mid-air over the hurdles. The pre-focus approach is the best option but, unlike agility, you need to focus about 8cm (3in) in front of the hurdle because of the speed at which the dogs are running.

CROSSBREED
Canon EOS D60; focal length 56mm; 1/1000sec at f/6.7; ISO 400

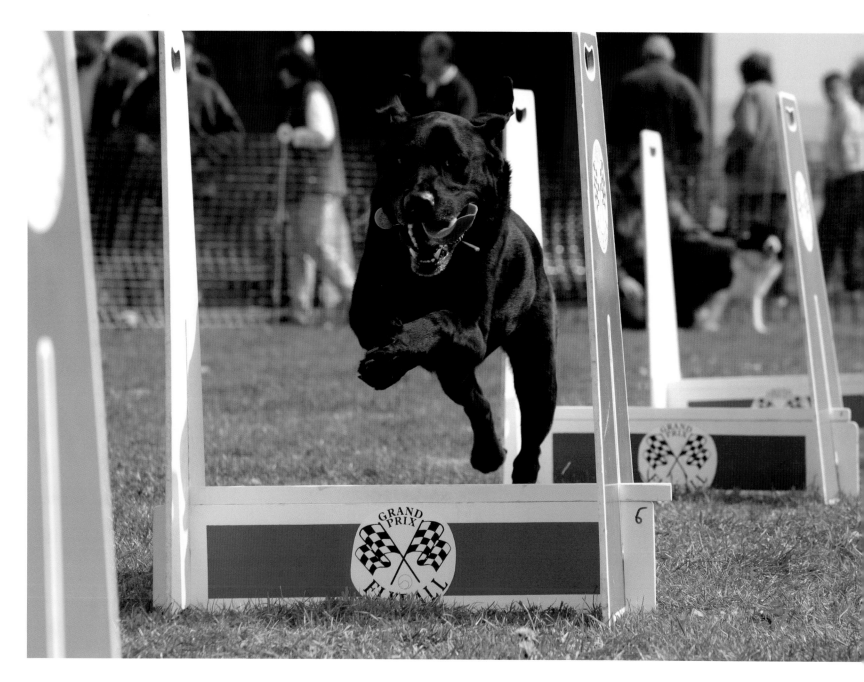

BLACK LABRADOR
Canon EOS D60; focal length 135mm; 1/1000sec at f/6.7;
ISO 400; exposure compensation of +1/2

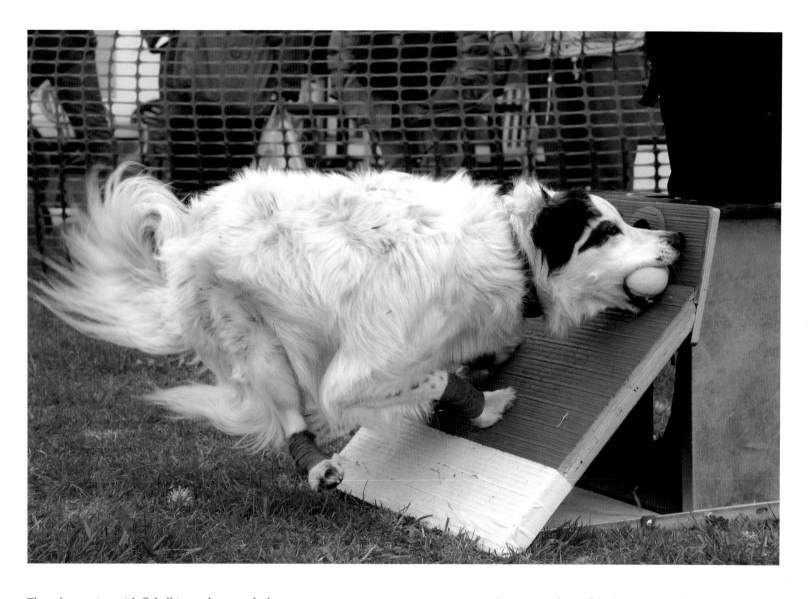

The other option with flyball is to photograph the dog as it hits the box to grab the ball. This really is a hit-and-miss affair, as just like the weaves in agility, dogs definitely have a preference to go left or right into the box and if you are on the wrong side you will miss the action. The good thing is that most flyball matches are run over the 'best of five' legs, so you get plenty of opportunity to practise. Use a fast shutter speed and pre-focus on the box.

One option during flyball events is to photograph the dog as it grabs the ball from the box.

BORDER COLLIE
Canon EOS D60 ; focal length 56mm; 1/1000sec at f/6.7; ISO 400

BE PREPARED

It would be quite impossible to account for all of the activities that our canine companions enjoy and I guess the best advice is to always carry a camera with you when you are out and about with your dog.

Always carry your camera, as you never know what you might come across.

BRACCO ITALIANO
Canon EOS D60; focal length 160mm; 1/750sec at f/8; ISO 400

I remember a situation when I should have practised what I preach. I was walking my young pup around a field, when she suddenly stopped and stared into a small bush. As I got closer a young badger cub stuck its head out and the two animals stood nose-to-nose for what seemed like an eternity. It was a once-in-a-lifetime moment as each tried to work out what the other was looking at. I, of course, didn't have my camera with me and I regret that to this very day. Commercially the picture could have made me a small fortune but, more important than that, it would have brought a smile to my face each time I looked at it.

The Digital Dog

Digital imaging is the fastest growing area of photography and, whether you own one of the latest top-of-the-range digital SLR cameras or a cheaper 35mm compact zoom, you can enjoy and experience the excitement of manipulating your images on a computer. There are various methods of capturing your digital image, either through a camera using a scanner attached to your PC, or by having your films put onto a CD-ROM by your processor. Either way, once you have your digital file, you can do far more than just look at it.

Computer Equipment

Without a computer and some basic software, you will not be able to enter the exciting world of digital imaging. As technology improves, the specification of computer hardware is changing at a dramatic rate and, in many cases, what you buy today will be out of date tomorrow, so do ensure that your system can be upgraded easily.

The Computer

The heart of any PC is the central processing unit (CPU). Digital images take a huge amount of processing and, the more powerful your CPU chip, the faster the computer will run. Imagine that your camera produces an image consisting of three million pixels; if you want to rotate the image just a few degrees, the CPU will have to map each individual pixel, and then calculate its new position, and that takes a lot of processing. If you are in the market for a new computer system, buy one with the fastest CPU speed that you can afford. It will literally save you time in the long run.

Most modern systems come with high-capacity hard drives (HDD); this is the filing cabinet of your computer. The software and any files that you create are stored in the hard drive and, as image files consist of large amounts of data, your hard drive will need to be large enough to cope with this demand. HDDs come in varying sizes but ideally you will need one with a capacity of at least 40 gigabytes (Gb), which should be suitable for most purposes.

If you are ordering a new workstation, make sure that it has two internal hard drives: the primary drive (used for programs, data and so on), plus a secondary drive that can be allocated as the 'scratch disk'. Some programs use the scratch disk to provide extra RAM (see below), and it will ensure that the system is really fast. Also, drives now come in various speeds, from 5400rpm upwards. If you want the quickest system, it is worth paying the extra cash for a faster speed.

The main issue with RAM (random access memory) is that the more you have the more easily and quickly a task can be accomplished. Most PCs will allow you to increase the amount of RAM and this is an important consideration when buying a new computer, especially if you plan to do a significant amount of digital-image work. Ideally, you want to have 256 megabytes (Mb) of RAM at the very least but, if you start using professional software products, you may need to increase this to around 512Mb. For example, Adobe PhotoShop requires RAM of four to five times the size of the file that is being edited, so for a single file size of 31Mb this means approximately 130Mb of RAM. Video RAM also plays an important part, as this governs the speed at which images are displayed on your monitor. Most graphics cards now have a standard 4Mb or more, which should be sufficient.

A computer and some basic software will enable you to view and adjust your photographs easily.

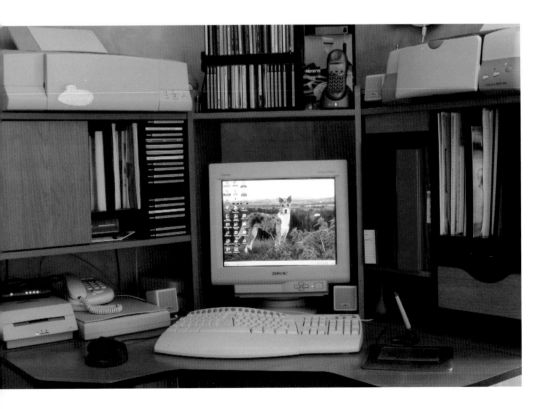

Peripheral connections

Computers have a great deal of associated hardware (even more if you use a digital camera), and these generally use one of two connection types. The most common is USB, but perhaps the easiest to manage is FireWire (sometimes referred to as IEEE394). To take advantage of these connections you'll need the necessary boards on your workstation. Macs have had these connections for some years, but older PCs may not have a single USB. Ideally you want at least one of each, and further expansion can be achieved by using an external hub.

External Hard Drives
If you are scanning a large number of high-resolution images, or if you use a digital camera and need to store your images, you are likely to find that your computer's hard-drive space starts to run out quite quickly. Additionally – and particularly important for digital photographs – it is always a good idea to have a back-up copy of your files. An external hard drive provides a flexible and affordable storage solution. They are only marginally slower than an internal hard drive, range in size from 80–500GB, and can be connected and disconnected at will using either USB or FireWire. For most users, a single 125Gb drive should be sufficient storage for many years' worth of photography.

CD Read/Writers
To make the most of your scanned or digitally captured images, it is essential that you have a CD burner. CDs can contain up to 700Mb of information (compared to 1.4Mb on a standard floppy disk), which is enough to store, for example, up to 23 high-resolution scanned images of 30Mb each. This makes them invaluable for storage, back-up and distribution purposes.

Most of the latest computers have a CD drive included as standard, but older workstations may only have a CD-R (Read only). If this is the case, external CD-RW (Read/Write) drives are readily available. When buying a new CD drive, pay particular attention to the speed of the write operation (usually quoted after the read speed). Ideally, the minimum should be 24x.

DVD burners are now also available, and as DVDs offer 4.9GB of storage this may seem like a better option. However, placing so many images on a single device is a risky option, especially if you plan to use it as your prime storage method.

CDs are not perfect. Consistent use of a CD will cause it to degrade more rapidly, and they are further prone to accidental damage such as scratches. Additionally, it is easy to build up a stack of CDs so large that finding a particular image can become a real hassle without a well-organized cataloguing system. Fortunately, companies like Adobe and Extensis produce visual image-management software that greatly simplifies this process.

Cable ports at the back of a Mac lap-top computer.

An external CD drive

Scanners

There are two types of scanners available: film and flat bed. Both enable the photographer to take transparencies (slides), negatives or photographs, and to turn them into digital files which can be stored on the computer.

Flat-bed scanners are incredibly cheap to buy and, in fact, many are supplied with shop-bought PCs. To use a flat-bed scanner, simply put your image face down and shut the lid (similar to a photocopier). The scanner works by passing an optical lens over the image and bouncing the light on to a charge-coupled device (CCD), similar to that used in a digital camera. The CCD then converts the image into pixels, and sends them to your PC.

Most scanner software will allow you to make some adjustments, such as contrast or colour balance. It should also allow you to set the resolution, which is normally expressed as dots per inch (dpi). The higher the dpi the better the quality of the final scans. Basic models will start at around 300dpi, but you should aim for one with at least 9600dpi.

Film scanners can be used to scan either the negative or transparency as well as prints, and tend to be more expensive to buy. Because negatives have to be enlarged, they need to have a far greater resolution. Most desktop models have at least 2000dpi, with the high-end models having up to 4000dpi.

A cheaper option of getting your images converted to digital files is to have your images saved on to a CD-ROM, either when you get them processed or at a later date when you have sorted them out. This costs very little and the scans tend to be of a higher quality.

The theory of scanning

To get the most from your scanned images, you need to appreciate the concept of resolution. Resolution does two things: it describes how many pixels should be captured as a scan is made, and it describes how large those pixels need to be when an image is printed. Alongside resolution, the three most used (and confused)

Some flat-bed scanners, such as this one, have a carrier for scanning slides and negatives but will not offer the same level of resolution as a dedicated film scanner.

EPSON PERFECTION 3200 PHOTO

phrases are spi (samples per inch), ppi (pixels per inch) and dpi (dots per inch).

Although dpi is often used interchangeably for all three terms, spi has the greatest relevance when you scan an image, because the spi resolution setting determines the size of the image in pixels. The scanner looks at little portions (or 'samples') of your image and records what they look like. Scan a 2 x 2in negative at 800spi and you end up with an image that is 1800 x 1800 pixels, or 3.2 million pixels in total.

One option when scanning an image is to scan at the highest resolution you are likely to need. In theory, you should then only have to scan it once; if you add this to a high-resolution image library, you can return to it time and again without ever going back to the original film. Furthermore, the image can easily be scaled down using image-editing software (see page 128) should you require low-resolution version – e.g. for use on the Internet. However, while small reductions in image size generally produce no discernible problems, substantial changes using this kind of digital manipulation can lead to problems. Secondly, unless you have a very powerful computer, working on unnecessarily large image files puts greater demands on your time and computing resources. On occasion you may have to go back to the original film to re-scan it if a particularly high-resolution version is required – perhaps for publication in a magazine – but your throughput could be much higher if you scan at a lower resolution in the first place.

All-in-one scanner

Many manufacturers now produce an all-in-one printer/scanner/copier, which is a very versatile option for any keen amateur photographer. It is an equally useful piece of kit for digital-camera owners, as many will print straight from a memory card or digital camera to give PC-free operation.

Printers

Once you have created your masterpiece, you will probably want to print it out. There are various printers on the market, ranging from the affordable to the extremely expensive.

Ink jet
Modern ink-jet printers are capable of producing very high-quality prints, providing the file contains sufficient data. There are issues regarding the archival quality of ink-jet prints, but the manufacturers are addressing this. It is always worth remembering that to get the best prints you should use the ink and paper that is recommended for your particular printer and, if you want photographic quality, you will need to use a specially coated paper that can cope with the distribution of the ink.

Dye sub
If you are aiming to produce a more traditional feel and look to your photographs, then a dye-sub printer may be the solution. The availability of affordable dye-sub printers is now making this type of printer more popular among digital photographers. Dye-sub printers work by heating a multi-coloured ribbon onto specially coated paper and then laying a final laminate coat over the image to protect it from wear and tear and fading. The resulting prints not only look and feel like traditional photographs, they can be produced in the comfort of your own living room.

Printing resolution
Just as with scanning (see page 126), it is possible to print at different resolutions. But while the significant variable with scanning is samples per inch (spi), the relevant terms with printing are pixels per inch (ppi) and dots per inch (dpi). When you scan an image, you capture a set number of pixels, but these pixels do not have to occupy the same physical space when an image is printed out – i.e. you can vary the size of the pixels and hence the number per inch. If you reproduce your image at 100%, the spi and ppi values will remain the same. However, if you want to print your image at twice its original size, you might scan at 800spi and then print at 400ppi.

Ink-jet printers construct colours or shades of grey from much smaller dots of ink. You therefore need a certain number of dots to reconstruct any given pixel, and the dpi setting literally translates to the number of ink dots per inch. The rule of thumb for this is simple: the ppi value should be lower that the dpi, and the general recommendation is that this should be by a factor of three. For example, if your ink-jet printer prints at 720dpi, your ppi value should be around 240 for any given file size. If you are using a dye-sub printer, however, ppi and dpi should be equal.

Colour-corrected prints
A perfect colour-corrected print is almost impossible to achieve without a lot of hard work and endless testing; most of the time it is just down to luck and persistence. However, there are some methods that you can use to help increase your chances of success. One option is to buy and/or download from the Internet a printer profile that is specific to your printer/paper combination. Another approach is to stick to an sRGB workflow throughout all your image processing. This means that everything must be set to sRGB: colour matrix (if you are using a digital camera), computer, software (e.g. PhotoShop) and the printer-supplied profile (which is usually sRGB-based anyway).

Dye-sub printers use a thermal print head to transfer the ink onto specially coated paper. The resulting prints look and feel like traditional photographs, but can be produced in the comfort of your own home.

The Digital Darkroom

Once you have put your image into the computer, the fun can really start. Whether you want to change a colour image into black and white, or 'age' it with a sepia tone, this can be easily done using most image-manipulation programs. If you have bought your computer recently, the chances are that it was supplied with some form of image-manipulation software. These programs are normally scaled-down versions of full-blown packages. However, do not dismiss them as being useless, as they can normally perform the basic adjustments that can turn an ordinary picture into one that is something special.

Software Software packages fall into two categories: basic and advanced. The basic programs are designed for those people who don't know much about image manipulation and only need to perform the most basic of functions. They are very user-friendly and the interface is easy to use, guiding you through the function you want to perform. The advanced programs have been developed for the professional image-maker and the learning curve is immense. Although not particularly user-friendly, these programs allow the photographer to perform complex functions and create images way beyond what the traditional photographer could ever have achieved in his or her darkroom.

Because of the diversity of software programs on the market, it would be impossible to ensure that the techniques shown on the following pages can be achieved by all of them, but all programs should be able to deal with some of the basic tasks.

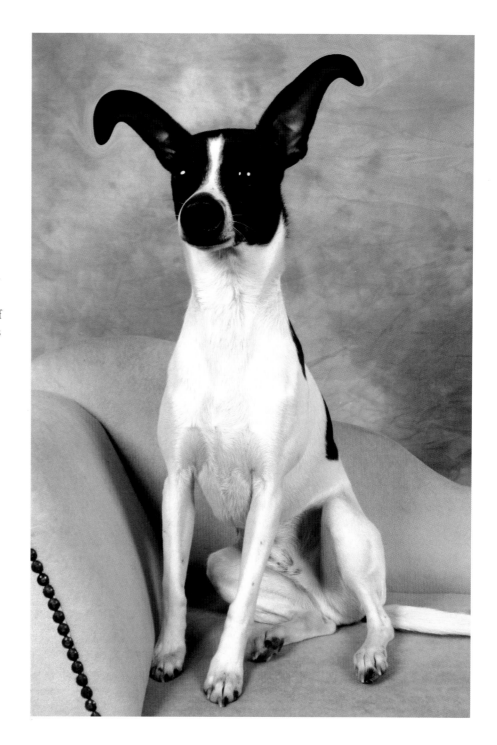

Digital image manipulation can be fun as well as having a more serious application in modern day dog photography.

CROSSBREED
Canon EOS D60; focal length 50mm; 1/60sec at f/22; two studio flash units; ISO 100; ears stretched in Adobe Photoshop 7.0

Cropping

When photographing dogs, especially when taking action shots, it can be difficult to get sufficiently close to the animal to ensure that it is large enough in the photograph. You may want to exclude some unwanted feature that you did not notice when you pressed the shutter button. Composition can also be improved by judicial use of the cropping tool, but it is not an excuse for sloppy technique; it is always better to get it right 'in-camera', rather than constantly re-composing on the computer.

There are problems associated with cropping images, especially if your dog is quite small in the frame. The camera can only record so much on the film or digital chip and, the smaller the main subject, the less detail will be captured. If you crop in too much, you could find that the image will be degraded to the point where it is unusable and nothing more than a mass of indistinguishable colour. This is another good reason to ensure that your composition is right before taking the photograph.

BEFORE

LEFT The original image before cropping in Adobe Photoshop.

COLLIE-CROSS-LURCHER Canon EOS D30; focal length 135mm; 1/500sec at f/6.7; ISO 100

RIGHT
The crop tool in use. The greyed-out areas will be discarded after the image has been cropped.

AFTER

ABOVE The final result after cropping. Not only has the dog been made more prominent in the frame, but the format has also been changed from landscape to portrait.

Green- or Red-eye Reduction

In some cases, despite using bounced flash or a diffuser (see page 51), you will still get the dreaded green eye (or red eye if a dog has light-coloured eyes), and you may have to resort to some post-image manipulation. Many programs will offer a simple one-click green-eye removal function. With others you may have to select an alternative colour and paint it over the eyes – the program will do its magic and seamlessly blend the new tone so that the opacity is retained. As with all software functions you will need to practise and remember, if it goes wrong you can always start again.

BEFORE

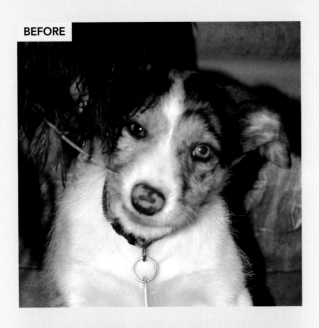

AFTER

The in-built flash has caused red eye in this young pup (*ABOVE LEFT*). Using the one-click solution in the software quickly and easily repairs the problem (*BELOW LEFT*).

COLLIE-CROSS-LURCHER
Canon EOS D30; focal length 105mm; 1/60sec at f/5.6; ISO 400

Cloning Out Unwanted Elements

The clone tool (or stamp tool in Photoshop) has to be the most useful implement that image-manipulation software has created. Whether you have a telegraph pole seemingly growing out of your dog's head, or an annoying piece of vegetation spoiling an otherwise perfect photograph, judicial use of this duplication tool can dramatically transform an image.

The clone tool can be used to 'remove' an object (as show in the example, right) by copying parts of the photo that surround the object you want to remove (in this case the dog's lead) and pasting them over it, thereby making it 'disappear' into its surroundings.

Alternatively, you can add objects by cloning in larger areas; for example, you could take a sample from one of the dog's in the picture shown here and clone a 'twin' of the same dog into another part of the picture. You can even clone in areas from a completely different photo.

The most common mistake that people make when using this function is that they tend to keep the source point static of the area they copied, which leads to a repeated and very obvious pattern in the target area. The secret is to keep moving the selection point, so that a natural and irregular pattern is built up over the section of the image that you want to hide.

A new feature that has found its way into one of the top-end programs is a 'healing brush'. This clone tool not only samples and replaces pixels, it can even blend in the cloned part with the same light and texture as the original. To get consistently good results this requires practice and patience but, when mastered, this trick can rescue a disappointing picture and turn it into a masterpiece.

BEFORE

The clone tool can be used to remove, or in truth replace, unwanted elements in a picture. The dog on the far left of this group (*ABOVE*) had to be tethered as a precaution, however this meant that the lead would show on the final print. A few deft touches with the cloning tool and the lead has been removed (*BELOW*).

BRACCO ITALIANO
Canon EOS D60; focal length 50mm; 1/60sec at f/11; ISO 200

AFTER

Colour Changes and Toning

One basic function common to nearly all of the manipulation-software programs allows you to make changes to the colour or tone of your image. Brightness and contrast can also be adjusted and are normally controlled either by entering values in a toolbox, or by using sliders to make the alteration.

Converting to Black & White
Some of the entry-level programs may have pre-set toolbar buttons that will automatically change the image from colour to black and white, or sepia. If you do not have these, you can use the 'Hue and Saturation' toolbar. The most straightforward technique is to literally drain the colour from the image by adjusting the saturation slider so the value is at zero. You might find that you will also need to make some adjustment to the contrast, to bring back some depth to the image.

Sepia Toning
This traditional photographic tone is very popular: it gives the image an 'aged' look that can be particularly effective if your pet has been photographed in an environment such as an antique chair, or in an old barn. Once again there are various methods of producing sepia pictures and, if you are using a program that has a pre-set button, simply click on that and let the computer do all the work for you. If you are using advanced-level software, you may have to make the adjustments yourself, once again by using the 'Hue and Saturation' tool.

If you can enter values for the 'Hue and Saturation', then a good starting point is 25 and 30 respectively. If you do not like the tone, then adjust the values to taste. Depending on which program you are using (for example, Photoshop), you might find that you will have to click a check box (colorize) before you can make this adjustment.

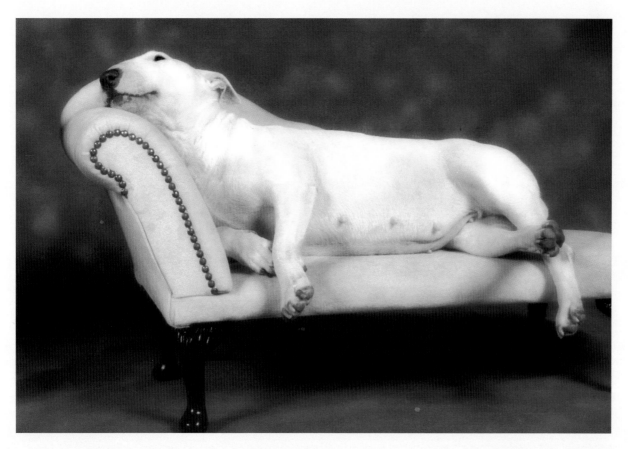

MINIATURE STAFFORDSHIRE BULL TERRIER
Canon EOS D60; focal length 28mm; 1/60sec at f/19; ISO 100

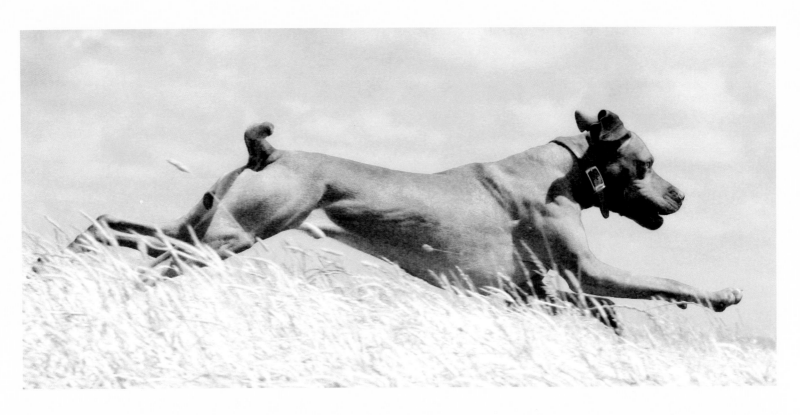

Fake infrared can turn an ordinary colour photo into something very surreal.

HUNGARIAN VIZSLA
Canon EOS D60; focal length 90mm; 1/1500sec at f/8.0; ISO 400

Fake Infrared If you are looking for something different, you could try converting a colour photo into a surreal infrared-effect image. This technique will not suit all dog pictures; ideally the image will need a simple background with a lot of green foliage as this will create the ghostly whites and deep moody blacks that are indicative of an infrared photograph.

For those image-makers that use Adobe Photoshop or Elements, a simple and fairly straightforward method for fake infrared is to:

- Open an RGB colour photo and go to 'Image', then 'Adjustments', then 'Channel Mixer'. Click the 'Monochrome' box and dial in the following values: Red: -20%, Green: +200%, Blue: -80%. You can adjust these values to suit your taste but, as a general rule, the three values should add up to 100%.

- Go to the 'Channels' palette (this is usually linked with the 'Paths' and 'Layers' palettes), or go to 'Window', then 'Channels'. Select the 'Green'

channel and apply a 'Gaussian Blur' filter, by going to 'Filter', then 'Blur', then 'Gaussian Blur': this will just apply the filter to the greens in your picture. Use a fairly low value of between two and 20, depending on your file size.

- Now go to 'Edit', then 'Fade Gaussian Blur'. Slide the mode down to 'Screen' and reduce the opacity to about 50%. You will see that this reduces the blur effect and also lightens the overall picture.

- The photo will now have a more surreal look to it, but will also have a green colour cast when you switch back to 'RGB' in the Channels palette. If you want to adjust this, repeat the 'Gaussian Blur', and 'Fade Gaussian Blur' steps in both the red and green channels, experimenting with the opacities, until you get a result that you are happy with.

You may have to experiment with this technique, but persevere and it will be worth it.

Creating Borders and Shapes

One of the simplest techniques to enhance any picture is the inclusion of a border. These can range from simple, coloured lines to a faded frame called a vignette. There are specialist programs on the market that have pre-designed borders supplied on CD-ROMs, varying quite widely in price. They can add that extra something to your photograph. Some consumer software will come with a variation of built-in borders and it is worth experimenting with these, but avoid the garish and the gimmicky ones.

Borders come in a range of designs from the simple to the sublime. There is plenty of choice from independent manufactures, or you can make you own.

STAFFORDSHIRE BULL TERRIERS
Canon EOS D60; focal length 90mm; 1/90sec at f/6.7; ISO 200

Creative Filter Effects

There are a wide variety of 'filters' in the different image-manipulation packages, and they can usually be adjusted to give more subtle or more extreme results.

Some of the 'brush' or 'artistic' ranges of filter can give the impression that the image has been painted with either watercolours or oil paints. These filters do call for some experimentation to achieve the right effect and usually work best when there is a good variation of tones in the original picture. When you have created your new masterpiece, try printing it out on one of the many art-grade papers that are available for ink-jet printers, as this will add to the 'textured' effect.

This image was treated to a brush filter and then a canvas texture was applied to simulate a painting.

ROUGH COLLIE
Canon EOS D30; focal length 135mm; 1/500sec at f/6.7; ISO 100

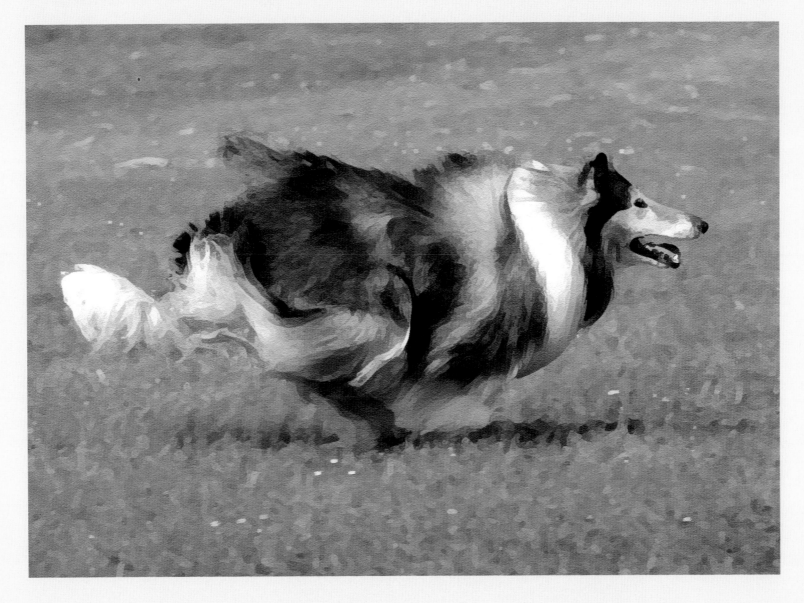

Un-sharp Mask

'Un-sharp Mask', (believe it or not) is designed to sharpen your digital image. Whether you have scanned a photograph, or taken one using the most expensive and up-to-date digital cameras available, it will need some degree of sharpening before printing.

The 'Un-sharp Mask' filter normally has two or three settings available: percentage, radius and threshold. The first two are the most important. You will need to experiment with this filter but, in general, most images benefit from a percentage setting of between 100–200% and a radius setting of 0.05 to 1.0. Bear in mind that an image will always look sharper on your computer screen than it will when it is printed.

Soft Focus and Blur Effects

Most image-manipulation software has some kind of 'blur' facility and if you are using an advanced software package, you may well be offered the choice of anything up to six different types of blur filter.

Gaussian Blur

Even the most basic software package normally gives you the option of using a filter known as 'Gaussian Blur'. This filter gives the photograph a dream-like quality that can give fur or hair a wonderfully soft texture. Don't overdo this effect, though, or your photograph may end up looking as if it was taken out of focus.

The 'Gaussian Blur' filter gives a dream-like quality to images. Although normally used for human portraits it can also work extremely well for dog photography.

GOLDEN LABRADOR
Canon EOS D60; focal length 15mm; 1/125sec at f/5.6; ISO 100

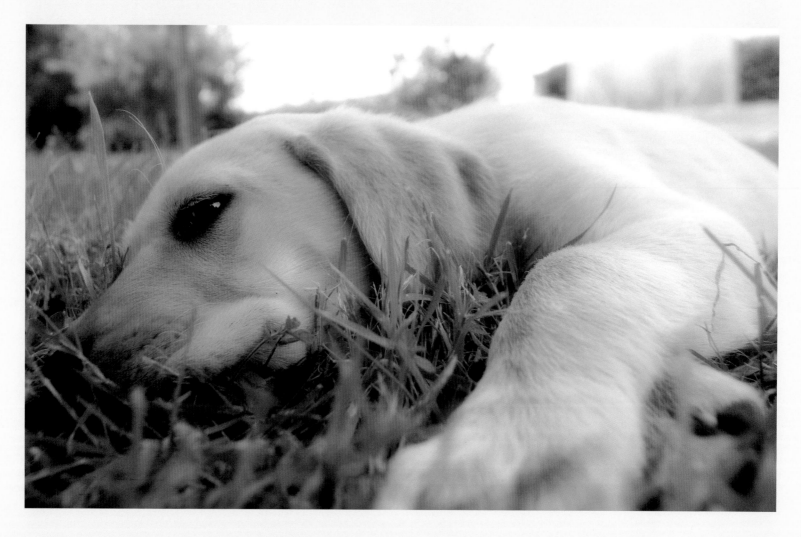

Motion Blur Another option under the 'Blur' filters menu can be used to give an impression of speed. Applying the 'Motion Blur' filter gives the same sense of movement as you get by panning a photo (see page 97), although the result is unlikely to be as realistic as it would be if the effect were created 'in-camera'.

To add a subtle speed effect to this photo of a border collie, I decided to apply the 'Motion Blur' filter to the dog from the shoulders back, but kept the dog's face and front legs sharp.

BEFORE

I started by selecting an area from the dog's shoulders back, then 'feathered' this selection: feathering softens the effect of any treatment that is applied afterwards so that the result is less obvious. I then added the area around the dog's head to my selection and feathered again, to a lesser extent. This gave me an area to apply the blur filter to, leaving the dog's head untouched.

Under the 'Filters' menu, I selected 'Blur', then 'Motion Blur'. With the 'Preview' option checked, I was able to move the slider along and see what effect the filter would have. I adjusted the angle so that the dog would be blurred horizontally and chose a fairly low amount to blur by.

BORDER COLLIE
Canon EOS D60; focal
length 200 mm; 1/750sec
at f/6.7; ISO 400

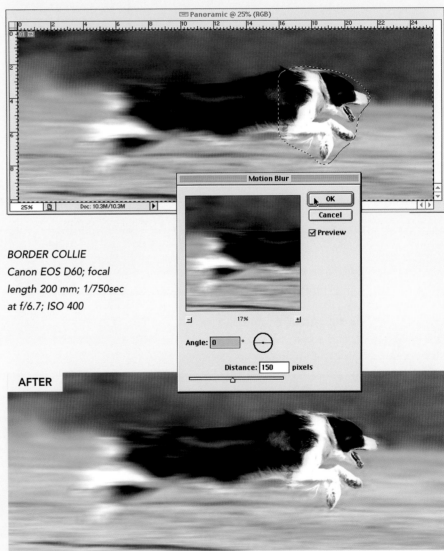

AFTER

Taking Your Pictures Further

Once you have created your masterpiece in the digital darkroom, the next step is to produce a photograph that can be shown proudly to your family and friends.

Printing Out

Digital photography is growing at a fantastic pace and it can be difficult to keep up with all the new software and hardware. If you don't have a high-resolution colour printer at home you can still get photographic-quality prints from your digitally enhanced pictures by sending them off to be printed out. With the increase in the use of the Internet, there are now a number of companies offering photographic services via the Web. You can now e-mail your digital file to one of them, a few days later, a print will drop through your letterbox. Alternatively, you could write your files to a CD-ROM, or take your digital film in to one of the high street processors who will produce your prints using one of the latest digital printers.

Calendars and Greetings Cards

Now we've looked at the basics of printing it's time to be a little more creative. Most printers, scanners and digital cameras come with some sort of digital imaging software. If you buy a new computer you will almost certainly have some included in the basic package. One of the benefits of this basic software is that it often include templates for turning your pictures into cards, calendars and a host of other projects.

Normally using these templates couldn't be simpler and it is often just a case of selecting the template and positioning your picture within it. You shouldn't let this simplicity stop you from being creative though. Why not try a combination of pictures or styles to see what you can create?

One final note is that it is well worth investing in some card. Although it is pricier than normal paper it will make sure that your creations look great and last a lot longer.

The card and calendar below were created using MGI Photosuite 4.0.

The card and calendar were made by combining templates from the image manipulation program with digital pictures.

Email and the Internet

If you are connected to the Internet, why not e-mail your images to your friends and family, all at the press of a button. If you are really ambitious, you could even design a website to show off your photographs.

Creating a Website

The Internet is a great resource for photographers: it allows you to upload your images and make them instantly available to anyone in the world. This can include potential clients or simply friends, relatives or members of a photographic club.

Creating a website might seem like a daunting prospect, requiring serious software and in-depth technical understanding, but it really depends on how for you want to take things. Several packages – including BreezeBrowser, Adobe PhotoShop Album, and Extensis Portfolio – allow you to generate simple web pages quickly and easily. For example, PhotoShop Album can be used to create a virtual 3-D gallery that you use the cursor to walk round, complete with musical accompaniment! Computer programs such as these are very useful for any photographer with a large number of digital images (whether scanned or digitally originated) to edit and/or catalogue, and the web-development facilities are an additional feature.

Alternatively, if you want to get the most from the medium you can build a website from scratch with relatively little experience or additional equipment and software. *Photographers' Guide to Web Publishing* (see page 156) gives a jargon-free approach that is specifically tailored to photographers, and explains everything from how the Internet works to how to promote your own site.

Setting up your own website allows you to share your work with friends, family and potential clients cheaply and almost instantly.

Glossary

Aperture
A (theoretically) circular adjustable opening of the lens which lets light into a camera. Measured in f/stops – the larger the f/stop number, the smaller the hole and the less light is let in. The smaller the number, the larger the hole and the more light is let in.

'Bulb' setting
Long shutter speed mostly used at night. In 'Bulb', the shutter is open as long as the shutter release button is depressed.

Bracketing
The process of taking a sequence of photographs at different exposures to ensure at least one is correct.

Cable release
Off-camera shutter release which allows the camera to be fired from a distance. An air release is similar but uses air rather than a metal cable to trigger the shutter release (also known as remote release).

Dedicated
Indicates that a flashgun is specially designed for a particular camera range.

Depth of field
The amount of the image that is acceptably sharp. This is controlled by the aperture (f/stop) setting. The smaller the aperture, the greater the depth of field.

Element
The main component of a lens, generally a single piece of glass with two polished and coated surfaces. A combination of elements is used to attain optimum quality.

Exposure latitude
The flexibility of a film in dealing with different exposures. While most print films can perform with up to about three stops overexposure and two stops underexposure, slide film allows only about half a stop either way.

f/stop
The description of the size of an aperture in relation to the focal length of a lens – f/2 in a 50mm lens would describe an aperture with a diameter of 50/2 = 25mm.

Fast lens
A fast lens has a wide maximum aperture (e.g. f/2) to allow more light in and therefore allow faster shutter speeds.

Field of view
The angle diagonally across the frame. Telephoto lenses have a narrow field of view, while wideangle lenses have a large field of view.

Fill-in flash
A flash combined with daylight in an exposure. Used with naturally back-lit or harshly side-lit or top-lit subjects to prevent silhouettes forming, or to add extra light to the shadow areas of a well-lit scene.

Film speed
A measure of a film's sensitivity to light. Usually given as an ISO number. The larger the number, the more sensitive the film is to light (the 'faster' it is).

Filter
A generic term for any object placed in front of a lens or light source that is used to modify the light falling on the subject or the film. Filters can 'correct' the colour of the light, distort certain colours, reduce reflections or allow special effects to be created.

Flare

Non-image-forming light that scatters within the lens system. This can create multi-coloured circles or a general loss in contrast. It can be reduced by multiple lens coatings, low dispersion lens elements and by the use of a lens hood.

Flash guide number (GN)

A number indicating the power of a flash unit. Measured in metres, the GN relates to the aperture needed to expose a certain speed film with the subject at a certain distance from the flash. GN divided by distance equals required aperture (GN/d = f). Usually measured against ISO 100 film. When using faster or slower films, the guide number doubles or halves every two stops so, for example, ISO 400 film will deliver a guide number twice as big as ISO 100 which itself is twice as big as for ISO 25.

Flash sync

The sync(hronization) speed is the maximum speed at which a focal plane shutter can work with flash. At speeds faster than the sync speed, only part of the film shot with the flash will be lit.

Focal length

The optical definition of focal length is irrelevant, but the effects are vital. It defines the magnification of the image and the field of view of a lens. The longer the focal length the larger the image magnification on the film.

Focusing

The adjustment made to the distance between the lens and the film to get a sharp image.

Focus lock

Allows you to recompose while keeping the main subject in focus.

Fogging

When an area of light-sensitive material has been damaged by exposure to light, multiple X-rays or chemicals. This can take the form of a misty or black negative or a bleached area on transparency film.

Hotshoe

The fitting on top of a camera for electronic flash units, or other accessories. It enables the flash to synchronize with the shutter.

Hyperfocal distance (HFD)

A useful shortcut for getting maximum front-to-back sharpness at a given aperture. When the lens is focused at infinity, the HFD is the distance of the nearest object still in focus. When the lens is then focused at the hyperfocal distance, all objects between infinity and half the hyperfocal distance will be sharp.

ISO

Abbreviation for the International Standards Organization. A measure of nominal film sensitivity. (See Film Speed).

Macro lens

A lens that allows close focusing and large image magnification. True macro lenses produce 1:1 images on film.

Metering

A system the camera uses to read the amount of light coming from a scene. Metering systems include: spot metering, centre-weighted metering, and 3D matrix metering.

Multiple exposure

Taking several exposures on a single frame of film.

Neutral density (ND)
Filters that reduce the brightness of an image without affecting colour. Graduated ND filters are useful for reducing the contrast between a very bright sky and darker land in landscape shots.

PC
Abbreviation for Power Cord. The standard camera to flash connector.

Pushing/pulling
Pushing is uprating the ISO speed of the film and compensating for this by developing the film for longer than normal. Pulling is the opposite, where a film is rated at a slower speed.

Rear/second-curtain sync
It is usual for a flash unit to fire as soon as the second shutter curtain is fully open. With rear-curtain sync, the flash is fired the instant before the second shutter closes.

Slow sync flash
A flash burst combined with a slower than usual shutter speed, i.e. a shutter speed longer than the maximum flash sync speed.

SLR
Single Lens Reflex. A camera where you view the image through the same lens that projects the image onto the film.

Speed
Term applied to the light sensitivity of specific films or plates. The faster the film speed, the greater the sensitivity to light and the shorter the required exposure. Film speed is now expressed in ISO numbers (it used to be ASA).

Spot meter
An exposure meter that allows you to measure the intensity of reflected light from a very small or distant area.

Standard lens
A standard lens is one that provides approximately the same field of view as the human eye. In 35mm format this approximates to a 50mm lens.

Stopping down
Reduction of the opening of the diaphragm aperture (e.g. from f/8 to f/11) which cuts down on the light entering the lens and increases depth of field.

Sync lead
A cable that connects a flash unit to the PC socket of a camera or flash meter. The camera triggers the flash, via the cable, when the shutter is open.

TTL
Through-the-lens. Normally applied to metering where readings are measured through the taking lens rather than through a separate camera window.

Vignetting
The cropping or darkening of the corners of an image. This can be caused by a generic lens hood or by the design of the lens itself. Most lenses do vignette, but to such a minor extent it is unnoticeable. This is more of a problem with zoom lenses than fixed focal lengths.

Wideangle Lenses with a wider angle of vision than the human eye. Lenses wider than 60 degrees are wideangle, more than 90 degrees is super-wide.

Zoom lens A lens with a variable focal length that can be altered by the photographer.

About the Author

Nick Ridley has a passion for dogs and this, coupled with the experience he gained whilst working as an Inspector for a well-respected animal-welfare charity, gives him an undeniable edge when photographing our canine companions.

Four years ago he set up an event-photography business, specializing in 'Action and Portrait Animal Photography'; this has now developed into one of the highest profile businesses of its kind in the UK and on most weekends he can be found practising what he preaches. In 2003 Nick left his job to pursue one of his many 'dreams and schemes' and become a full-time professional photographer and writer.

Such a busy working life requires boundless energy and enthusiasm, and these Nick has in large measures: he has featured in numerous national TV programmes, made many appearances on local TV news programmes, and his articles and photographs have been published in various animal and photography magazines. This is his second book; his first, *How to Photograph Pets*, was published in 2002 by GMC Publications.

Nick now lives in Buckinghamshire, England, with his wife, two teenage daughters and of course 'the dogs'.

To see more of Nick's work visit his web site at : www.nickridley.com

Image Index

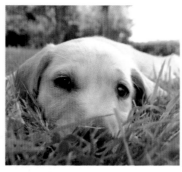

page 16
GOLDEN LABRADOR
Canon EOS D60; focal length 15mm;
1/180sec at f/5.6; ISO 100

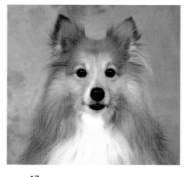

page 17
SHELTIE
Canon EOS D60; focal length 50mm; 1/60sec
at f/22; two studio flash units, ISO 100

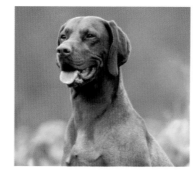

page 17
HUNGARIAN VIZSLA
Canon EOS D60; focal length 200mm;
1/350sec at f/5.6; ISO 400

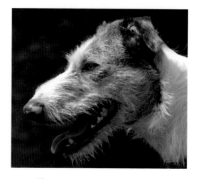

page 18
COLLIE-CROSS-LURCHER
Canon EOS D60; focal length 50mm;
1/500sec at f/6.7; ISO 100

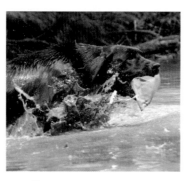

page 19
BLACK LABRADOR
Canon EOS D60; focal length 235mm;
1/750sec at f/6.7; ISO 800

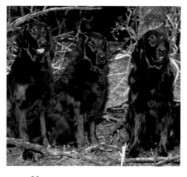

page 20
FLAT-COAT RETRIEVERS
Canon EOS D30; focal length 43 mm; 1/60
sec at f/4.5; External flash E-TTL Auto +
Red eye reduction; ISO 100

page 23
DOGUE DE BORDEAUX
Canon EOS D60; focal length 35mm;
1/60sec at f/19; ISO 100

page 27
RED SETTER
Canon EOS-1D; focal length 90mm;
1/50sec at f/3.5; ISO 640

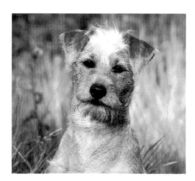

page 28
LAKELAND-CROSS-TERRIER
Canon EOS D60; focal length 90mm;
1/1500sec at f/3.5; ISO 400

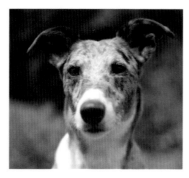

page 29
COLLIE-CROSS-LURCHER
Canon EOS D30, 1/4000sec at f/2

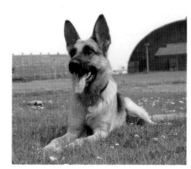

page 29
GERMAN SHEPHERD
Canon EOS D30; focal length 41mm;
1/1000sec at f/6.7; ISO 200

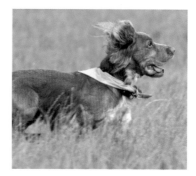

page 30
COCKER SPANIEL
Canon EOS D60; focal length 285mm;
1/1000sec at f/8; ISO 400

page 31
WORKING BEARDED COLLIE
Canon EOS D30; focal length 135mm;
1/60sec at f/5.6; flash; ISO 100

page 31
TERRIER
Canon EOS D60; focal length 190mm;
1/30sec at f/9.5; ISO 400

page 32
BLACK LABRADOR
Canon EOS D60; focal length 100mm;
1/60 sec at f/9.5; ISO 400; exposure
compensation of +1/2

page 33
BOXERS
Canon EOS D30; focal length
105mm;1/45sec at f/11; ISO 400

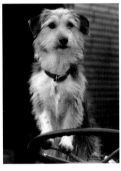

page 34
TERRIER
Canon EOS D60; focal length 135mm;
1/60sec at f/6.7; ISO 100; exposure
compensation of +1

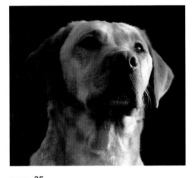

page 35
GOLDEN LABRADOR
Canon EOS D60; focal length 135mm;
1/90sec at f/9.5; ISO 200

page 36
COLLIE-CROSS-LURCHER
Canon EOS D60; focal length 95mm;
1/45sec at f/5.6; ISO 200

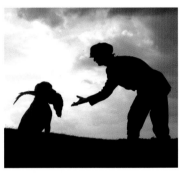

page 37
WEIMARANER
Canon EOS D30; focal length 50mm;
1/1000sec at f/8; ISO 100

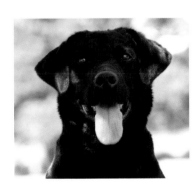

page 38
BLACK LABRADOR
Canon EOS D30; focal length 200mm;
1/30sec at f/9.5; ISO 200

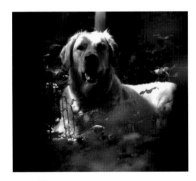

page 39
GOLDEN RETRIEVER
Canon EOS D60; focal length 200mm;
1/20sec at f/6.7; ISO 400

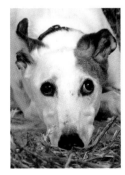

page 40
GREYHOUND
Canon EOS D60; focal length 135mm;
1/60sec at f/16; two studio flash units;
ISO 200

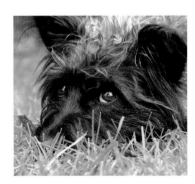

page 40
CROSSBREED
Canon EOS D30; focal length 135mm;
1/20sec at f/11; ISO 400

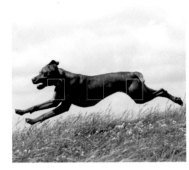

page 41
HUNGARIAN VIZSLA
Canon EOS D60; focal length 90mm; 1/1500sec at f/8; ISO 400

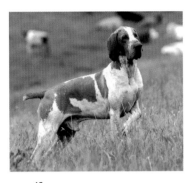

page 42
BRACCO ITALIANO
Canon EOS D60; focal length 350mm; 1/1500sec at f/8; ISO 400

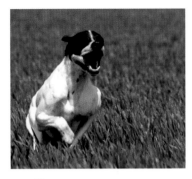

page 43
ENGLISH POINTER
Canon EOS D60; focal length 300mm; 1/1000sec at f/9.5; ISO 400

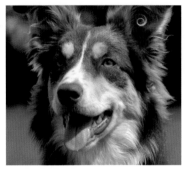

page 43
BORDER COLLIE
Canon EOS D30; focal length 130mm; 1/1000sec at f/6.7; ISO 200

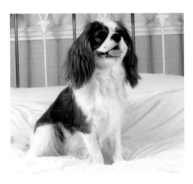

page 46
KING CHARLES CAVALIER SPANIEL
Canon EOS D30; focal length 38mm; 1/60sec at f/16; ISO 100

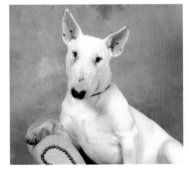

page 48
ENGLISH BULL TERRIER
Canon EOS D60; focal length at 33mm; 1/60sec at f/22; ISO 100

page 48
CROSSBREED
Canon EOS D60; 1/60sec at f/16; two studio flash units; ISO 100

page 49
KING CHARLES CAVALIER SPANIEL
Canon EOS D30; focal length 53mm; 1/60sec at f/13; ISO 100

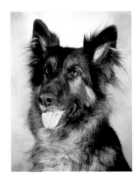

page 49
GERMAN SHEPHERD
Canon EOS D30; focal length 50mm, 1/200sec at f/8; two studio flash units; ISO 100

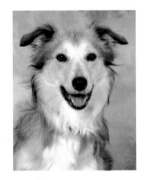

page 50
CROSSBREED
Canon EOS D60; focal length 105mm, 1/60sec at f/22; two studio flash units, ISO 100

page 56
WOLF
Canon EOS D60, focal length 135mm; 1/125sec at f/11; ISO 200; exposure compensation of +1/2

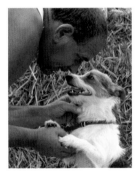

page 57
JACK RUSSELL TERRIER
Canon EOS D30; focal length 70mm; 1/250sec at f/8; ISO 200

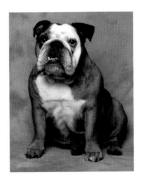

page 57
ENGLISH BULLDOG
*Canon EOS D60; focal length 50mm;
1/60sec at f/16; ISO 100*

page 58
ITALIAN SPINONIE
*Canon EOS D60; focal length 28mm;
1/90sec at f/11; ISO 200; exposure
compensation of +1/2*

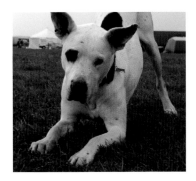

page 59
CROSSBREED
*Canon EOS D60; focal length 44mm;
1/250sec at f/11; ISO 200*

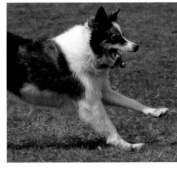

page 59
BORDER COLLIE
*Canon EOS D60; focal length 135mm;
1/1000sec at f/9.5; ISO 400*

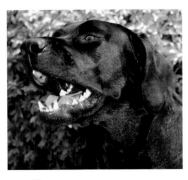

page 60
BLACK LABRADOR
*Canon EOS D30; focal length 117mm;
1/350sec at f/5.6; ISO 200; exposure
compensation of +1/2*

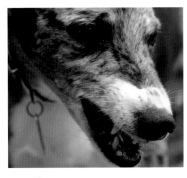

page 60
COLLIE-CROSS-LURCHER
*Canon EOS D30; 1/350sec at f/5.6;
ISO 200*

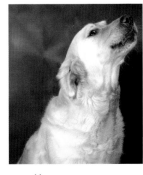

page 61
GOLDEN RETRIEVER
*Canon EOS D30; focal length 135mm;
1/60sec at f/16; 2 studio flash units;
ISO 200*

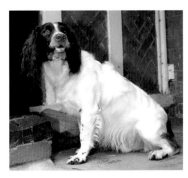

page 61
ENGLISH SPRINGER SPANIEL
*Canon EOS D30; focal length 135mm;
1/350sec at f/8; ISO 200*

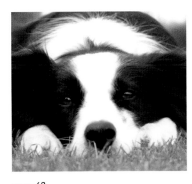

page 62
BORDER COLLIE
*Canon EOS D30; focal length 135mm;
1/90sec at f/9.5; ISO 200*

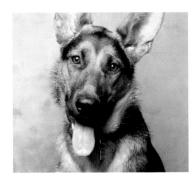

page 63
GERMAN SHEPHERD
*Canon EOS D60; focal length 60mm,
1/60sec at f/16; ISO 100*

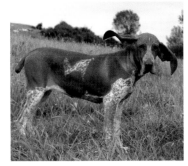

page 63
BRACCO ITALIANO
*Canon EOS D60; focal length 65mm;
1/180sec at f/8; ISO 200; exposure
compensation of +1*

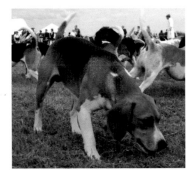

page 64
BEAGLE
*Canon EOS D60; focal length 15mm;
1/250sec at f/9.5; ISO 200*

page 65
TERRIER
Canon EOS D60; focal length 155mm;
1/500sec at f/8; ISO 400

page 68
COLLIE-CROSS-LURCHER
Canon EOS D30; focal length 38mm;
1/90sec at f/6.7; ISO 100

page 68
COLLIE-CROSS-LURCHERS
Canon EOS D30; focal length 115mm;
1/60sec at f/5.6; flash on; ISO 100

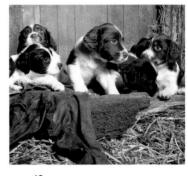

page 69
ENGLISH SPRINGER SPANIELS
Canon EOS D30; focal length 28mm; single
studio flash unit

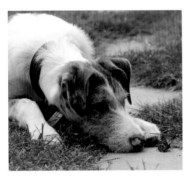

page 69
COLLIE-CROSS-LURCHER
Canon EOS D60; focal length 135mm;
1/350sec at f/6.7; ISO 400

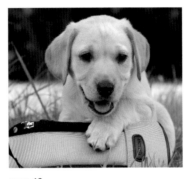

page 69
GOLDEN LABRADOR
Canon EOS D60; focal length 135mm;
1/125sec at f/9.5; ISO 400; exposure
compensation +1/2

page 70
COLLIE-CROSS-LURCHER
Canon EOS D30; focal length 35mm;
1/250sec at f/5.6; ISO 100; exposure
compensation +1/2

page 71
GOLDEN LABRADOR
Canon EOS D60; focal length 210mm;
1/1000sec at f/8; ISO 400

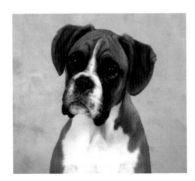

page 71
BOXER
Canon EOS D60; focal length 50mm;
1/60sec at f/19; two studio flash units;
umbrellas; ISO 100

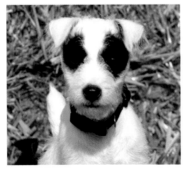

page 72
JACK RUSSELL TERRIER
Canon EOS D60; focal length 100mm;
1/1500sec at f/8; ISO 400

page 72
ITALIAN GREYHOUND
Canon EOS D60; focal length 44mm;
1/60sec at f/16; two studio flash units;
umbrellas; ISO 100

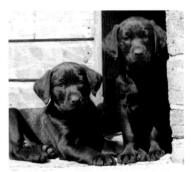

page 73
BLACK LABRADORS
Canon EOS D30; focal length 80mm;
1/90sec at f/6.7; flash off; ISO 100

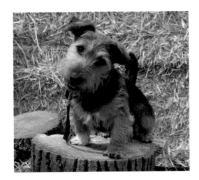

page 74
TERRIER
Canon EOS D60; focal length 30mm;
1/90 sec at f/9.5; ISO 100; exposure
compensation +1/2

page 75
TECKEL
Canon EOS D30; focal length 185mm;
1/750sec at f/5.6; ISO 200

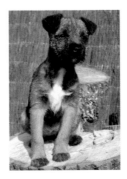

page 75
BORDER TERRIER
Canon EOS D60; focal length 50mm;
1/350sec at f/11; ISO 400

page 76
COLLIE-CROSS-LURCHER
Canon EOS D30; focal length 80mm;
1/15sec at f/11; built-in flash; ISO 200

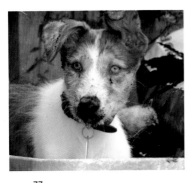

page 77
COLLIE-CROSS-LURCHER
Canon EOS D30; focal length 135mm;
1/45sec at f/11; ISO 200

page 78
GOLDEN LABRADOR
Canon EOS D30; focal length 135mm;
1/125sec at f/3.5; ISO 100

page 79
GOLDEN LABRADOR
Canon EOS D30; focal length 127mm;
1/750sec at f/8; ISO 100

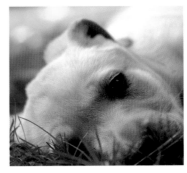

page 79
GOLDEN LABRADOR
Canon EOS D30; focal length 135mm;
1/180sec at f/3.5; ISO 100

page 82
CROSSBREED
Canon EOS D60; focal length 60mm;
1/500sec at f/5.6; ISO 400; exposure
compensation of +1/2

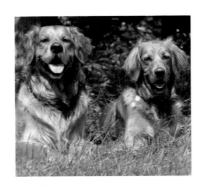

page 82
GOLDEN RETRIEVERS
Canon EOS D60; focal length 90mm;
1/350sec at f/8; ISO 200; exposure
compensation of + 1/2

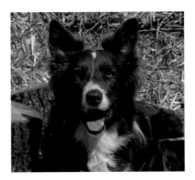

page 83
BORDER COLLIE
Canon EOS D60; focal length 53mm;
1/350sec at f/9.5; ISO 200

page 83
PARSONS JACK RUSSELL
Canon EOS D60; focal length 90mm;
1/350sec at f/11; ISO 200

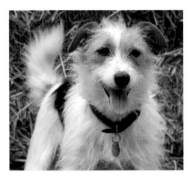

page 84
JACK RUSSELL TERRIER
*Canon EOS 10D; focal length 125mm;
1/500sec at f/8; ISO 400*

page 84
GOLDEN LABRADORS
*Canon EOS D60; focal length 235mm;
1/500sec at f/8; ISO 400*

page 85
ITALIAN SPINONIE
*Canon EOS D60 ; focal length 112mm;
1/250sec at f/11; ISO 200*

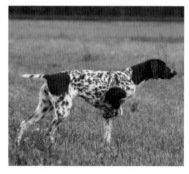

page 85
GERMAN SHORT-HAIRED POINTER
*Canon EOS D60; focal length 195mm;
1/180sec at f/8; ISO 400*

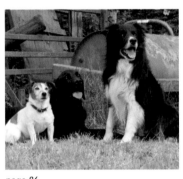

page 86
**JACK RUSSELL, BLACK LABRADOR AND
BORDER COLLIE**
*Canon EOS D30; focal length 47mm;
1/90sec at f/9.5; ISO 100*

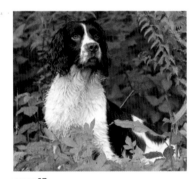

page 87
ENGLISH SPRINGER SPANIEL
*Canon EOS D60; focal length 105mm;
1/250sec at f/5.6; ISO 400*

page 87
WEIMARANER
*Canon EOS D30 ; focal length 60mm;
1/250sec at f/5.6; ISO 100*

page 88
ENGLISH SPRINGER SPANIEL
*Canon EOS D60; focal length 50mm;
1/90sec at f/8; ISO 400*

page 89
COLLIE-CROSS-LURCHER
*Canon EOS D30; focal length 145mm;
1/125sec at f/8; ISO 200*

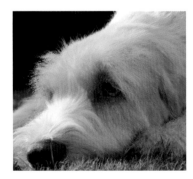

page 89
ITALIAN SPINONIE
*Canon EOS D60; focal length 117mm;
1/125sec at f/11; ISO 200*

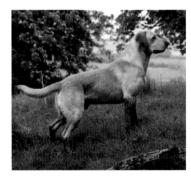

page 90
GOLDEN LABRADOR
*Canon EOS D60; focal length 210mm;
1/500sec at f/13; ISO 800*

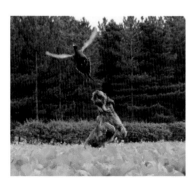

page 91
ITALIAN SPINONIE
*Canon EOS D60; focal length 85mm;
1/500sec at f/6.7; ISO 400; exposure
compensation of +1/2*

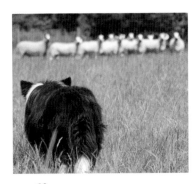

page 92
BORDER COLLIE
Canon EOS D60; focal length 135mm;
1/180sec at f/8; ISO 100

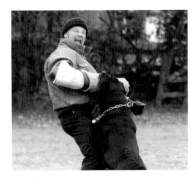

page 93
ROTTWEILER
Canon EOS D60; focal length 148mm;
1/180sec at f/5.6; ISO: 400

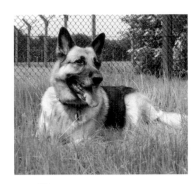

page 93
GERMAN SHEPHERD
Canon EOS D30; focal length 28mm;
1/250sec at f/9.5; ISO 200

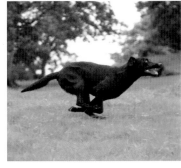

page 94
BLACK LABRADOR
Canon EOS D60; focal length 120mm;
1/750sec at f/4.5; ISO 400

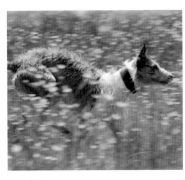

page 95
COLLIE-CROSS-LURCHER
Canon EOS D60; 1/250sec at f/8; ISO 100

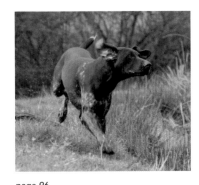

page 96
GERMAN SHORT-HAIRED POINTER
Canon EOS D30; focal length 135mm;
1/500sec at f/6.7; ISO 200

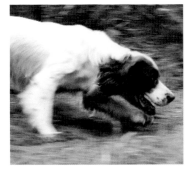

page 97
ENGLISH SPRINGER SPANIEL
Canon EOS D60; focal length 117mm;
1/125sec at f/8; ISO 800

page 98
GERMAN SHORT-HAIRED POINTER
Canon EOS D60; focal length 270mm;
1/500sec at f/5.6; ISO 400

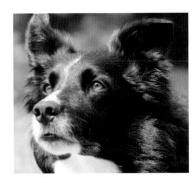

page 99
BORDER COLLIE
Canon EOS D30; focal length 109mm;
1/350sec at f/6.7; ISO 400

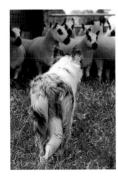

page 99
BORDER COLLIE
Canon EOS D60; focal length 35mm;
1/180sec at f/8; ISO 100

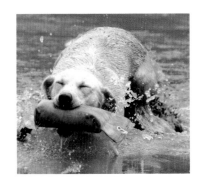

page 100
GOLDEN LABRADOR
Canon EOS D60; focal length 260mm;
1/500sec at f/9.5; ISO 800

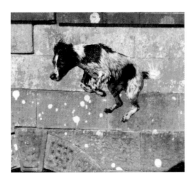

page 101
ENGLISH SPRINGER SPANIEL
Canon EOS D60; focal length 170mm;
1/1000sec at f/11; ISO 800

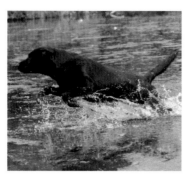

page 102
BLACK LABRADOR
Canon EOS D60; focal length 75mm;
1/1500sec at f/5.6; ISO 400

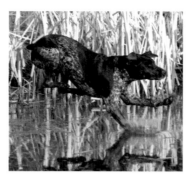

page 102
GERMAN SHORT-HAIRED POINTER
Canon EOS D60; focal length 100mm;
1/1000sec at f/5.6; ISO 400

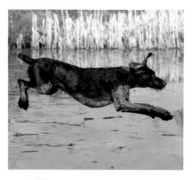

page 103
GERMAN WIRE-HAIRED POINTER
Canon EOS D60; focal length 90mm;
1/1500sec at f/8; ISO 400

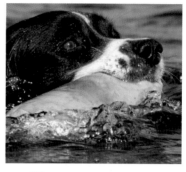

page 104
ENGLISH SPRINGER SPANIEL
Canon EOS D60; focal length 300mm;
1/750sec at f/9.5; ISO 400

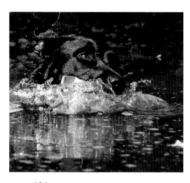

page 104
BLACK LABRADOR
Canon EOS D60; focal length 275mm;
1/1500sec at f/5.6; ISO 400

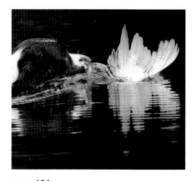

page 104
ENGLISH SPRINGER SPANIEL
Canon EOS D60; focal length 220mm;
1/500sec at f/6.7; ISO 800

page 105
NEWFOUNDLAND
Canon EOS D60; focal length 260mm;
1/500sec at f/8; ISO 400

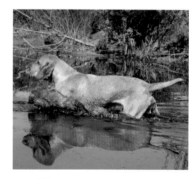

page 106
HUNGARIAN VIZSLA
Canon EOS D30; focal length 300mm;
1/200sec at f/9.5; ISO 200

page 107
GIANT MUNSTERLANDER
Canon EOS D30; focal length 75mm;
1/750sec at f/5.6; ISO 400

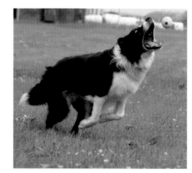

page 110
BORDER COLLIE
Canon EOS D30; focal length 135mm;
1/1000sec at f/8; ISO 400

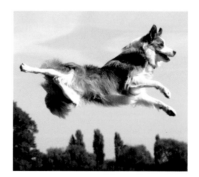

page 111
BORDER COLLIE
Canon EOS D60; focal length 100mm;
1/750sec at f/9.5; ISO 400

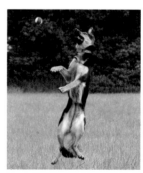

page 111
GERMAN SHEPHERD
Canon EOS D60; focal length 100mm;
1/1000sec at f/8; ISO 400

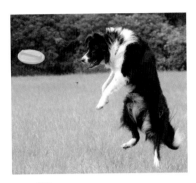

page 112
BORDER COLLIE
*Canon EOS D60; focal length 115mm;
1/750sec at f/8; ISO 400*

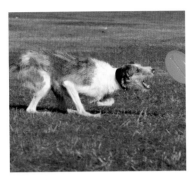

page 112
COLLIE-CROSS-LURCHER
*Canon EOS D60; focal length 70mm;
1/1500sec at f/8; ISO 400*

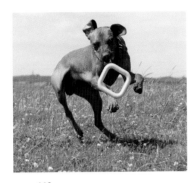

page 113
HUNGARIAN VIZSLA
*Canon EOS D60; focal length 90mm;
1/1000sec at f/8; ISO 400*

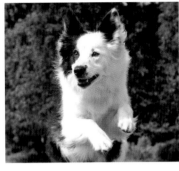

page 114
BORDER COLLIE
*Canon EOS D60; focal length 44mm;
1/500sec at f/4.5; ISO 200*

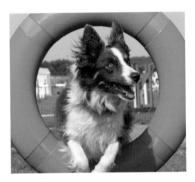

page 115
BORDER COLLIE
*Canon EOS D60; focal length 60mm;
1/1000sec at f/8; ISO 400, exposure
compensation of +1/2*

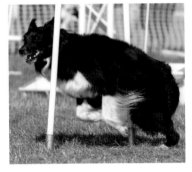

page 116
BORDER COLLIE
*Canon EOS D60; focal length 180mm;
1/1000sec at f/6.7; ISO 200*

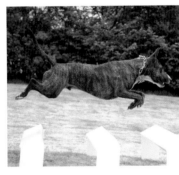

page 116
ENGLISH BULL TERRIER
*Canon EOS D30; focal length 56mm;
1/1000sec at f/4.5; ISO 40*

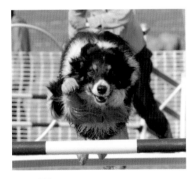

page 117
BORDER COLLIE
*Canon EOS D60; focal length 180mm;
1/1000sec at f/11; ISO 400*

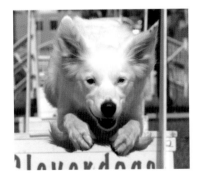

page 118
CROSSBREED
*Canon EOS D60; focal length 56mm;
1/1000sec at f/6.7; ISO 400*

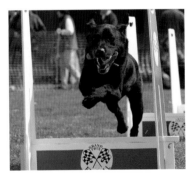

page 119
BLACK LABRADOR
*Canon EOS D60; focal length 135mm;
1/1000sec at f/6.7; ISO 400; exposure
compensation of +1/2*

page 120
BORDER COLLIE
*Canon EOS D60; focal length 56mm;
1/1000sec at f/6.7; ISO 400*

page 121
BRACCO ITALIANO
*Canon EOS D60; focal length 160mm;
1/750sec at f/8; ISO 400*

Index

The Photographers' Institute Press, PIP, is an exciting name in photography publishing. When you see this name on the spine of a book, you will be sure that the author is an experienced photographer and the content is of the highest standard, both technically and visually. Formed as a mark of quality, the Photographers' Institute Press covers the full range of photographic interests, from expanded camera guides to exposure techniques and landscape.

The list represents a selection of titles currently published or scheduled to be published.

All are available direct from the Publishers or through bookshops and specialist retailers.

To place an order, or to obtain a complete catalogue, contact:

**Photographers' Institute Press,
Castle Place,
166 High Street, Lewes,
East Sussex BN7 1XU
United Kingdom**

Tel: 01273 488005
Fax: 01273 402866
E-mail: pubs@thegmcgroup.com

Orders by credit card are accepted

Animal Photographs: A Practical Guide Robert Maier
ISBN 1 86108 303 3

Approaching Photography Paul Hill
ISBN 1 86108 323 8

Bird Photography: A Global Site Guide David Tipling
ISBN 1 86108 302 5

Digital SLR Masterclass Andy Rouse
ISBN 1 86108 358 0

Garden Photography: A Professional Guide Tony Cooper
ISBN 1 86108 392 0

Getting the Best from Your 35mm SLR Camera
Michael Burgess
ISBN 1 86108 347 5

Photographers' Guide to Web Publishing Charles Saunders
ISBN 1 86108 352 1

Photographing Changing Light: A Guide for Landscape Photographers Ken Scott
ISBN 1 86108 380 7

Photographing Flowers Sue Bishop
ISBN 1 86108 366 1

Photographing People Roderick Macmillan
ISBN 1 86108 313 0

Photographing Water in the Landscape David Tarn
ISBN 1 86108 396 3

The Photographic Guide to Exposure Chris Weston
ISBN 1 86108 387 4

The PIP Expanded Guide to the: Nikon F5 Chris Weston
ISBN 1 86108 382 3

The PIP Expanded Guide to the: Nikon F80/N80
Matthew Dennis
ISBN 1 86108 348 3

The PIP Expanded Guide to the: Canon EOS 300/Rebel 2000 Matthew Dennis
ISBN 1 86108 338 6

Travel Photography: An Essential Guide Rob Flemming
ISBN 1 86108 362 9